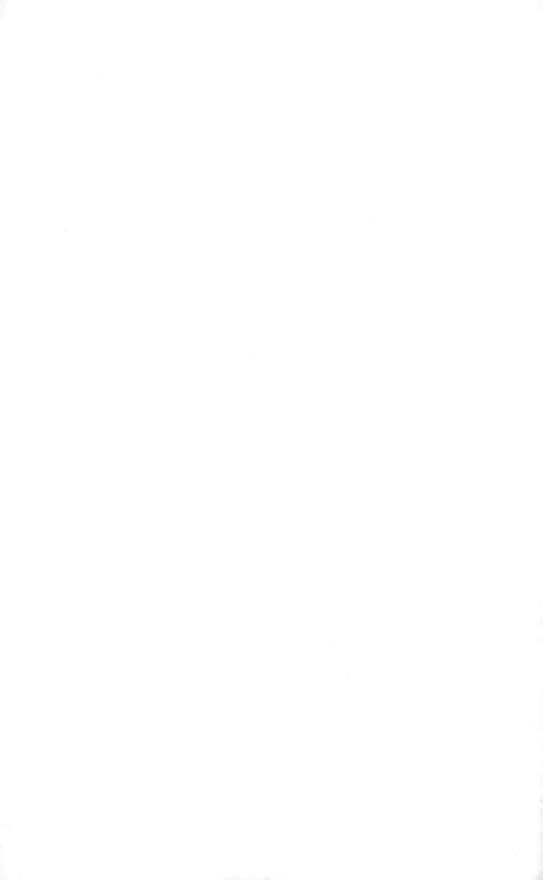

DIEGO RIVERA

As Epic Modernist

■

André Breton, Diego Rivera, and Leon Trotsky in Coyoacán in 1938, photograph by Fritz Back. Taken from the Surrealist journal *Minotaure*, Number 12–13, 1939.

WORLD ARTISTS SERIES

BRUCE COLE
Series Editor

DIEGO RIVERA

As Epic Modernist

■

by David Craven

G. K. Hall & Co.
Simon & Schuster Macmillan
New York

Prentice Hall International
London Mexico City New Delhi Singapore Sydney Toronto

This book is dedicated to Professor Joseph Sloane
and to my parents, Dr. and Mrs. Albert Craven.

G.K. Hall & Co.
An imprint of Simon & Schuster Macmillan
1633 Broadway
New York, NY 10019

Printed in the United States on permanent paper.

Library of Congress Cataloging in Publication Data

Craven, David, 1951–
 Diego Rivera : as epic modernist / by David Craven.
 p. cm.
 Includes bibliographical references and index.
 ISBN 0-8161-0537-5 (alk. paper)
 1. Rivera, Diego, 1886–1957 — Criticism and interpretation.
I. Rivera, Diego, 1886–1957. II. Title.
ND259.R5C66 1997
759.972—dc21 97-24321

TABLE OF CONTENTS

■

LIST OF ILLUSTRATIONS

∎

Book Cover: Diego Rivera, *Zapatista Landscape: The Guerrilla*, 1915, oil on canvas, Mexico City, Museo Nacional de Arte (INBA), Photograph © Dirk Bakker.

Frontispiece Photo: *André Breton, Diego Rivera, and Leon Trotsky in Coyoacán in 1938*. Photograph by Fritz Bach. Taken from the Surrealist journal *Minotaure*, Number 12–13, 1939.

1. *Head of a Woman*, 1898, pencil on greenish blue paper, Mexico City, UNAM, Escuela Nacional de Artes Plásticas. Photograph © Dirk Bakker.

2. *Classical Head*, 1902, oil on canvas, Guanajuato, Mexico, Museo Diego Rivera (INBA). Photograpy © Dirk Bakker.

3. *La Era (The Era)*, 1904, oil on canvas, Guanajuato, Mexico, Museo Diego Rivera (INBA). Photography © Dirk Bakker.

4. *Portrait of Adolfo Best Maugard*, 1913, oil on canvas, Mexico City, Museo Nacional de Arte (INBA). Photograph © Dirk Bakker.

5. *Zapatista Landscape: The Guerrilla*, 1915, oil on canvas, Mexico City, Museo Nacional de Arte (INBA). Photograph © Dirk Bakker.

6. *Creation*, 1922/23, encaustic and gold leaf, Mexico City, Escuela Nacional Preparatoria, Anfiteatro Bolivar. Photograph © Dirk Bakker.

7. *The Embrace and Seated Peasants*, 1923, fresco mixed with nopal juice, Court of Labor, Ministry of Education, Mexico City. Photograph by Bob Schalkwijk.

8. *The Rural School Teacher*, 1923, fresco mixed with nopal juice, Court of Labor, Ministry of Education, Mexico City. Photograph by Bob Schalkwijk.

ACKNOWLEDGEMENTS

■

While doing research on this book over the last seven years, I have accumulated a number of intellectual debts. Among the people whom I must thank for their provision of primary documentation in a series of 1992 interviews are three scholars who were once friends of Diego Rivera: Raquel Tibol, the late Meyer Schapiro, and Lillian Milgram Schapiro. I also gained considerably from discussions with three eminent figures in the fields of Mexican Art and History: Adolfo Gilly, Dore Ashton, and Dawn Ades. In addition, I have gained much from a close reading of my manuscript by Stanton Catlin, who is, after all, the "dean" of Latin American art history in the United States. Moreover, I benefited greatly from a probing reading of my text by Alejandro Anreus, whose own work on José Clemente Orozco is quite important.

The stimulus to write about the work of Diego Rivera came from my two research trips to Nicaragua in the 1980s, where a major mural movement was then underway in this Central American country. Discussions with muralists like Leonel Cerrato and art critics like Raúl Quintanilla provided me with insights into the nature of Rivera's influence. Moreover, I was able to discuss Rivera with Nicaraguan intellectuals when, at the *Universidad Nacional de Ingenieria (Managua)*, I gave a public lecture in 1995 entitled *"Diego Rivera y su influencia en la pintura nicaragüense de la decada de los 80."* I would like to thank Professor Porfirio García for inviting me to lecture there.

In 1995 I also gave a public lecture, *"El Legado Artístico de Diego Rivera en Nicaragua,"* at the Museo Dolores Olmedo Patiño near Mexico City. I need to thank Leticia López Orozco for arranging this public presentation and Armando Torres Michúa for his insightful comments after the talk. While teaching a seminar in 1995 at the *Instituto de Investigaciones Estéticas of the Universidad Nacional Autónoma de México* (Mexico City), I had the opportunity to meet prominent Mexican scholars who voiced their various, sometimes conflicting, and generally challenging interpretations of Rivera's artwork. These scholars included Rita Eder, Alicia Azuela, Leticia López Orozco, Renato González Mello, Elizabeth Hulverson, and Pablo Escalante.

On February 19, 1996 at the Western Carolina University "Arts

Festival" for that year, I presented some of the material in this book as part of my Keynote Lecture "Art and Politics in the Art of Diego Rivera." I would like to thank Professors James Thompson and Robert Godfrey for arranging this public lecture.

Several scholars, artists, and administrators at various universities deserve thanks because of the scholarly aid, moral support, or monetary help that they have given me at one point or another. These people include Sonya Lipsett-Rivera, Sergio Rivera, Felix and María Masud-Piloto, Leonardo and Cecilia Vargas, Marcos Sánchez Tranquilino, Holly Barnet-Sánchez, David Kunzle, Francisco Letelier, Bard Prentiss, Fred Zimmerman, Hubert Keen, John Ryder, Janet and Henry Steck, Karl Werckmeister, Andrew Hemingway, Alan Wallach, Thomas Dodson, Douglas George, Joyce Szabo, Jim Jacob, José Rodriguez, Tom and Lori Barrow, Christiane Joost-Gaugier, Charlene Villaseñor Black, Stella de Sa Rego, Rudolf Baranik, May Stevens, Donna Peirce, Joe Rothrock, Flora Clancy, Christopher Mead, and Colleen Kattau.

There are several institutions to which I am very grateful for their having allowed me to study primary documents associated with Diego Rivera. These are the *Centro Nacional de Investigación, Documentación e Información de Artes Plásticas (CENIDIAP),* whose compilation of material is to be found in the Library of the *Centro Nacional De Las Artes* In Mexico City; The *Biblioteca "justino Fernández"* at the *Instituto de Investigacionces Estéticas;* the *Museo Casa Diego Rivera* in Guanajuato and the *Biblioteca del Museo Franz Meyer* in Mexico City; as well as the *Escuela Nacional de Artes Plásticas; the Museo Anahuacalli; the Museo Estudio San Angel;* and the *Museo Frida Kahlo, Casa Azul,* all of which are in Mexico City.

In Managua, Nicaragua, I was fortunate to be able to consult the *Rubén Darío Archive* at the *Biblioteca Nacional,* and also to discuss the modernist achievement of Rubén Darío with Sergio Ramírez, the distinguished novelist and former Vice President of Nicaragua.

Acknowledgement should also be made of the support for my research by the Latin American Institute at the University of New Mexico (where I presented some of this material in the Fall of 1996) and the United States Information Agency (which on the recommendation of Dean Thomas Dodson provided me with a generous grant to visit Mexico in 1995).

I would like to express gratitude to various graduate students at the University of New Mexico, several of whom have done significant work on Latin American topics: Florencia Bazzano Nelson, Gina Tarver, Heather Van Horn, Andrea Quijada, Catherine Redd, Jasmine Alinder, Stephanie Iverson, Kathryn Davis, Mark Friel, Debbie Boehm, Lindsay Jones, Vicki Norman, Kim Romero, Diane Zuliani, and Brian Winkenweder.

Aside from expressing gratitude to John Andrews and the staff of G.K. Hall for fine editorial help, I must also thank Jim Franco and the staff at the cafe/book store in Albuquerque named *"Best Price Books and Coffees."* For almost two years, they provided me with stimulating conversation and the free "office space" in which I was able to write most of this book. Lastly, two *compañeros* should be singled out beyond all others for my deepest show of appreciation, friendship, and gratitude, namely, Stephen Eisenman and Margery Amdur.

David Craven
Albuquerque, Mew Mexico

INTRODUCTION

■

Jorge Luis Borges once remarked that "fame is a form of incomprehension," and this observation is justified by the current nature of Diego Rivera's celebrity.[1] A prodigious talent from his earliest years, Rivera was a strikingly protean and remarkably prolific artist throughout his long career. His artistic achievement in the second quarter of the twentieth century was such that by mid-century he was one of the two or three most celebrated painters in the world. Yet his reputation at the end of the twentieth century is in need of considerable reassessment because, to a greater degree than is true of most other artists, Rivera is both widely known and little recognized, especially in the West.

On the one hand, Rivera is well known because of the imposing dimensions of his still-prominent public murals that he executed in both Mexico and the United States. Just as the fresco cycle of 117 paintings in the Ministry of Public Education in Mexico City alone covers almost 1,600 square meters, so art critic Luís Cardoza y Aragón also noted that the space filled by the entire oeuvre of Rivera extends to more than 6,000 square meters.[2] On the other hand, Rivera is currently little recognized for his undeniable aesthetic successes as a colorist and draughtsman in a variety of technics as well as media. Many scholars, who claim to be put off by Rivera's lifelong admixture of art and politics, refuse to analyze his artworks seriously because of their own politics. Ironically, those very same scholars are insensitive to Rivera's noteworthy aesthetic accomplishment, owing to their inability to gain any critical detachment from their own political views.

Nonetheless, those who have failed to grasp his artistic achievement in this way have inadvertently reminded us not only of the impossibility of entirely leaving behind one's own politics but also, and equally importantly, that to conflate art with politics, or to reduce one to the other, is a grave intellectual shortcoming. The unfortunate tendency to collapse art into politics, as if the two did not exist in a fundamentally asymmetrical relationship with each other, has long been a problem for many of Rivera's ardent admirers. For these partisans of Rivera's murals, art is merely a way of broadcasting or illustrating visual slogans that have *already* been formulated elsewhere by means of an appropriate politics.

1

Aside from being insensitive to the internal logic of the artistic values at issue, such a restrictive view is incapable of assessing art either as a language or formative force in its own right, both politically and aesthetically, which exceeds the mere mechanical reflection of supposedly pre-existent social views. Paradoxically, just as Rivera's detractors often cannot see his art for their politics, so the same (albeit for different reasons) must also be said for many of his admirers as well. The weaknesses of both sides in this debate were indirectly summarized by a Latin American intellectual, Armando Hart Dávalos, when he observed that *"to confuse art with politics is one mistake, while to separate art entirely from politics is another mistake."*[3]

Not surprisingly, for such a stylistically varied, technically distinguished, politically committed, and historically attentive artist, Rivera is markedly multifaceted, even contradictory. It would perhaps be preferable to speak of several Diego Riveras who exist in an uneasy, sometimes deeply conflictual relation, to each other. Yet, each of these different Riveras is explicable, in part, only by means of a larger-than-life historical force who was already legendary during his lifetime. In order to appreciate the unusual range and commanding scope of Diego Rivera's "unstable" achievement, and to establish many of the key issues that need to be addressed in this book, we must enumerate several of these Diego Riveras.

First, there is the child prodigy named José Diego María Rivera, whose precocity with a pencil rivaled that of his contemporary, Pablo Picasso, and who won a scholarship to the National Academy of San Carlos at age twelve with a series of neo-classical studies that bespeak an artistic maturity far beyond his years.

Second, there is the *modernista* Diego Rivera of scholars like Olivier Debroise, Jorge Alberto Manrique, Ramón Favela, and Rita Eder who, having mastered the neo-classical line of teacher Santiago Rebull (himself a student of Ingres), and also the distinctive use of chiaroscuro by José María Velasco (for "naturalistically" depicting the topography of Mexico), then went on to employ in rapid succession a whole range of modernist styles that included Symbolism, expressionism (with overtones of El Greco), Post-Impressionism, and Cubism. In fact, a usage of the latter visual idiom, with its compositional dependency on collages faceted together from various moments and components, remained one of the most enduring attributes of all his best artworks from the 1920s onward.[4]

Third, there is the *"indigenista"* Rivera of Lázaro Cárdenas (one rather

at odds with the *"Hispano-* or *cosmic raza"* Rivera of José Vasconcelos) who in his mural paintings "reclaimed the past like a campesino reclaiming his land."[5] This *"indigenista"* Rivera was the one who began to forge a new national language in the arts that drew upon past non-Western art, specifically, pre-Columbian visual forms — from the *Codex Borbonicus* through Aztec sculpture — to arrive at a transcultural visual language that decentered, but did not eliminate, European art within Mexican national culture. Furthermore, the paintings of Native Americans by this so-called *"indigenista"* Rivera contradicted, as Alberto Híjar has so deftly shown, the dominant cultural discourse on *indigenismo* in Mexico, along with the "Rousseauian paternalism" and racialist essentialism allied to it.[6]

Fourth, there is the little acknowledged Diego Rivera of Leon Trotsky (and more recently of scholars like O. K. Werckmeister) in whom, "in the field of painting, the October Revolution has found her greatest interpreter. . . . Nurtured in the artistic cultures of all peoples, all epochs."[7] This Rivera of Trotsky, a fundamental voice for the urban working class of modernization, was one who spoke more eloquently of the present *re-imagined,* or even "idealized," in the future than he did of the past or present in mere "realistic" terms.

Fifth, there was the culpable Rivera of the Stalinists who, according to fellow painter David Alfaro Siqueiros was a false friend of the proletariat, owing to an insufficiently *engagé* art, an antiquated use of materials, and a purely careerist concern with gaining fame through serving such rich patrons as Dwight Morrow, Edsel Ford, and John D. Rockefeller.[8]

Sixth, there is the only recently recognized Diego Rivera of Mikhail Bakhtin — a Rivera who unknowingly shared the now celebrated dialogical conception of peasant culture and popular carnivals for which the Russian author has become famous through such studies as *Rabelais and His World.*[9] This new and quite noteworthy Rivera, with an unintended affinity to Bakhtin, spoke about his own use of *campesino* (peasant) popular culture in one of his greatest murals of the 1930s:

> [T]he masses utilize carnival as a means of evening up scores with the social classes that consider themselves above them. . . . [my] murals to the left of the entrance [then in the Hôtel de la Reforma] are of the carnival at Huejotzingo, Puebla, in which the epic battle against the French is represented, in itself [as] a protest of the people.[10]

Seventh, there is the equally recent internationalist Diego Rivera of

Armando Torres Michúa (in keeping with the thought of Stuart Hall, Gerardo Mosquera and Roger Bartra), whose sophisticated and "impure" *mestizaje,* or hybridity of diverse ethnic languages both Western and non-Western in nature, undeniably constitutes one of the first great chapters in modern art history involving the creation of a post-Eurocentric, or "post-colonial," language (as Desmond Rochfort termed it) for this century and beyond.[11] It is this Rivera, along with one or two of the other Riveras, who embodies considerable promise for the most progressive tendencies of what has been too imprecisely named "post-modernism."

Eighth, there is the contested Rivera of Raquel Tibol and the feminists who artistically represented woman in active, even revolutionary roles, as in the *"Rural Schoolteacher"* in the Ministry of Education, but who also personally reproduced many of the inequitable values associated with traditional machismo.[12]

Ninth and tenth, there are the various Diego Riveras avowed by the artist himself at different points in his career. There is the advocate of popular art — such as, *retablos* and *pulquería* wall paintings — who said that a "revolutionary artist" was one who through popular values and through *"bueno artesano"* (good artisanship or artistic labor) demonstrated that for *"una expresión revolucionaria no importa el tema,"*[13] (for a revolutionary expression the theme or subject is not important). And we must also recall the Rivera of Alicia Azuela and Adolfo Sánchez Vázquez for whom artistic production was, before everything, *"a form of labor."*[14]

On the other hand, there was the related, but not necessarily synonymous, Rivera whose epic chronology of the Mexican people, in particular, and of humanity, in general, enjoyed few parallels in the modern period, as Meyer Schapiro noted of his friend's work in the 1930s.[15] This Rivera remarked late in his career that the greatest achievement of the Mexican mural movement was its *unprecedented content* — a content which marked the "first time in the history of art" that the heroes of monumental public paintings were not gods, kings or political leaders, but *"el pueblo"* (the people) from urban workers to campesinos.[16]

These two Diegos, who are not always compatible or easily reconciled, represent one of the major analytical challenges of the twentieth century for anyone grappling with the problem of art for and/or by "the people." The first of these two latter Riveras was a supporter of popular self-expression, on behalf of which Rivera sought only a greatly expanded

dialogue. The second, however, was a populist par excellence whose vanguardist claim to speak *for, rather than with,* the popular classes often presupposed an unduly monolithic view of various classes and class fractions known too simply as "the masses."

Among the aims of this book will be to reestablish the common threads that link, without necessarily unifying conclusively, most of these diverse tendencies and divergent positions noted above, so as to provide at least a provisional coherence to them. In so doing, I shall try to consolidate the position of Sánchez Vázquez that there was a "poetics or aesthetic ideology" constructed by Rivera with notable consistency throughout the many phases of his career.[17] This will be done, in part, by showing how this interpretation relates to what Alberto Híjar called Rivera's "voluntarism." Without denying that points of irresolution will remain, I shall try to articulate a certain type of historical cohesion. However open-ended this cohesion might be, it should permit us to appreciate the rich legacy produced by an artist of enormous artistic achievement and compassion for humanity, especially as manifested in his lifelong commitment to socialism, popular democracy, and racial equality. As should become clear, *all of these commitments embody much more varied concerns than we normally have a right to expect from any single person.*

In the study that follows, I shall address the career of Diego Rivera in a roughly chronological order, though I must also acknowledge a multilateral development both forward and backward in time, as well as a radial expansion outward at any one moment in history. Rivera's art will be seen both as part of a well-directed, if also delta-like, stylistic progression *and* as a body of work subject to a nonlinear process of uneven historical development.

CHAPTER ONE

■

The Renovation of Classicism: Rivera's First Years Through Studies in San Carlos and His Trip to Spain

■

"Rivera is the culmination of the lineage of a renovated classicism [in Mexican Art]."

Justino Fernández
El Arte del Siglo XX (1952)[1]

"His [Rivera's] life was fabulous, his accounts of his life more fabulous still. . . . His talk, theories, anecdotes, adventures, and his successive retellings of them, were an endless labyrinth of fables. . . . [Furthermore] he seemed always to be probing the cherished beliefs and point of tolerance of his listener. . . . His life as he recounted it was by no means the least interesting of his works of art. . . . [Yet] if Diego rarely told the simple truth, he did not tell simple lies either."

Bertram Wolfe
The Fabulous Life of Diego Rivera (1963)[2]

At a time when fact and fiction have become ever more difficult to distinguish from each other, the new art history seems to have found its perfect subject in Diego Rivera. Among the many people who sometimes failed to make this distinction between the fictive and the factual when writing about Rivera were all of his biographers, from Bertram Wolfe, Ernestine Evans, Florence Arquín, and Luís Suárez to Gladys March, Leah Brenner, and Loló de la Torriente.[3] A revealing example concerns the date recorded by all of the above for Rivera's birthday, December 8, 1886, a date given and "corroborated" by the artist himself. Yet instead of this day, which is the Feast Day of the Immaculate Conception, the correct

date for Rivera's birth in the city of Guanajuato was the less christological and more prosaic one of December 13, 1886. Similarly, the original name given to Rivera was not — as he and his biographers have claimed — Diego María de la Concepción Juan Nepomuceno Estanislao de la Rivera y Barrientos Acosta Rodríguez but simply José Diego María Rivera, with his twin brother, who died at age one and a half, being named José Carlos María Rivera.[4]

What little we know with certainty about Diego Rivera's earliest years does indicate, however, that he was a markedly precocious child, though not the miraculous one of the artist's later "memories." The son of two school teachers, including a father with very liberal political views in an illiberal period, Rivera began drawing extensively at age three and he learned to read at around age four. His first extant drawing is of a train and dates from his third year. (There are at least twelve drawings still extant by Rivera of varying levels of achievement up to and through the age of ten.)[5]

By six Rivera had been nicknamed "the engineer," owing to his fascination with mechanical objects, especially trains and mining machinery, and his lifelong interest in the natural sciences, particularly geology, would seem to represent traces of his childhood years in Guanajuato, the site of the huge Valenciana silver mine that was the greatest mine ever worked in colonial Spanish America.[6] Diego was at first deeply unhappy when his family felt compelled to move to Mexico City during his sixth year, only shortly after the birth of his sister María Rivera Barrientos. This abrupt change of residence was caused by the political enmity toward the Rivera family in conservative Guanajuato, which resulted from the advocacy of left-wing ideals by Diego Sr. in the liberal newspaper *El demócrata*. As Rivera later recalled, his father took "the side of the oppressed — the miners and the peasants . . . [Thus] we were subject to petty persecutions."[7]

The current situation of this region was summarized as follows by Eduardo Galeano in his now classic study of 1971 entitled *The Open Veins of Latin America*: today Guanajuato and Zácatecas (another mining center of the same period) "languish amid the skeletons of the camps of the mining boom . . . [while] tourists flock there to see the exuberant splendor of olden times."[8] In order to understand the reasons for the critiques by Diego Rivera's father and also the potency of the forces aligned against such criticism, it is necessary to recall some nineteenth-century accounts of the "glory days" of Guanajuato. The radical contrast of extreme wealth

and abject poverty that existed during the Rivera family's last years in the city had been analyzed earlier in the century by a celebrated visitor, namely, the German scientist Alexander von Humboldt.[9] Although the ornate baroque churches, posh theaters, and striking natural setting had led some to compare the city's layout and gardens to those of ancient Babylon, Humboldt entitled Guanajuato the "country of inequality."

> Perhaps nowhere is inequality more shocking [than in Guanajuato]. . . . The architecture of public and private buildings, the woman's elegant wardrobes, the high-society atmosphere: all testify to an extreme polish which is in extraordinary contrast to the nakedness, ignorance, and coarseness of the populace.[10]

Shortly after relocating to Mexico City, Diego contracted first scarlet fever, then typhoid and diphtheria. These illnesses perhaps explain why he started to school somewhat late. In 1894, at age seven, Rivera began school at the Colegio Católico Carpantier, a school selected by his devoutly Catholic mother. Well prepared for formal training by his parents, Rivera soon excelled in primary school. By 1896, he won the examination prize at the Liceo Católico Hispano-Mexicano. This was also the same year that Diego first began evening art classes at the National Academy of San Carlos in Mexico City and it was at this point that he produced two artworks that were quite remarkable for an artist of ten: The first was entitled *Portrait of María Barrientos de Rivera*, and was a pencil drawing on paper of his mother (31 x 22 cm.). The second, called simply *Landscape*, was an oil on canvas (55 x 70 cm.).[11]

The drawing of his mother evinces a precocity rivalled only by that of his contemporary, Pablo Picasso, at a comparable age. Already Rivera demonstrates in this portrait something of the deft touch, acute observation, and seemingly effortless aptitude for evoking a sense of volume that would all be developed further into hallmarks of his most noteworthy paintings. Furthermore, the sober, almost melancholic, expression that he has given his mother's face attests to a degree of psychological probing on the young Rivera's part making this a work of uncommon accomplishment for anyone of his age.

Likewise, the small cabinet painting discloses an unusual level of achievement for a ten-year-old. The sensitive combination of tertiary colors (various blues, bluish greens, and bluish greys) in the middle ground aptly intimates without overstating the visual weight of the two figures,

one of whom is mounted on a horse. In turn, this use of local color interaction recedes before a much broader contrast of primary hues that counterpoises various high-value yellows and light browns to the more somber blue hues in the middle area. All in all, it is a painting with a distinctly poetic quietude that is enhanced by the notable vigor of the color interaction that animates the work and moves the spectator's eye about.

At age eleven, Rivera's life became focused in a profound direction when, after enrolling in a military college at his father's insistence, he rebelled against the prospect of a career in the armed forces. As Rivera later recalled:

When my father came in late to discuss the curriculum of the military preparatory school he proposed to send me to, I was so repelled by the idea of the regimented life I would lead there that I literally ran out of the room and into the open air.

It was then, I think, [that] I knew that whatever false road I took afterwards, art was my destiny and would find me everywhere.[12]

In 1898, at age eleven, Diego Rivera was enrolled, with his parents' support, in regular classes at the Academy of San Carlos, the major school of the fine arts in Mexico and the oldest art school in the entire hemisphere (it was founded in 1785). His precocity was also acknowledged by means of a scholarship even though the usual age for admittance to the academy was at least sixteen. At this time, he executed some drawings that are outstanding in a number of respects. These works also remind us of what Justino Fernández identified as Rivera's central role later on in the culmination of a "renovated classicism" that would nonetheless represent a "synthesis of Apollo and Huitzilopchtli."[13]

These two remarkable drawings by Rivera in graphite from 1898 are the *Classical Standing Figure Leaning on an Urn* (50.7 x 35.2 cm.) and *Portrait of a Woman: Head of a Woman* (36.2 x 28.3 cm.). (Figure #1) The first work is an example of Rivera's French Academic training, which his program of study in Mexico was based upon, known as a *modèl a la bosse* (a drawing after a plaster cast featuring heightened shading). According to nineteenth-century teaching, the execution of such a *modèl* was necessary for acquiring a mastery of the concept of *effet* (the unified relationships of planes, lights, and darks) along with enhancing one's skill

in using *demi-teintes* (a graduated application of halftones). Rivera's drawing at age eleven is already a textbook example of precisely how to arrive at these effects in preparation for producing the spare, crisply focused style of nineteenth-century neo-classicism, with its lapidary surface texture and highly nuanced tonalities.

The second work, the head of a young woman, is even more impressive. Executed in graphite on greenish blue paper, it at first evokes somewhat the look of an old master metalpoint, or perhaps chiaroscuro, drawing (although there are no white highlights in Rivera's drawing). This work was most likely done from a live model and would have been a preparatory stage for painting an *ébauche* (the oil sketch of a head, usually one from life, that used a limited color range and featured transparent darks as well as emphatic highlights). An example of a variation by Rivera on the French academic *ébauche* does exist in the form of a black and white oil on canvas study from 1902 of a classically sculpted head (Collection of the Diego Rivera Museum, Guanajuato).[14] (Figure #2). This striking study in contrasts was done by Rivera when he was sixteen years old.

The earlier 1898 portrait drawing of a young woman's head features a sovereign delicacy of touch that heralds both the salient attribute of virtually all of Rivera's mature works (murals included) and also goes against the ungainliness that one would normally associate with the manual movements of a twelve-year-old without the polished grace of later years. The notable sensitivity with which the shading has been realized resulted from the use of a stomper to gently meld the various graphite lines employed. (Shading by means of cross-hatching only was the rule in academic exercises before the mid-nineteenth century and there is at least one pen and ink drawing by Rivera from 1900 of a classical bust which does showcase this type of shading in what the neo-classical tradition termed a *modèl de dessin*.)[15]

Rivera's portrait drawing of the young woman is marked by a subtle conveyance of substantial form through the most minimal formal components, all of which recalls the tradition represented most famously by Jean Auguste Dominique Ingres. Rivera's early mastery within this tradition also alerts the viewer to just how quickly he had gained proficiency in the approach to line and form demanded by one of his Academic professors, Santiago Rebull. A student of Ingres, Rebull would have a profound, if not always easily detectable, influence on the subsequent development of Rivera's career. This influence would manifest itself in the distinctive linearity of Rivera's approach with its under-

stated yet sensual line of considerable range and matching evocativeness.

Rivera's studies at the Academy of San Carlos lasted from 1898 to 1905, (age eleven to eighteen). These studies departed somewhat from those of the *École des Beaux Arts* in France. The program in Mexico was less wedded to the type of platonism intrinsic to French academic pedagogy, even though the visual language taught and the specific methods for teaching it were predicated on French procedures. In 1900, Rivera progressed from copying prints after plaster casts to drawing from actual plaster casts. In 1901, he began the study of perspective and anatomy, then in 1902 he started to draw from life. The following year, 1903, he studied art history and painted from nature.[16]

The strictly-ordered program of studies at San Carlos was under the influence of Comtian positivism as advocated by *los Científicos* ("the scientific ones") at the court of Dictator Porfirio Díaz, and emphasized the ideal of empirical study from nature coupled with a rationalist investigation of structure. Although the influence of positivism here reinforced Rivera's admiration for scientific study, there is no evidence that Rivera confused the *pseudo-scientific* philosophy of positivism with genuine scientific inquiry. An important distinction between the two was made by Bertrand Russell when he observed that by "ruling out hypotheses in general as metaphysical, positivism misconstrues the nature of scientific explanation."[17]

Among his professors at the Academy, there were three who stood out in Rivera's accounts of his time there. One was Félix Parra, to whom Rivera dedicated one of his own landscape paintings of 1902 with the inscription: "To my dear master, the notable artist Don Félix Parra."[18] About Parra, Rivera stated that he was "a conventional painter himself but [was] possessed with a passionate love for our pre-Conquest Indian art," which is a passion that Rivera quickly acquired. The second teacher of note was José María Velasco, whom Rivera regarded as "the world's greatest painter of landscapes."[19] It was from Velasco that Rivera learned how to use one-point perspective and to love the Mexican landscape as a important subject matter in art.

Finally, there was the disciple of Ingres, Santiago Rebull, from whom Rivera learned not only the rudiments of neo-classical draughtmanship but also about the "golden section" as a compositional device. Rivera noted how Rebull had made him more aware of "the laws of proportion and harmony, within which movement proceeds, and which are to be discerned in the masterpieces of all ages."[20] After Rebull's

death in 1903, and his replacement as subdirector by the Catalán painter Antonío Fabrés Costa, Rivera became increasingly disenchanted with San Carlos.

Fabrés introduced the *Pillet Method of Drawing*. This approach, which was named after French artist Jules-Jean Désiré Pillet, emphasized the importance of drawing from photographs or directly from nature, rather than from old master prints and classical casts. In a real sense, the Pillet Method, with its scientistic claim to total "objectivity," functioned in Mexico as an analogue for the official positivism of the Díaz dictatorship against which Rivera and other intellectuals would increasingly rebel in the years leading up to the Mexican Revolution.[21] In 1903, Rivera and his colleagues at San Carlos revolted against the directorship of Fabrés as well as school policies. All were expelled and then reinstated. Despite his lack of enthusiasm for Fabrés and the new method, Rivera still won the medal in 1904 for Fabrés' painting class, and in 1905, he won a government pension of 20 pesos per month.[22]

While he was at the Academy of San Carlos, Rivera claimed to have been deeply influenced by the nonacademic and popular images of Posada. To quote Rivera from an interview in the 1940s:

> About this time I met and came under the influence of the great folk artist José Guadalupe Posada, the most important of my teachers. . . . Posada had no place in the official circles of Mexican art. . . . It was he who revealed to me the inherent beauty in the Mexican people, their struggle and aspirations. And it was he who taught me the supreme lesson of all art — that nothing can be expressed except through the force of feeling, that the soul of every masterpiece is powerful emotion. . . . I think the best I have done grew out of things deeply felt, the worst from a pride in mere talent.[23]

This deeply moving avowal aside, the fact remains that there is little of Posada's influence to be found in Rivera's artwork produced during this period. Rivera's first recorded mention of Posada dates from 1928, at a time when earlier in the 1920s a popular sensibility, perhaps influenced by Posada, had first begun to inform Rivera's drawings and paintings. Thus, the illustration that Rivera did in 1944 of Posada and himself during his student years for Leah Brenner's book *An Artist Grows Up in Mexico* has more to do with a retrospective recognition of Posada's

artistic worth than it does with any "documentation" of a period apprenticeship.[24]

In 1904, at seventeen, Rivera painted *La Era* (The Era), an oil on canvas (100 x 114.6 cm.) (Figure #3). A *tour de force* in the deployment of perspective as well as in the orchestration of color interaction, this painting is "frankly 'modernist' " ("francamente modernista") with its lucid color and *mexicanist* theme.[25] The landscape influence of noted teacher José María Velasco is ever present even as the personality of the young Rivera is obtrusively evident. In short, Rivera opened up a new path for himself with this work.[26] The astuteness of Justino Fernández's reference to Rivera's work as "modernist" should not go unnoted since it reminds us that we really must engage in a long overdue rethinking of what modernism originally meant when it emerged in Latin America and of how it has come to mean something quite different in recent literature. (The concept of modernism in both a pre- and post-Greenbergian sense will be an issue which we shall periodically return to in this study.)

In *La Era* we see a magisterial use of primary, secondary, and tertiary colors, the interaction of which is based on a warm-to-cool progression of hues rather than on the light-to-dark contrast so fundamental in the academic tradition. Aside from the broad ranging variations of red in the foreground — from almost pastel orange to a resonant red hue of almost normal value — and the notable range of blues in the background — most of which are at higher than normal value — there is a virtuoso use of diagonals in the construction of space. These diagonals cut quickly from left to right (with the rural Mexican worker as a repoussoir element in the front plane) and then just as rapidly from left to right in the middle ground by means of a sharply perspectival disposition of the building in the right-hand corner only to attain panoramic depth through the subtle use of atmospheric perspective in the remote background leading up to the well-known volcano Popocatepetl.

One of the first things to consider when reflecting upon Fernández's reference to this painting as "modernist" is the delicate balance between Rivera's attention to formal problems and his focus on extra-aesthetic concerns of identity. This balance involves the counterforces generated by a self-conscious use of formal conventions based on European modernism, as in the warm-to-cool progression of color á la Impressionism, while being marked by the non-European character of an indigenous topography conveyed through the swiftly jutting diagonal cuts. This latter trait, which is reinforced by the bird's-eye view and

sweeping expanse of the space, recalls the influence of José María Velasco, whose own work was praised in 1875 by Cuban author José Martí for its "colors of genius," opalescent skies, and atmospheric subtlety as distinctively representative of the Americas, that is, of "our America."[27]

In 1906, Rivera became associated with a modernist group in Mexico City named *Savia Moderna* ("Modern Sap"). He exhibited with this group in May 1906 and designed the cover for its journal, *Savia Moderna* the same year. Rivera's cover design (17.7 x 12 cm.) was entitled *Corredor indígena visto de perfil* (View of an Indigenous Runner in Profile) and used an *"indigenista"* theme in an *un*sentimental way that was quite at odds with similar academic renditions. As Alfonso Reyes has noted of the intellectuals' situation on the eve of the Mexican Revolution this modernist group, along with several other tendencies, constituted an implicit rejection of the positivism that reigned as official ideology during the highmark of the Díaz dictatorship.[28]

In opposition to the supposedly nonsubjective and value-free objectivity claimed by the positivists, the countercultural elements of *Savia Moderna* named their group something that was intentionally absurd and also organic in keeping with Bergsonian vitalism, thus mocking, in proto-dada fashion, the high-minded and "rational" claims of the official Francophile ideologues of Díaz. Similarly, other figures like José Vasconcelos, opposed the Francophilic and Eurocentric values of the Díaz dictatorship with a "filosofía anti-occidental que alguien ha llamado 'la filosofía molesta'" (an anti-occidental philosophy that someone has named "the irritated philosophy").[29] Likewise, as shown by the young Rivera, there was a countercultural tendency that was meant to "descubrir todo lo que daban de si la tierra nativa y su glorioso pasado artístico" (discover everything about the native terrain and its glorious artistic past).[30]

When situated at the crossroads of these various dissident currents, Rivera's *La Era*, along with his other works of the period, can be seen as part of a homegrown, avant-garde tendency to forge an anti-postivist, non-Eurocentric, and formally self-conscious visual language (under the influence of Neo-Impressionism and Symbolism) that in some respects was allied with the antiauthoritarian forces that gave rise to the Mexican Revolution of 1910.

The iconography of Rivera's landscapes in oil on canvas from 1904–06, with their fusion of European modernism and Mexican thematic concerns, is revealing in a way that has been largely overlooked

to date. *La Casteñada or Paseo de los Melancolicos* (1904) references insane asylums, while *The Mixcoac Ravine* (1906) refers to an important pre-Columbian archaeological site, and *Cerro de las Campanas* (1906) depicts the place where an earlier dictator, the Emperor Maximillan, was executed. Taken together, they seem to add up to a nuanced list of nonofficial, antigovernment themes, similar to those in Jacques Louis David's works in France from 1785–89.[31]

In 1906, Rivera received a four-year scholarship for study in Europe from Don Tedoro A. Dehesa, the maverick Governor of the state of Veracruz. Dehesa, who was a friend of Rivera's liberal father, was a figure tolerated by the Díaz dictatorship even though he openly opposed the group of *Científicos* centered around Porfirio Díaz and led by the Minister of Finance José Yves Limantour. Dehesa was a "cultured gentleman of the old school" and also an intellectual capable of appreciating Rivera's growing disenchantment with the official values of "la paz porfiriana."[32] The only stipulation that Dehesa made for retention of the scholarship was that Rivera send him a canvas every six months as evidence of the benefits from his study in Europe. Through the efforts of the landscape painter Gerardo Murillo (who would later rename himself Dr. Atl), a 1906 exhibition at San Carlos of fifteen Rivera landscapes in a variety of media was held to raise money to pay for Rivera's voyge to Europe.[33]

Shortly prior to his departure for Europe, Diego Rivera witnessed a series of historical events that woud have a deep impact on his outlook as a painter as well as on his political formation. While in Veracruz doing landscapes, he saw increasing labor unrest develop among the textile workers owing to harsh work conditions, inadequate wages, and stark outbreaks of police repression. By the winter of 1906, these workers from the Orizaba region plus those from other parts of the country, organized a large crowd to march to the National Palace and to appeal for help from President Díaz as the so-called "father of his people." And Díaz did indeed promise to aid these workers.

In Veracruz; as well as elsewhere, however, this "aid" came in the form of massive governmental repression and even wholesale massacres by federal troops in an effort to "pacify" the populace. Díaz's military force of *rurales* ("rural police") was increasingly transformed into a veritable "praetorian guard" for private capital to guarantee what the positivists and Social Darwinists of the dictatorship called "order and progress" in the economic sphere.[34] Rivera diescribed the situation in Veracruz along the following lines, lines that closely paralleled the accounts of what was

occurring throughout Mexico in 1906–07:

> The way he [Díaz] took care of them [the wokers] was to send troops to shoot down men, women, and children gathered in the streets. To this day, I can see the still bodies of the victims lifeless in the widening pools of blood. . . .
>
> I boarded the ship that was to take me to Spain, still in the grip of horror. I could not sleep. Often I would stand at the bow alone, singing and yelling. My fellow passengers must have thought me a madman. How could I explain the scenes of carnage which I could not make myself forget?
>
> And yet my chants and cries on shipboard remained more the wild shouting of a Nietzschean than the steely anger of a true revolutionary. . . . But I can truthfully say that the final crystalization of my political ideas began at this time.[35]

Whether in Veracruz or within other industralized areas, it would have been impossible to avoid exposure to the labor unrest that shook Mexican society from 1906–08. During this period the illegal *Partido Liberal Mexicano* (Mexican Liberal Party) or *P.L.M.* organized over 250 strikes nationwide in the mining, textile, rail, and industrial sectors. These strikes were put down ruthlessly and at great cost to human life by the Díaz government.[36] Symptomatic of this situation was the suppression of the *P.L.M.*-led strike at the Cananea mine in Sonora that was directed against a subsidiary of Anaconda Corporation (a United States firm).[37]

Ultimately, these suppressed strikes helped to undermine the dictatorship's claims of "stability" and they also eroded its ideological legitimacy.

Officially organized in 1905, the *P.L.M.* had its roots in the hundreds of "Liberal Clubs" that were formed by disgruntled middle-class liberals, such as Diego Rivera's father, in the late nineteenth and early twentieth century. Within a short time the *P.L.M.* was led by anarchists, notably Ricardo and Enrique Flores Magón, who would later be depicted in one of Diego Rivera's most accomplished murals, *Sueño de una tarde dominical en la Alameda Central* (Dream of a Sunday Afternoon in Alemeda Central Park) of 1947–48.[38]

Also among the more dynamic leaders of the rebellion were several women intellectuals. These included the poet Dolores Jiménez y Muro, the journalist Sara Estela Ramírez of *La Corregidora*, and the co-founders

in 1907 of the "Mexican Socialist" Group, Juana B. Gutiérrez de Mendoza and Elisa Acuña y Rosete. Women workers of the rank and file in the textile and tobacco industries were often militant participants in the strikes. Not surprisingly, some of Diego Rivera's early depictions of revolutionary leaders in his murals for the Ministry of Education in the 1920s would be of women.[39]

The strikes and even armed revolts organized by the *P.L.M.* in the industrialized northern states and industrial zone of Veracruz were based on demands that would be incorporated into the 1917 Constitution, including an eight-hour work day, a minimum wage, an end to child labor, cessation of *latifundismo*, land redistribution, protection for Mexican migrants in the United States, an end to United States intervention in the domestic affairs of Mexico, and a one term limit for the president.[40] These views were circulated in the *P.L.M.*'s working-class-based newspaper, *Regeneración*, which in 1906 had a circulation of at least 30,000. Despite the fact that it was repeatedly shut down and its editors jailed or killed by the Díaz government, this dissident publication continued to appear throughout this period.[41]

Furthermore, overdetermining this opposition to the *Porfiriato* (as the Porfirio Díaz dictatorship was called from 1876–1910) were insurgent movements that notably predated and ultimately outlasted the upheavels of these years, namely, those involving ethnic unrest. Insurrection by Indians had been an intermittent feature of Mexican society from the 1520s right up to the concluding years of the Díaz regime. The Huastecas along the Panuco River in Veracruz, Hidalgo, and San Luís Potosí, who had resisted the Spanish so tenaciously before securing their own self-declared anarchist communities in the nineteenth century, were among the groups that helped to launch the Revolution of 1910–20 against the national government. Comparable oppositional traditions of hard-won, self-determining localities were also to be found among the Maya of the Yucatán, the Yopes in the coastal Guerrero, Zácatecas, and Jalisco, the Chichimeca in the north, the Yáques of Sonora, and various Native American groups in Oaxaca, Tehuántepec, and Chiapas. The crucial role assumed by these various indigenous groups in this insurgency helped to spawn the multidimensional concept of *indigenismo* that would later be an ideological cornerstone of the arts and culture produced by Diego Rivera and many others within the Mexican Revolution.

Thus, at the time that Rivera was leaving for Europe, Mexico found

itself in a momentous crisis that saw both the onset of the 1907 depression and the emergence of proto-revolutionary forces not only among the popular classes and different ethnic groups, but also *within* the ruling order itself, all of which would splinter the status quo in 1910–11. Not surprisingly, the ruling order became increasingly divided over how best to deal with this worsening situation. In 1908, when Finance Minister José Yves Limantour began calling in government loans from *hacendados* in order to halt a major credit crisis, he alienated many of the members of the ruling order who had formerly backed Díaz as part of the entrenched network of *hacendado-ranchero-caciques* (hacienda owners/ranchers/local bosses).

A shortage in food resulting from crop blights plus the ill-advised increase by the *Porfiriato* of agricultural products sent abroad when there were severe domestic shortages in Mexico greatly aggravated the situation. Banks became overextended, more loans were called in, mineral production diminished radically, industries began to shut down, and unemployment catapulted to over 50%. Many of the northern industrialists, financiers, and landholders (including the Maderos, Carranzas, and Terrazas) blamed Díaz and the *Científicos* for the crisis, even as they continued to depend on federal troops to put down the labor strikes that were threatening their own monopoly-controlled areas.[42]

RIVERA'S STUDY IN SPAIN AND TRIP TO NORTHERN EUROPE (1907–10)

On January 6, 1907, Diego Rivera's ship arrived in Spain, with Rivera carrying a letter from Gerardo Murillo to the Spanish realist Eduardo Chicharro y Agüera. Agüera taught at the Academy of San Fernando in Madrid and was considered one of Spain's most important painters. According to Rivera, "[When I arrived] I was twenty years old, over six feet tall, and weighed three hundred pounds. But I was a dynamo of energy."[43] Whatever his actual size, Rivera was indeed an imposing figure physically, and as his fine *Self-Portrait* from early in 1907 indicates, a striking one as well.

One of the first of around twenty self-portraits he executed throughout his life, this painting (84.5 x 61.5 cm.) owed a clear debt to Gustave Courbet and Edouard Manet, with Courbet, in particular, being a favorite artist of Rivera.[44] With its splendid use of silhouetting, earthy

and heavily impastoed application of pigment, starkly flattening
light/dark passages, and restrained palette based on variations of reddish
brown (with hints of yellow and touches of green), this self-portrait also
reminds us of the neoromantic tenor that prevailed in much late
nineteenth-century and early twentieth-century modernist painting from
Europe. The manner in which the textural distinctions are well
established, such as the glistening glass of a beer bottle, the amber
colored brew in the beer glass, the dense fiber of his wardrobe, and the
weathered skin on his hand, all elicit a recollection of works by the
Venetian School in the sixteenth century, which is evident in the Prado
Museum where Rivera spent innumerable hours. Particularly effec-
tive for setting the pensive tone of this bohemian cafe scene — and here
one thinks of Manet's early *Absinthe Drinker*, among other works — is
the way in which Rivera has so tellingly emphasized the dramatic con-
trast between the illuminated hand and the shadowy face beneath the
imposing as well as rakish hat.

Of the other eight or nine works still extant from this same year, several
are portraits while the rest are landscapes and/or street scenes in cities,
such as Ávila and Toledo. With few exceptions, the paintings fluctuate
stylistically back and forth between an extroverted *realismo* (as in the
Portrait of Joaquín Ventura) and the brooding introversion of late
symbolist art (as in *Night in Ávila*).[45] The latter of these two paintings is
a solid example of the enigmatic ambience and ambient chill registered
by symbolist night scenes.

Despite the fact that Rivera would later characterize his works of this
period as among "the most banal of my paintings," he managed to
captivate his teacher, Eduardo Chicharro y Agüera, within a short time.
In a report made in June 1907, after Rivera had been with him only six
months, Chicharro y Agüera wrote:

> He [Rivera] has, from the time he arrived to the present, done
> numerous landscapes in Madrid and Toledo, and in those . . . has
> made much progress, which I do not hesitate to qualify as
> astonishing. And therefore I am pleased to state that Señor Rivera,
> my pupil, shows that he has magnificent qualities for the art in
> which he is engaged, and united with them . . . [has] the qualities
> of a tireless worker.[46]

Rivera would also be praised by another Spanish artist who enjoyed
more international prestige than did Rivera's teacher, Joaquín Sorolla y

Bastida. Sorolla was a counterpart to such high-society artists of dazzling bravura as John Singer Sargent of the United States and Giovanni Boldini of Italy. On a visit to Chicharro y Argüera's studio, Sorolla singled out Rivera's *La Fraga* (The Blacksmith's Shop) as a work of exceptional promise.[47] Interestingly enough, *The Blacksmith's Shop*, which is hardly one of Rivera's more commanding works of the period and which also seems to owe a debt to the German realist Adolph von Menzel, was one of Rivera's very first works to focus on manual labor, specifically preindustrial artisanship, although the theme of labor would figure prominently in many of his mature works.[48] According to Rivera, Sorolla predicted that Rivera would become rich through his paintings — a prediction that the impoverished Rivera then viewed with ambivalence, since he wished to be free of monetary concerns and not "to become enslaved to the checkbook."[49]

While in Spain during 1906–08, Rivera systematically studied the Spanish old masters, such as El Greco, Velásquez, and Goya, as well as the work of Flemish painters like Bosch and Breughel, all of whom are well represented in the Prado Museum. He also became friends with two of the major *modernista* writers of the period, Ramón Gómez de la Serna and Ramón del Valle-Inclán. Rivera also met the anarchist philosopher Silverio Lanca, who dreamed of a Utopia where total equality prevailed and all people were aristocrats and artists.[50] Among the works in Rivera's oeuvre that stand out from this period are several cityscapes, such as *Landscape of Ávila: The Street of Ávila*, an oil on canvas (129 x 141 cm.). As others have noted, this painting attests to a multiple apprenticeship. It features an emphatically geometric construction of space in keeping with realism and an understated treatment of the sky through an underpainting consistent with Impressionism.[51]

Rivera's studies in Spain were summed up largely in extra-artistic terms by Rivera.

Towards the end of my stay in Spain . . . I immersed myself in the works of Nietzsche, Huxley, Zola, Schopenhauer, Darwin, Voltaire, Kropotkin, and above all, Karl Marx. In books, I sought ideas. I read very little fiction. . . . [Yet] what I gained most from Spain was what I saw of the Spanish people and their condition. . . . [T]he infamous *Guardia Civil* . . . helped to make the social system of Spain one of the most unjust and backward in the world and shielded the darkest of religious fanaticism.[52]

After being in Spain a year and a half, Rivera went to Paris for the first time in the spring of 1909. He lived at the Hôtel du Suisse in the Latin Quarter.[53] Once there, he set to work and fell into the normal routine of the art student, which involved copying from museum collections, working in the free academies of Montparnasse, and executing open-air paintings along the Seine River.[54] Among the more noteworthy paintings of this time in his career are two cityscapes in oil on canvas: one is of Bruges, Belgium and the other of Notre Dame in Paris. The first painting, entitled *Casa sobre el puente* (House on the Bridge) is 147 x 120 cm. and was accepted for an important 1910 exhibition organized in Paris by the vanguard group, *Société des Artistes Independents*.

This work is a highly accomplished late symbolist painting, owing to its Hugoesque emphasis on Gothic architecture, its haunting usage of disfiguring reflections, its somber colors that are subtly offset by delicately placed accents of primaries, and its overall mood of intimate melancholy. Furthermore, the city of Bruges, which appears in the distance of his 1909 *Portrait of Angelina Beloff*, was also a metaphor for the place in which Rivera originally met Angelina, who would later be the first of his four wives.[55] Rivera spoke of this meeting with "a slender blonde young Russian painter, Angelina Beloff: a kind, sensitive, almost unbelievably decent person." He then added, "Much to her misfortune, Angelina would become my common-law wife two years later."[56]

The other cityscape, *Nuestra Señora de Paris* (Notre Dame of Paris), which is slightly saller at 146 x 115 cm., is an engaging example of how Rivera was able to assimilate the late manner of Claude Monet and perhaps also aspects of J.M.W. Turner's mature style as well.[57] With its pastel atmospheric tints in pink and light blue as well as its rich range of resonant brown shades in the foreground and middle ground, this painting features a supple dematerialization of the architectonic components. In particular, Rivera has employed with virtuosity the diverse types of brushstrokes earlier used by Monet — from directional strokes, skip strokes, and textural strokes to corrugated strokes and *vermicelli*.[58] All of them involved using a loaded brush to create a sophisticated layering effect by means of different forms of overpainting that, in permitting the underpaint to be detectable, further undermine the perceived substantiality of concrete forms.

In October 1910, Diego Rivera returned to Mexico City to exhibit his paintings at the Academy of San Carlos, as part of Mexico's centennial celebration of national independence from the Spanish colonial empire.

On November 20, 1910, Díaz's wife, Carmen Romero Rubio de Díaz, inaugurated Rivera's show. Whether or not Rivera was involved in an unsuccessful attempt to assassinate Díaz on this same day (as he later told Luís Suárez and Gladys March) seems rather unlikely, although it is true that an insurrection against the *Porfiriato* did commence in Puebla two days before Rivera's opening.[59] The most plausible claim that Rivera later made about his own involvement in the earliest stage of the Mexican Revolution concerned a poster with Zapatista overtones that he supposedly designed (at present, no independent documentation exists to corroborate this avowal). Rivera's recollection went as follows:

> As a contribution to the revolution, I designed a huge poster, copies of which were distributed among the peasants throughout Mexico. Its message to the poor, ignorant farmers was that divine law did not forbid them to repossess the land which rightfully belonged to them. The corrupt Church of the time had been preaching the converse.
>
> The slogan dominating the poster read: "THE DISTRIBUTION OF LAND TO THE POOR IS NOT CONTRARY TO THE TEACHINGS OF OUR LORD JESUS CHRIST AND THE HOLY MOTHER CHURCH."
>
> Since the majority of the peasants could not read, the message was illustrated by a painting showing a family plowing their field behind a team of oxen. Above the oxen hovered a benevolent image of Christ fondly gazing upon his children, whom he blessed for preparing the field for growing.[60]

Late 1910 and early 1911, while Rivera was in Mexico, did see the public declaration by Francisco Madero of the *Plan de San Luís Potosí*, along with successful guerrilla actions in the north and south by Pancho Villa and Emiliano Zapata. By May 25, 1911 Díaz was forced out of office in accordance with the terms of the Ciudad Juárez Treaty. As for Rivera's claims to have fought in the countryside with the forces of Zapata, these seem highly implausible.[61]

Nonetheless, Bertram Wolfe rightly noted of this historic upheaval, that it obviously caused Rivera to acquire an admiration for Zapata, the most politically progressive of all of the revolutionary leaders, that would be a mainstay of the artist's thinking from that time forward.[62] When Rivera left for Paris in June 1911 and Madero won a landslide victory

in October of that same year, the Mexican Revolution appeared to be concluded. But this was, of course, only the quiet before a far larger storm that would batter Mexico shortly thereafter, thus opening the way for major changes in all spheres of the national life.

CHAPTER TWO

∎

Diego Rivera as "Alternative Modernist" in Europe, 1911–21

∎

"Diego Rivera occupies a place in painting that corresponds to that of Rubén Darío in poetry: both, using European and indigenous elements, initiated and advanced aesthetic movements in the Americas that rivalled and at times went beyond similar European movements."

> Antonio Castro Leal
> *"Diego Rivera y Rubén Darío"* (1957)[1]

" 'Modernism' can best be understood as a cultural field of force triangulated by three decisive coordinates. The first of these . . . was the codification of a highly formal *academicism* [as a foil] in the visual and other arts. . . . [Second] for a different type of 'modernist' sensibility, the energies and attractions of a new machine age were a powerful imaginative stimulus: one reflected, patently enough, in Parisian cubism, Italian futurism or Russian constructivism. . . . The third coordinate of the modernist conjunction, I would argue, was the imaginative proximity of social revolution."

> Perry Anderson
> "Modernity and Revolution" (1984)[2]

"[Rivera] regarded cubism as the most important experience in the formation of his art."

> Bertram Wolfe
> *The Fabulous Life of Diego Rivera* (1963)[3]

In the decade following Rivera's return to Europe (1919–21), his

artistic practice advanced both forward and backward in almost equal measure. He arrived in multilateral fashion at an innovative variant of Cubism, Cubo-Futurism, or perhaps more accurately, *"Cubismo Anáhuac"* (Anáhuac Cubism) as it has been labeled in one study of Mexican art.[4] The pictorial logic of this distinctive type of "collage," if not the particular form it assumed in Rivera's Cubist period (1913–17), would continue to be of considerable importance for his artistic development long after this phase of his career had ended. A stringent reconsideration here of Rivera and his contribution to *modernismo* (or "alternative modernism") will allow us to consolidate Rita Eder's insight that a long needed reinsertion of Mexican muralism back into the broad historical matrix of modernity will yield new insights concerning the distinctive nature of Mexican modern art — insights that the old binary framework of modernism vs. realism cannot accommodate. As Eder has argued, this is a particularly noteworthy shift to undertake now since it has become ever more clear that "modernity transcends any exclusionary definition" and thus reveals several divergent tendencies as part of the project of modernity in the arts.[5]

By carefully reassessing modernism, modernity, and modernization in relation to the work of Diego Rivera and Rubén Darío, as well as others, we shall be able to articulate more tellingly the long-term formal continuities and discontinuities within Rivera's oeuvre. We will also better understand the notably different "external" relation of Mexican modern art via modernism and modernity to modernization, as a singular set of relations sometimes at odds with those that were symptomatic of Europe. With Rivera's murals from the 1920s in the Ministry of Education, what emerged in Mexican art during the Revolution was a concrete artistic manifestation of modernity in the arts of this nation. Yet this distinctive emergence of modernism among Mexican artists was not reducible to being a celebration of modernization along the lines of the "machine aesthetic" in Europe. Nor could it be adequately characterized as a mere provincial derivative of the "true" modernism in Europe.[6]

Modern art in Mexico simultaneously drew upon and distanced itself from European currents of modernism, so as to engage ethnic concerns nationally and invigorate the democratization of cultural production within the newly transformed nation-state, all in relation to a process of modernization that meant quite different things outside the West. This organic manifestation of Mexican modernism that first emerged in Rivera's work was predisposed to find some qualified degree of favor

within the new state institutions that were produced in the aftermath of
the Mexican Revolution. If the modernism of Rivera was hardly a mere
reflection of some naive faith in Western modernization, neither was it a
formalist modernism that disconnected itself from modern social
transformation in the name of some putative "medium purity."

Revealingly, the deeply agrarian inflection that Rivera sometimes gave
to the generally urban idiom of Cubism in Paris, in such magisterial
paintings as *Paisaje Zapatista* (Zapatista Landscape) of 1915, (Figure #5)
helped to expand notably the international nature of modernism, even as
it also aligned this particular version of *"renovated Cubism"* with what
were then the revolutionary forces in Mexico. Charting this course anew
will help us to better understand not only the "modernist" phase of
Rivera's development, but also why the rest of his career would be deeply
indebted to it as well. Nothing underscores more the need to undertake
this re-examination than Rivera's lifelong claim that Cubism constituted,
in his view, "the outstanding achievement in the plastic arts since the
Renaissance."[7]

As for modernism's imaginative proximity to social revolution during
"the moment of Cubism," Rivera himself summarized it.

> It [Cubism] was a revolutionary movement, questioning everything
> that had previously been said in art. It held nothing sacred. As the old
> world soon blew itself apart, never to be the same again, so cubism
> broke down forms as they had been seen for centuries and was creating
> out of *the fragments new forms, new objects, new patterns, and —
> ultimately — new worlds.*[8]

Rivera returned to Paris in September 1911, only a few months after
the first public exhibition in Paris of Cubism during the spring of that
year at the *Société des Artistes Independents*. Almost at once, Rivera began
to explore several visual languages both "old" and "new." These
experiments were performed not only in Paris but also in Spain, where
Rivera would return to at least once a year over the next decade. Like
other modernists in the visual arts, Rivera gave credence to André
Malraux's subsequent observation that the most modern artists were those
who rummaged most furiously in the past, without losing either an
important place in the present or a visionary faith in the future.[9]

Among the first paintings that he executed upon his arrival in Europe
was *Paisaje de Cataluña: Montserrat* (Catalonian Landscape: Montserrat),

an oil on canvas (87 x 107 cm.) Its manner is strongly derived from the
Neo-Impressionism of Seurat and Signac, with its broad mosaic of
juxtaposed green, blue, and yellow pigments of varying values and
intensities that alternately glisten with high-value colors and throb with
low-intensity hues and came to signify leftist, specifically anarchist, views.[10]
The serrated profile of Mt. Montserrat was a prominent symbol for the
Catalonian independence movement at this time. Antonío Gaudí (and
other *modernistas* who were also anarchists) used references to this image
in such works as the skyline of the Casa Milá to advance an anti-imperialist
line against Castillian hegemony and the nation-state.[11] And in fact the
governmental suppression of the autonomy movement during what is
known in Barcelona as "The Bloody Week" of 1909, saw the public
execution of anarchist leaders like Francisco Ferrer.[12] This painting of
Montserrat and another work, *Paisaje* (Landscape), were shown in the
Spring 1912 Exposition of the *Société des Artistes Independents* in Paris.
Earlier, in the fall of 1911, Rivera also exhibited two depictions of the
Mexican volcano Iztaccihuatl, a clear signifier of "nuestra America," (our
America), at the Salon d'Automne in Paris, at about the time that Justo
Sierra, Francisco Madero's new Minister of Education, was renewing
Rivera's annual grant from the Mexican government.[13]

Rivera set up residence in Paris at 26 Rue de Depart in Montparnasse[14]
with Angelina Beloff, who would be his partner until he returned to
Mexico in 1921. Among his closest friends in this new bohemian enclave
of Paris was the Italian painter Amadeo Modigliani, whom Rivera ganged
up with in the cafes to scandalize the clients through bizarre tales and
eccentric behavior. An oil sketch *Portrait of Diego Rivera* from 1916 by
Modigliani is testimony to this relationship, as is a passage by Spanish
modernista author Ramón Gómez de la Serna in his book, *Ismos*, where
he describes *Riverismo* as the type of notorious countercultural deportment
in which Rivera and Modigliani specialized.[15]

The brilliant poet and apostle of modernity named Guillaume
Apollinaire, who in 1912–13 authored the first book on Cubism, noted
in a 1914 essay that Montparnasse was the most important art quarter of
the time, the period anatomy of which has been eloquently disclosed by
Roger Shattuck in *The Banquet Years*.[16] Apollinaire's discussion went as
follows:

Montparnasse henceforth replaces Montmartre. . . . Daubers,
however, no longer feel at home in modern Montmartre. It is difficult

to climb and full of false artists, eccentric industrialists, and devil-may-care opium smokers.

In Montparnasse, on the other hand, you can find the real artists, dressed in American-style clothes. You may find a few of them high on cocaine, but that doesn't matter; the principles of the *Parnassois* (so called to distinguish them from the Parnassians) are opposed to the consumption of artificial paradises in any shape or form.

This is an agreeable country in which heavens are for external use only, a country of fresh air and cafe terraces . . . [such as] the terrace of La Rotonde, where you can see Kisling, Max Jacob, [Diego] Rivera, Friesz, and others.[17]

The year 1912 would mark Rivera's reunion with a group of Mexican artists then expatriated in Paris that included Angel Zárraga, Dr. Atl (Gerard Murillo's new name for himself after the Nahuatl word "atl" meaning water), Roberto Montenegro, and Adolfo Best Maugard, along with other *modernistas* of note from Spain and Latin America, such as Nicaraguan poet Rubén Darío, who would reproduce a work by Diego Rivera in his *Mundial Magazine* in 1912, as well as Spanish author Ramón Gómez de la Serna, Chilean painter Ortes de Zarete and Mexican novelist Martín Luís Guzmán.[18]

The peripatetic Rivera, who made two trips to Toledo, Spain in 1912, drew heavily upon the work of El Greco.[19] He also was influenced by contemporary artists like Spaniard Ignacio Zuloaga and compatriot Angel Zárraga, both of whom Rivera would outstrip in very short order. Two of the oil paintings generally considered to be his best in this year were *Los Viejos: En las fueras de Toledo* (The Elders: On the Outskirts of Toledo) and *Vista de Toledo* (View of Toledo).[20] With its striking similarity to his own birthplace of Guanajuato and its fame as the ultimate homeplace of El Greco, Toledo was a particularly significant stimulus for Rivera's own artistic development in this period.

The Elders, a larger than usual painting for the artist at 210 x 184 cm., features attenuated figures with a head-to-body ratio of 1:9 (as opposed to the classical one of 1:6 or 1:7) in keeping with El Greco's greatly elongated proportions, and is marked by an exceedingly abrupt spatial recession without any graduated or smooth transition from foreground to middle ground, a haunting sense of austere openness in the terrain that is heightened by a contraction of space in the upper register, and crystalline forms that are delineated by a stark neo-classical outline that

throws the outsized figures of the front plane into monumental relief. Commonplace in subject matter and yet uncommon in treatment, this linear painting with its broad ranging use of umbers and roseated browns elevates the ordinary to an almost extraordinary level. Without any allegorical elements to symbolize a sense of the beyond, the painting nonetheless refuses to remain only about the surface events depicted, as if some higher sense of things could not be entirely supressed in the conception of this artwork.

Another markedly vertical painting also dating from 1912 (112 x 91 cm.,) is the *View of Toledo*. Two attributes stand out immediately in this work: a chilly high-value palette coupled with proto-Cubist architectonic elements *and* the manifest affinity of this view selected by Rivera with that of the one earlier chosen by El Greco for his 1610 cityscape, *View of Toledo*.[21] The use of the mountain-cresting city skyline that locates the Alcázar in the right-hand corner, the Cathedral of Toledo in the left-hand corner, and the Tagus River at the base of the picture differs from the more "expressionist" painting by El Greco mostly in terms of the minor role played by the placid sky in Rivera's calmer painting. The tranquillity of the sky and the blanched look of the architecture are concomitant with a surpassingly high-keyed use of color that permits no hue in the entire work to appear either at normal value or lower. Yet the almost exclusive use of high-value colors, which would at first establish a point of intersection with the Impressionist paintings of Monet, is offset by an icily crystalline delineation of the structure of the city along with the landscape, thus suggesting a formal affinity with Cubism.

Rivera's return to Paris in the winter of 1913 triggered his first engagement with Cubism. Subsequently, a thoroughgoing use of this new visual language would result in approximately 200 Cubist or Cubo-Futurist paintings from 1913 through 1917, some of which are among the finest paintings that Rivera ever executed.[22] Rivera neither worked exclusively in a Cubist vein throughout these years nor did he develop only in one direction within the multipoint manner of Cubism, and he increasingly forged a highly distinctive Mexicanist variant of Cubo-Futurism within the generic language of Cubism. Although he exhibited his various Toledo paintings in the *Groupe Libre* Exhibition of January 1913 at the Galerie Bernheim-Jeune (and Rivera's *View of Toledo* was reproduced on the cover of the show's catalog), Rivera increasingly graduated from this El Greco-inspired manner via the acknowledged influence of Robert Delaunay and Piet Mondrian.

The key transitional painting that Rivera, in fact, deemed his best to date and which he felt "marked my entry into the Paris art world," was a commanding portrayal of a fellow Mexican artist and dandy entitled *Retrato de (Portrait of) Adolfo Best Maugard* (226.8 x 161.6 cm.)[23] (Figure #4). This painting showcased an imposing depiction of the foppish Maugard in a manner indebted to El Greco's dramatically elongated figures and clearly updated by means of such 1890s works as James McNeill Whistler's famous portrait of the Comte Robert de Montesquiou. The hazy Parisian backdrop to Maugard was executed in a semi-Cubist style along the lines of Robert Delaunay's "simultaneity" and represents a celebratory look at modernity (including trains and mechanized leisure, as in the giant ferris wheel), but with a slightly more limited color range and a somewhat more muted use of color. As Robert Hughes once noted of the composition, the dramatic centering of the wheel on Maugard's hand, as though he were twirling its flickering spokes, is a device entirely of Rivera's own invention.[24]

A more frank Cubist work from the same period was a small study in watercolor entitled *Arbol,* or Tree (33.8 x 26 cm.). About one work of 1913, Rivera stated that "it owed not a little to Mondrian, a good friend and neighbor."[25] This is certainly true of *Arbol,* in which Rivera followed such works as Mondrian's *Horizontal Tree* (1911), and created an example of what is normally designated "Analytical" or "High" Cubism. Cursively adumbrated in Rivera's work, the basic forms of a tree and its surrounds are intimated only by means of a dense network of shallow lines alternately organic and geometric in character. The resulting all-over composition is largely monochromatic in keeping with Analytical Cubism, except for the low intensity flourishes of green on the right and left edges of the sketch.

Among other works in which Rivera demonstrated a growing mastery of various other tendencies of Cubism, such as "Synthetic Cubism" and "Early Cubism" or even proto-Cubism, are three oil paintings in particular. These include the neo-Cézannian *Le jeune fille aux artichaux* (The Young Girl with Artichokes), which hints in an understated way at simultaneous views of the same subject, the *Naturaleza muerta con balalaika* (Still Life with Balalaika), with its Synthetic Cubist combination of Russian popular cultural elements along with traces of a Parisian cafe in an irregular mosaic, and *Retrato cubista del pintor Zinoviev* (Cubist Portrait of the Painter Zinoviev), which deftly depicts the Russian artist in profile, in three-quarter view, and frontally, all at the same time in a

dynamic painting that in certain respects recalls Picasso's masterful 1909 portrait of Ambroise Vollard.

Contemporary events in Mexico, which would increasingly force their way into Rivera's paintings, took a dramatic turn on February 12, 1913, with the assassination by General Victoriano Huerta of the mildly reformist President Francisco Madero and his Vice-President Piño Suárez. Not only was the country plunged into both a civil war and a class war, but also into an acute economic crisis that spelled the end of Rivera's government grant. Thereafter, he would be forced to support himself through the sale of his paintings. In late summer of 1913, the increasingly successful Rivera would become an intimate of Fernand Léger and the Puteaux Cubists, as well as of Marc Chagall. Afterwards, though, this set of friendships would be replaced by the more radical links that Rivera came to enjoy from 1914–17 with Russian revolutionaries (such as Anatoli Lunacharsky and Ilya Ehrenburg, and possibly, even briefly, with Lenin and Trotsky) and also with many modernist artists from Russia (Goncharova, Zadkine, Lipchitz, and possibly Tatlin and Popova on their visits to France), all of whom either lived in exile in Paris or at least visited there on the eve of the Bolshevik Revolution.[26] It was these latter associations, which caused "Diego Diegovich" to learn Russian in order to participate more directly in their animated political discussions. Ultimately, these friendships served as a more enduring marker of the maturation of Rivera's radicalism during his years in Paris, as Olivier Debroise has convincingly argued in *Diego de Montparnasse*.[27] (Intriguingly enough, Rivera apparently applied unsuccessfully for a visit to go to Russia and participate when news of the October Revolution first hit the headlines.)

In 1914, Rivera met Juan Gris and Pablo Picasso, the latter of whom evidently expressed considerable admiration for Rivera's work and remained a friend for a few years. From the cerebral Juan Gris, Rivera absorbed several technical procedures, including a re-acquaintance with the use of the "golden section" and the idea of mixing sand with oil paint in order to create impasto or to evoke textural distinctions. Of the three or four paintings by Rivera in this year that stand out, Rivera stated with justification late in life about one of them, the *Jóven con sueter gris: Retrato de Jacques Lipchitz* (Youth in Grey Sweater: Portrait of Jacques Lipchitz) that it still caused him "to feel some pride in it."[28] It is more dynamic in tenor, more allover in character, more *mexicanista* in signification (with its incorporation of the image of a *sarape* being a new element in Rivera's

oeuvre). A remarkable fusion of both Analytical Cubism and Synthetic Cubism, it displays a highly disciplined dissection of form in geometric terms. Simultaneously, it features a generally unified color range and tightly faceted "collage" components — all of these different elements are actually painted, however, not appended as would be the case in a "real" collage — that both sit resolutely flat on the surface and yet also extend the dispersal of the formal components to the far reaches of the canvas. One can well understand why Picasso immediately admired works such as this and also why Apollinaire would be an early advocate of the Mexican artist.

The other two paintings from 1914 by Rivera that seem most accomplished — *Fusilero marino: Marino almorzando* (Marine Sailor Eating Breakfast) and *El Jóven de la estilográfico: Retrato de Adolfo Best Maugard* (The Youth with the Stylograph: Portrait of Adolfo Best Maugard) — are less innovative in their use of diverse tendencies within Cubism and they are more anecdotal along the lines of works by the Puteaux Cubists.

From April 21 to May 6, 1914, Rivera had his only one-person exhibition in Paris and it included twenty-five paintings from 1913–14. The show, which was held at the Gallery of Berthe Weill, was a financial success that alleviated Rivera's penurious condition at the time. Nonetheless, the cynicism with which Berthe Weill sold Cubist works, even though she did not admire Cubism per se, ended up causing a scandal, owing to her anonymously published catalog essay about Rivera's work. Among the many partisans of modernism offended by this particular conjunction of philistine views and mercenary dealership was Apollinaire, even though he did not know at the time that Weill herself was the author of the essay in question.

In the May 7 issue of *Paris-Journal*, Apollinaire responded:

At the B. Weill Gallery, 25 Rue Victor-Masse, M. Diego Rivera is exhibiting a group of studies and drawings that show what a deep influence modern art has exerted on this young painter. In any case, the sensitivity of two or three drawings would itself have justified this exhibition.

Someone who signs himself simply "B." wrote a preface in the catalogue in which he practically insults the artist he is supposed to introduce to the public. . . . What is one to say about a critic who agrees, without even being asked by the artist, to write the preface to

an exhibition of whose whole tenor he disproves?[29]

This insulting incident was repeated in a similar manner by the prominent dealer Leonce Rosenberg, with whom Rivera signed a two-year contract in the fall of 1916. In an interview of 1936 with Bertram Wolfe, Rosenberg said that Rivera did around five paintings a month for him, not counting sketches, pastels, and watercolors. To quote Rosenberg, Rivera was "always one of my most prolific painters."[30] In addition, Rosenberg discussed how the enthusiasm of the Cubist painters for geometry and mechanization manifested itself in the mathematical-mechanical formula that they devised for measuring a painting's value. This formula was predicated on a code book in which each painter was assigned a different "personal factorial value" by the group of artists themselves along with the dealer and a standardization of canvas sizes, such as a "size 60" (1 meter 27 cm. by 97 cm.), which was generally the one used by Rivera during this period. The personal value unit was multiplied by the size factor to arrive at the price for the work. A "size 60" by Rivera owing to his specifically assigned "factorial value" generally went for between 250 and 280 francs.[31] According to Rosenberg, "Rivera was very enthusiastic, as I remember, for the mathematical value theory of picture prices."[32] At a time when Rivera undertook a study of the writings of the mathematician and scientist Jules-Henri Poincare.[33]

Despite having produced handsomely for Leonce Rosenberg's gallery, Rivera nonetheless found himself denounced by a close friend of Rosenberg's, the art critic Pierre Reverdy in his essay "Sur le Cubisme," which appeared in the charter issue of a journal entitled *Nord-Sur*.[34] At a subsequent dinner party given by Rosenberg, Rivera and Reverdy got into an argument that led to physical violence, with Reverdy definitely getting the worst end of it. Labelled by author André Salmon as *"l'affaire Rivera,"* the incident led to Rivera's being ostracized by Rosenberg and his stable of Cubist painters. Furthermore, Salmon himself referred to Rivera in patronizing and ethnocentric, if not racist, terms as a "an abstract Courbet of the Savannah."[35]

That ethnocentrism was evidently an issue in this dispute with Reverdy and Salmon was a fact later acknowledged by Rivera himself. In a rather generous assessment of this situation, Rivera observed:

[T]he orthodox cubists, proposed excommunicating me because of the exoticism they found in it [my painting]. And they were not

entirely wrong. . . . [These works] distinctly show the influence of the pre-Conquest tradition of Mexican art.[36]

RIVERA'S POSTCOLONIAL CUBISM
AND THE CAUSE OF ANARCHISM

Quite aside from the fact that Diego Rivera's non-Eurocentric Cubism would not now qualify as an example of the "exotic" (which is after all a charmed and essentializing view of another culture at some remove from one's own), this work also reminds us of just how far the orthodox "purity" of the Puteaux Group was from the transcultural concerns of Picasso and Gris. The abiding interest that Picasso showed in African art was deeply interrelated to the anticolonial politics and anarchist views of the Spanish artist that were shaped in Barcelona.[37] All of this led to Picasso's use of African art, in collusion with a dissident recycling of some aspects of European art, to highlight the negativity of this combination in regards to the status quo — a point that was hardly lost on his contemporaries.

For example, the notorious *Demoiselles d'Avignon* (1907), which is named after a street in Barcelona's red-light district, is not only about the uneasy encounter of the two sexes, but also about the conflictual relationship of two cultures as a consequence of European colonialism. The formally unsettling confluence gains in pictorial tension because of this jarring multicultural encounter, and this quality has now become even more amplified because of what we have recently learned about the depth of Picasso's opposition to French colonial conquest in Africa at precisely the moment of this artwork's conception. About the inclusion of these so-called "exotic" elements in his work, Picasso later stated:

> When I went to the old [Musee d'Ethnographie] . . . the masks weren't just like any other pieces of sculpture. Not at all. They were magic things. . . . They were against everything . . . I understood; I too am against everything. . . . *Les Demoiselles d'Avignon* must have come to me that very day. . . . [I]t was my first exorcism painting — yes, absolutely![38]

Picasso's use of African masks carried with it intertextual references to economic exploitation and forced labor and this usage was related to the

anarchist critique-by-inversion typical of Alfred Jarry and others in Paris at the turn of the century. Yet even Picasso's closest circle had difficulty with this work and several, including Braque, Salmon, and Matisse, were offended by the unrelenting negativity of this painting. Braque, for example, likened the work to an anarchist bomb and a stunned Apollinaire used only one term for it: *"Revolution."*[39]

Rivera's own use within Cubism of non-Western art, specifically that from Native Americans and Mexican campesinos, was both connected with and disconnected from Picasso's usage, since Rivera's work was about the constructive reconstitution of culture along lines that used, but no longer exclusively, privileged European art over other traditions. This emphasis on the reclamation of non-European art would be one of the great new themes of the 1920s' Mexican Muralists. Rivera's testimony from the period does provide extensive corroboration for Patricia Leighten's already cited studies concerning both the prewar left-wing activism of many in the Parisian avant-garde and the ideological critique through pictorial conventions of mainstream values.

In 1915, when Cubism made its debut in Spain through the public exhibition in Madrid of works by Diego Rivera and María Gutiérrez Blanchard, the controversy was such that authorities closed this exhibition of *"Los Pintores Intégros"* (The Complete Painters) as it was called. Organized by modernist author Ramón Gómez de la Serna, this exhibition elicited reactions even from intellectuals that, according to Rivera, "veered between indulgent pity and outright contempt."[40] The reason, in Rivera's view, was the anarchist critique manifested by the paintings and their accompanying cancellation of the public's expected "diet of precooked academicism."[41] No sooner had this controversy subsided than Rivera provoked another one with the exhibition of his *Retrato de (Portrait of) Ramón Gómez de la Serna* (1915), an oil on canvas (109 x 90 cm.). Rivera recalled the public response.

> The stir it caused was quite unlike anything I might have imagined. . . . the Mayor of Madrid himself ordered the painting removed from the window [of the Gallery]. . . . [Ramón Gómez de la Serna in my portrait] had the appearance of an anarchist demon, inciting crime and the general overthrow of order. In this Satanic figure everyone recognized the features of Serna, notorious for his opposition to every conventional, religious, moral, and political principle. But the Spanish people, I believe, responded to something more than an

effective caricature. The portrait of Serna caught the prevailing spirit of violent disintegration [in the early years of the war]. It gave a presence to their deepest fears with an intensity which their own academic painting had not prepared them for.[42]

In 1913–14 while in Paris on the eve of the First World War, Rivera had joined with other artists and authors of the left who "risked their necks in workers' demonstrations against war."[43] About this contumacious period in Montparnasse and beyond, Rivera spoke of how, shortly before the war, there emerged a major political figure on the French left, whom he and all of his friends went to hear give public speeches. This was the socialist leader Jean Jaures, an orator of considerable skill at addressing mass rallies on the left. Not only did Rivera share his political views. He was also inspired in his own artistic practice by the huge crowds being mobilized to work together that these rallies catalyzed. Rivera stated of their long-term influence on his own work that, "This vision [of a mass of people moving in tandem] I later transposed in many ways into heroic murals where, also, the hero was not an individual, but a mass."[44]

Similarly, it has been convincingly shown by Leighten that some of Picasso's collages, such as the *Bottle of Suze* (1912), are also embedded in this prewar period of insubordination by the anarchists and others on the left. This particular collage featured newspaper articles glued onto the work that report the horrifying loss of life in Turkey during the First Balkan War. They also related news about the antiwar speeches by anarchists before large groups that protested the "menace of a general European war," to quote from one of the articles incorporated into the collage.[45]

When Rivera and Angelina Beloff returned to Paris in 1915 after the controversy in Madrid over his Cubist paintings, he increasingly came to address the contemporary events of the Mexican Revolution about which he heard much from exiled Mexican writers like Alfonso Reyes and Jesús Guizo y Acevedo. The resulting "collage" paintings were in keeping with the actual events Rivera was himself responding to in the most advanced and virtuoso manner. Among his paintings from this urgent epoch in world history, when war and revolution were sweeping the globe, were two especially noteworthy works of 1915 that Justino Fernández has called *"Anáhuac Cubism."*[46] The first was his innovative *Retrato de (Portrait of) Martín Luís Guzmán*, an oil on canvas (72.3 x 59.3 cm.); the second, his utterly masterful *Paisaje Zapatista: El Guerrillero* (Zapatista Landscape:

The Guerrilla), also an oil on canvas (144 x 123 cm.). (Figure #5).

The *Portrait of Martín Luís Guzmán*, a major Mexican novelist then living in Paris who would serve in Pancho Villa's revolutionary army, featured Mexican popular cultural references to a *sarape* (a type of woven blanket) and to an *equipal* (a type of chair), both of which have been so deftly crafted in oil paint and sand that they evoke in *trompe l'oeil* fashion textural distinctions and attendant tactile values. At first one assumes that the *sarape,* if not the *equipal,* has been collaged onto the surface much like the printed oil cloth in Picasso's *Still Life with Chair Caning* (1912). Aside from the organic look and brilliant hues from various tertiary reds to glowing complimentary greens that faithfully reproduce the exact color scheme of a *sarape,* there is an overarching angularity to the almost arithmetical arrangement of the parts that reminds us of the scientific interests of many Parisian Cubists.

This painting also features a dynamic interplay of the rural and the urban, of fine and popular art, of resolute flatness and illusory volume. What emerges is not a portrait of Guzmán[47] but rather the depiction of period historical forces in a relation of buckled intertwinement. That Rivera's particular version of modernism has a diction all its own, with a detectably Latin American accent, is as easily acknowledged as the undeniable merits of this highly innovative hybrid *(mestizaje).* Not only did Rivera find his voice with this work, he also did it with verve and eloquence, finally overcoming "my Mexican-American inferiority complex, my awe before historic Europe and its culture."[48]

An even more well-calibrated balancing of boldness and obliquity can be found in his *Zapatista Landscape.* It is superb, and is a defining work of his entire career. Executed by the artist at the age of twenty-nine, it remained one of the finest works on canvas that he ever produced. At once richly detailed and artfully dispersed, this partially camouflaged painting causes the eyes to dart actively and searchingly about, thus eliciting an analogy between Cubist clues and a guerrilla's elusiveness. Inspired by a photograph of Zapata by Augustín Victor Casasola, this painted "collage" also portrays Rivera's historical role to link "the old Mexico with a new, postcolonial one."[49] Interestingly enough, Rivera's friend Dr. Atl was able to interview Zapata in 1915 around the time of the high point of the Zapatista movement at the Aguascalientes Convention.

Late in life, Rivera would claim that this painting embodied the "most faithful expression of the Mexican mood that I have ever achieved."[50] In

this case, the insurgent Mexican mood was a transformatory one in brash, aggressive popular colors, that depicts the familiar even as it reconfigures it to evade easy recognition. This mobile and "de-sanctified" look at the existing order of things shows how the aura of change "could be cleverly utilized by artistic guerrillas like Diego Rivera."[51]

Just as author John Berger stated in his well-known essay that the Cubist moment was one in which the promises of the future were more real than the circumstances of the present, so Rivera gave us in his *Zapatista Landscape* a visionary sense of this inadequacy of the status quo that affirmed something beyond it, something yet to appear fully. Berger stated as follows:

> I find it hard to believe that the most extreme Cubist works were painted over fifty years ago. It is true that I would not expect them to be painted today. They are both too optimistic and too revolutionary for that. Perhaps in a way I am surprised they have been painted at all. It would seem more likely that they were yet to be painted. . . .
>
> To appreciate this [art] we must abandon a habit of centuries. . . .
>
> During the first decade of this century a transformed world became theoretically possible and the necessary forces of change could already be recognized as existing. Cubism was the art which reflected the possibility of this transformed world and the confidence it inspired. . . .
>
> The vision of the Cubist moment still coincides with what is technically possible. Yet three-quarters of the world remain undernourished. . . .[52]

In Rivera's particular case within this visionary, internationalist "moment of Cubism," the key to imagining the world transformed is to be found paradoxically both in the *promise* of modern technology that originated with the urbanized West *and also* in the contemporary program for backward looking change demanded by campesinos (peasants) from the rural areas of this largely agrarian nation on the "periphery" of the world order. At this paradoxical locus in his artistic practice are to be found both the considerable merits of his paintings and also the undeniable problems interlaced with them. One of the visual facts that stands out prominently is the conjunction of an internationalist and cosmopolitan language with the campesino-inspired regionalism of the scene being evoked.

The ultra-urban idiom of Synthetic Cubism in *Zapatista Landscape*, with its symbiotic relation to the age of mechanical reproduction, has been allied to time-honored artisanal traditions that resituate everything within the ancient landscape called the Valley of Mexico. Furthermore, it has all been accomplished by a critical assimilation of the crisp lines and continuous lighting as well as elegantly finished surface of "renovated classicism" from Anáhuac. This latter set of components has both served as a foil for this painting and, ironically, helped to facilitate an historic rupture with the passive, static, and hierarchical world view traditionally embodied by official classicism.

What, then, of the extra-aesthetic links to Zapata's momentous call for agrarian reform that was programmatically articulated in the *Plan de Ayala* (November 28, 1911)? This was the most important manifesto put forth in the entire Mexican Revolution. As Adolfo Gilly noted of Zapata's plan, its "specific revolutionary character" resided in its transferral of the burden of proof for land ownership from the campesinos to the hacendados, thus turning upside down the existing legal system and placing in its stead revolutionary tribunals on the grassroots level to judge land claims.[53]

Furthermore, the Plan of Ayala called for the mass redistribution of land to those who worked it along with the restoration of a system of village democracies with common domain or *ejidos*. This meant that the state of Morelos where Zapata lived, was in some ways analogous to a Russian Soviet or the Paris Commune of 1871. The plan "therefore contained the principle of military organization in territorial [popular] militias linked to the point of production" and was fundamentally opposed to a professional army and to any national government.[54]

Much like the pictorial logic of Rivera's all-over, decentering, and nonnarrative Cubist paintings, Zapata's plan was antihierarchical and decentralized, as well as radically democratic. Zapata's project was also distinctly anarchist in character and it was, in many ways, the heir to the earlier anarchist insurgency led by Enrique and Ricardo Flores Magón of the *P.L.M.*[55] Of course, Rivera's own politics before 1916–17, and the impact of the Russian Revolution, were more anarchist than Marxist. Just as the Ayala program saw the future largely as one of redemption for the indigenous campesino past, so Rivera's painting was already, in some respects, also about a related revalidation of the indigenous and popular cultures that had been devalued by the Díaz dictatorship's neo-Western project of modernization.

The failure of Zapata's anarchist was directly related to its inability to

conceptualize a centralized national state capable of replacing the older one that had been overthrown. Zapata's regionalist program was also incapable of unifying the country and defending it against the mechanized professional armies of modern imperial nation-states in the West that operated in tandem with the market forces of Western modernization. United States intervention played a major role in deciding the ultimate outcome of the Mexican Revolution.[56] In short, limited as it was by the "anti-state and anti-organizational tenets of anarchism," Zapata's movement "lacked a clear and multi-class program that had more than regionalist appeal."[57]

In many ways, Diego Rivera would move away from the decentralizing and dispersive visual language of any thoroughgoing Cubist style, in hopes of centering his vision, stabilizing his message, and concentrating his epic sweep, so as to control more effectively the direction of historical change intimated by his *always* future oriented works. The considerable success with which Rivera accomplished this artistic task and the concomitant ideological shift it entailed accounts for the success that Rivera would ultimately have serving — and also contesting, when not subverting — the broad alliance of historical forces that solved the problem of how to reconceptualize the national government of Mexico in terms more responsive to the demands of the popular classes, thus advancing beyond the utterly fractured situation left by the Mexican Revolution.

Rivera never completely broke with Cubism, much less the formal impetus of an alternative modernism, so he never forgot Zapata and his compelling vision of the future — a vision of the future that was the most progressive one of the entire period.[58] The fact that Rivera would paint Zapata's portrait almost forty times, with several of these depictions being located in large federally-financed public murals that are an ironic testimony to the centralized state consolidated after 1920, alerts us to an important strain of ideological continuity in Rivera's long career. This preoccupation with the most radically democratic leader of the Mexican Revolution also points to just how much Rivera was really committed to reclaiming the still serviceable features of Zapata's stirring social vision of the future.

THE LATIN AMERICAN ORIGIN OF
THE CONCEPT OF MODERNISM

Before concluding this chapter on Diego Rivera as an "alternative modernist," we need to reconsider the term "modernism" in light of what has been demonstrated above about Rivera's use of a hybrid modernism called "Anáhuac Cubism," as part of an emergent post-colonial discourse that was affiliated with the left, most notably with anarchism. First and foremost, such a reexamination means conceding the inadequacy of most current discussions of modernism and modernity, as Paul Gilroy, and several others, have contended.[59] To speak with insight and sensitivity of modernist art from the late 1800s till the post–1945 period *is to speak of a plurality of related but also notably divergent and even fractious tendencies,* some of which were grounded in a broad ranging multiculturalism and some of which were not.

Yet all of these different tendencies within modernism and in relation to modernity, were part of an uneven, nonlinear development that needs to be charted anew in order to understand the radical heterogeneity of this set of movements.[60] This multilateral state of affairs has yet to be acknowledged either by Clement Greenberg's canonical definition of modernism as mere "medium purity" or by the counterarguments put forth by some post-modernists. What *has* been canonized by both sides in this debate is less modernist art than Greenberg's ethnocentric and homogeneous definition of it — a definition that has little place for Diego Rivera and many other post-colonial modernists of this early period.[61]

It comes as a surprise for many of us to discover that, far from being coined in the metropolitan West, the term "modernism" (or *modernismo*) was, in fact, invented in the 1880s on the periphery of the world economic order by Rubén Darío of Nicaragua, Latin America's first internationally acclaimed modern author and poet. Darío, (1867–1916) who probably met Rivera in Paris or Barcelona, inaugurated Latin America's earliest genuine avant-garde movement under the banner of *modernism.* He first used this term around 1885–86 to refer to certain novel attributes in the writings of Mexican author Ricardo Contreras, although Darío's own work exemplified these traits in a more thorough way.[62] (*Modernismo* should be understood here as one of several tendencies *within* modernism as a whole.)

In formal terms, Darío's own *modernismo* in such poems as *Azul* (1888) constituted a hybrid fusion of various artistic modes featuring

heterogeneous cultural citations that were both European and non-European, along with being precolonial, colonial, and post-colonial in origin. All of these elements were densely interwoven with references to experiences gleaned from the five senses.[63] Among the contemporary visual artists about whom Darío wrote were the French sculptor Rodin and Latin American painters such as Angel Zárraga. When he wrote an essay about the paintings of Zárraga, Darío selected Diego Rivera's portrait of Zárraga to accompany his essay. In this same issue of *Mundial* there was a brief discussion of Rivera's paintings by another Latin American writer.[64] In short, Darío was to *modernismo,* what Apollinaire was to Cubism, André Breton was to Surrealism or Marinetti was to Futurism. In all of these cases, a literary figure, specifically a poet, played a key role in articulating the project of an avant-garde movement whose most well-known practitioners often turned out to be painters.

On the one hand, the general dynamic of Darío's own poetry was driven by a reaction against the outdated and ossified literary conventions of official Spanish letters and, on the other hand, it was motivated by an assimilation of certain new developments in nineteenth-century French literature that were then combined with pre-Columbian cultural traditions of the remote past. The view motivating this unlikely synthesis was articulated by Darío in 1896: *"If there is poetry in our America, it is to be found in the old things."*[65]

This notable reference to the artistic representation of *"nuestra América"* by the founding figure of modernism also reminds us of the earlier 1891 essay that had first popularized throughout Latin America the explicitly non-Eurocentric phrase of "our América." This essay, entitled *"Nuestra America,"* was written by Cuban author José Martí (1852–95), the only Latin American writer of the second half of the nineteenth century who rivalled Darío in prestige and importance.[66] (Martí was also an art critic who praised French Impressionism and wrote reviews of exhibitions by Mexican artists such as Rivera's teacher José María Velasco.)[67] Martí's celebrated essay about "Our America" called for the construction of a post-colonial, multiracial, and transcultural society. Martí, a leader of the movement for national liberation in Cuba, was killed in 1895 while he was engaged in the armed struggle against Western colonialism.[68]

Such a new multiethnic society in the future would presuppose a fundamental rethinking of history. To quote Martí, "The history of America, from the Incas to the present, must be taught in clear detail and to the letter, even if the archons of Greece are overlooked. Our Greece

must take priority over the Greece that is not ours."[69] Aside from colonial peonage, there were also the grave impediments of racism and imperialism that blocked the path on behalf of reconstituting the Americas along more socially just lines. Accordingly, Martí closed his essay with two warnings: first, "Whoever foments and spreads antagonism and hate between the races, sins against humanity;" and, second, "The scorn of our formidable neighbor [the United States] who does not know us is Our America's greatest danger."[70]

These themes of anti-imperialism and racial harmony in concert with multiculturalism in the arts were abiding concerns of Darío's particular mosaic-like concept of modernism. In the VIIth Canto of his book *Cantos de Vida y Esperanza* (1905), which is entitled "A Roosevelt," Darío penned a critique of imperial intervention and soulless utilitarianism in tandem with positivism that, because of its soaring poetry and pungent politics, has remained a favorite of Central American audiences.[71] In the opening section, Darío declared:

Es con voz de la Biblia, o verso de Walt Whitman
que habría que llegar hásta ti, Cazador!
!Primitivo y moderno, sencillo y complicado,
con un algo de Washington y cuartro de Nemrod!
Eres los Estados Unidos,
eres el futuro invasor
de la América ingénua que tiene sangre indígena, . . .

(It was with a Biblical voice or the verse of Walt Whitman
that you arrived amongst us, O hunter!
Primitive and modern, simple and complex,
With something of George Washington and a quarter Nemrod!
You are the United States
You are the future invader
of the ingenuous America that has indigenous blood,) . . .[72]

Further on in the same Canto, Darío critically contrasts, the threatening colossus of the North, which had cynically combined the cult of Hercules and the worship of money, with, *"la América nuestra, que tenía poetas / desde los viejos tiempos de Netzahualcoyotl, . . . la América del grande Moctezuma, del Inca."* (Our America that has had poets since the ancient times of Netzahualcoyotl . . . the America of the great Moctezuma and

of the Incas.)[73] This criticism of the materialism and positivism concomitant with North American modernization was a prominent theme during this period in the work of other Latin American *modernistas*.[74] It was coupled by Darío with stark depictions of a view that had first emerged with European Romanticism, namely, that of the artist's alienation from bourgeois society. In his story, *El rey burgués* (The Bourgeois King), Darío told of the contemporary fate of the artist as one of being condemned to play a barrel organ in the snow because he had defied the values of middle-class society.[75] Similarly, in his prose poem *Canción de Oro* (Song of Gold), Darío wrote of a poet/beggar who sings ironic odes to the Golden Calf, or *cash nexus,* being widely worshipped in a society that was being transformed by economic modernization.[76]

In sum, the original modernism of Darío — with its collage-like formal language of hybridity, *mestizaje,* and multiculturalism — embodied precisely that multilateral trajectory that art critic Dore Ashton perceptively identified when she spoke of how modernist art at its most profound, "moved backward and forward at the same time."[77] Darío's particular strain of modernism was inflected by an alienation from capitalist social values, pervaded by an opposition to Western colonialism, imbued with a desire to revivify, or at least reuse, the non-Western and precolonial artistic traditions of Latin America and, finally, was marked by an ambivalent embrace of *modernité* (or modernity).[78]

Here it would be worthwhile to correct a very common misconception in art historical literature of the West. Charles Baudelaire's 1863 essay, *"Le Peintre de la Vie Moderne"* (The Painter of Modern Life), was neither a definition nor a theorization of modernism.[79] When Baudelaire wrote, "By *'modernity'* I mean the ephemeral, the fugitive, the contingent, the half of art whose other half is the eternal, the immutable,"[80] he was defining modernity in art as a thematic presentation of the historical and social experience of economic modernization, *to which the cultural practices and artistic production of modernism would subsequently come to constitute a more self-conscious, often dissident, and increasingly self-critical response.* This fact was unintentionally made clear by Baudelaire's choice of the minor late-Romantic artist, Constantin Guys, rather than his friend, Eduoard Manet, as the "painter of modern life."[81] In fact, Darío's closest counterpart and contemporary in French literature was Stephane Mallarmé, who according to both Roland Barthes and Marcel Duchamp, was the first French modernist, even though he generally employed the more restrictive but also modernist term of *Symbolism.*[82]

For the sake of clarity *modernism* designates the cluster of diverse artistic tendencies in opposition to the official high culture of mainstream society, or as an ambivalent response to the historical experience of *modernity*. An experience of modernity occasioned most modernist reactions, whether oppositional or not, to the economic project of capitalist *modernization* and its often allied program of Western imperialism.[83] Despite the fact that modernism, modernity, and modernization are routinely used as synonyms in much art historical literature, they have existed only in asymmetrical and unsettled relation to each other. The first step towards clarifying the plurality of practices known as "modernism," involves an understanding of how these three terms — *(modernism, modernity, and modernism)* — assume a quite different set of historical relationships, depending on *which tendency within modernism one has in mind*.

It was only after the Latin American term "modernism" crossed the Atlantic in the 1880s to discover Europe and its first port of call was Barcelona, not Paris — that it began to designate certain formal strategies and thematic concerns in the visual arts that were analogous with those in Rubén Darío's modernist poetry and which are now associated with the avant-garde and modernism. Just as Darío, while living in Barcelona, Spain, would have a significant influence on 1890s Spanish culture, so would the three major legatees in the visual artists of his hybrid conception of modernism namely, Antonio Gaudí, Pablo Picasso, and Diego Rivera.[84] Although it is probable that Darío never got to know the reclusive Gaudí, it is likely that he did meet the young Picasso and the still younger Diego Rivera, in Barcelona at the anarchist enclave and bohemian Cafe of the Four Cats *(El Quatro Gats)*, which all of them frequented when they were in this city.[85]

The label of *modernismo* (or *arte modernista*) was first used in the visual arts, while Darío was in Spain, to refer to such work as Antonio Gaudí's architectural projects in Barcelona, the *fin-de-siecle* city where Pablo Picasso was living and working from 1897–1904. It was, then, the anticolonial modernism of Barcelona, with a Latin American accent, that first gave us Gaudí and, subsequently, Picasso as well as Rivera.[86] And while the term *modernismo* generally denoted the Catalán version of *art nouveau,* in the case of both Gaudí and Picasso, this early designation of *modernist* signified much else as well, *thus expanding the concept of modernism so as to accommodate the even more divergent network of artistic directions that would soon emerge elsewhere.* Catalán *Modernismo,* like that of Darío, was both a distinct tendency *within* modernism proper and a

point of departure for developing other tendencies of modernism later, most significantly, the heterogeneous Cubism of Picasso and Rivera.

Catalán modernism in the work of Gaudí evinced a strikingly ambidextrous ability to go both forward and backward simultaneously. A person of the past and a partisan of the future, Gaudí used ultramodern materials (he was the first architect in Spain to use reinforced concrete, which he employed in the Parque Güell), yet he also employed the time-honored artisanal approach to traditional materials, such as ashlar, plus archaic building motifs that were both Western and non-Western in nature.[87] The singular-looking towers of *Sagrada Familia* came from the Berber building traditions of North Africa; the use of *azulejos* (ceramic tiles) on the facades of edifices was *Mudéjar*, or Moorish, in origin; the inclusion of Gothic arches was Catalán in derivation; and the recourse to modern engineering techniques along with new materials, such as steel, arose from the influence of Northern European modernization, even as Gaudí was inspired by the utopian socialism of William Morris and the arts-and-crafts movement.[88]

Perhaps Gaudí's best known aphorism is that *"originality is achieved by returning to origins."*[89] Not only should this be connected to his reaffirmation of the local artisanal traditions of Cataluña (his father was a coppersmith and his grandfather was a ceramist), but also to Gaudí's ardent commitment to the Catalán national autonomy movement against the imperial hegemony of Castile. It was, for example, this preoccupation with contesting the hegemonic dominion of the Spanish national state that led Gaudí to design a serrated roofline in 1905 for the *Casa Milá*, which symbolically echoed the shape of Montserrat, the mountain that had long been a signifier of Catalán independence and which also served as an important subject for Diego Rivera's Catalán landscapes when he was in Barcelona in 1911.[90]

The best metaphor for Gaudí's distinctive concept of modernism is an invention resulting from it, namely, the modernist "collage" that he used at Parque Güell only shortly before Picasso introduced collage into painting in 1912. On the upper deck of Güell Park, above the market area that is sheltered by reinforced concrete beams and supported by a whimsical red sandstone Doric portico, there are outdoor benches that feature what was probably the first, and what still remains one of the most striking, architectonic "collages," or modernist mosaics, ever produced in the visual arts. This mosaic collage was fashioned from the broken shards and left over fragments of rejects from a local Catalán ceramic workshop,

as well as from the rubble of fractured glass and tableware.[91] A cobbled-together *mélange* of ruins that signify the unevenness of historical development to which Gaudí's entire oeuvre so eloquently attests, this modernist mosaic/collage was also a metaphor for the multifacetedness of Catalán national identity that wedded a utopian gesture of future community to a somber sense of the past along with a view of the present as a field of ruins. It is important here to recall that *Sagrada Familia*, to which Gaudí devoted the last decade of his life, originated as a church for the expiation of the sins of the modern materialistic age, that is, of modernization.[92] The "collage" at Parque Güell, embodies the multiculturalism and dynamic open-endedness that have generally been a hallmark of the best modernist art, in addition to encapsulating a telling historical ambivalence at once hopeful in its vision of the future and, yet, harsh in its view of what preceded it.

A parallel for Gaudí's modernist belief in redemption among the ruins of history can be found in the late writings of Walter Benjamin, who remains one of the major theorists of modernism even as he is now routinely cited by post-modernists. Shortly before his death in 1940, Benjamin wrote eighteen theses on history in which he observed that *"There is no document of civilization that is not also at the same time a document of barbarism."* [93] The apocalyptic, yet redemptive concept, of history put forth in *Thesis IX* bears repeating because of how deeply it relates to the modernist work of Darío, Gaudí, Picasso, and Rivera.

A [Paul] Klee painting named *Angelus Novus* shows an angel looking as though he were about to move away from something he is fixedly contemplating. His eyes are staring, his mouth is open, his wings are spread. This is the angel of history. His face is turned toward the past. Where we perceive a chain of events, he sees one single catastrophe that keeps piling ruin upon ruin and hurls them in front of his feet. The angel would like to stay, awaken the dead, and make whole what has been smashed. But a storm is blowing from Paradise; the wind has caught his wings with such force that he can no longer close them. This storm irresistibly propels him into the future to which his back is turned, while the pile of ruins before him grows ever skyward. This storm is what we call progress.[94]

One of Pablo Picasso's most famous aphorisms was that "A painting used to be considered a sum of additions. In my case a painting is a sum

of destructions."[95] This early modernist concept of art, which is linked to collage, is related both to Picasso's tenure in Barcelona *modernista* and to his commitment to the cause of anticolonialism, as well as to his important affiliations with anarchist thought (at this time, Barcelona was one of Europe's main centers for anarchism).[96]

As for the use of the idea of the *fragment* to explain the historical import of critical modernism, we need only recall how Diego Rivera incisively defined Cubism along the lines of Darío, Gaudí, Picasso, and Benjamin. Rivera declared:

> It [Cubism] was a revolutionary movement, questioning everything that had previously been said and done in art. It held nothing sacred. *As the old world would soon blow itself apart, never to be the same again, so cubism broke down forms as they had been seen for centuries, and was creating out of the* fragments *new forms, new objects, new patterns and — ultimately — new worlds* [my italics].[97]

It was the deftly understated, even camouflaged, quality of post-colonial tendencies within Cubism that Thomas Crow explicated so well when he noted the internal dialogue between high art and mass culture, between Western and non-Western art, in many Cubist collages:

> The mixing of class signifiers was central to the formation of the avant-garde sensibility. . . . To accept modernism's oppositional claims, we need not assume that it somehow transcends the culture of the commodity; we can see it rather as exploiting to critical purpose contradictions within and between distinct sectors of that culture [especially between high art and kitsch, the product of the culture industry, as Adorno termed it]. . . . This ceaseless switching of codes is readable as articulate protest against the double marginalization of art . . . [so that] Cubism is . . . a message [with critical intent] from the margins of society. . . .[98]

The origins of the visual language associated with Cubism, in general, and with collage, in particular, presupposed a profound critique of the nature of painting in the West. Far from being restricted to a reductive exercise in medium purification, as proponents of Greenbergian variant of formalism maintain, the inception of Cubism entailed both an expansion of the communicative resources of the medium *and* a necessary

contraction of the pictorial claims of European Renaissance art — that is, of its illusions and illusionism. A Cubist painting, such as those analyzed above by Rivera, evokes and then undermines the high art conventions in the West for constructing perspectival space: as in the abbreviated use of *chiaroscuro;* in the coy deployment of overlapping; in the original suggestion but subsequent dissolution of figurative references; and, in the artful decentering of the images, so as to disallow the hierarchical structure along with the sense of formal resolution that were salient traits of the classical tradition.

A Cubist painting, with its overall tension between the actual two dimensions of the picture plane and the fictive three dimensions of Renaissance vintage, is not just about an interrogation of the medium.[99] More importantly, modernist space in Cubist work is about a critique of the official pictorial language in mainstream Western art, of which the medium itself is but one component. It is precisely because modernist art was a dehierarchizing and demotic critique of the overarching conventions of official Western art that the "collage" aesthetic could become so effective at accommodating a multicultural interplay of Western and non-Western elements on equal terms.

In one of the most incisive postformalist discussions of modernism Rosalind Krauss has illuminated further how a Cubist collage, with its distinctive use of modernist space, addresses the standard mechanics of pictorial logic in the West.[100] As Krauss has rightly observed, two of the formal strategies that developed out of Cubist space are those of figure/ground reversal and of the continual transposition between negative space and positive form, thus there is no visual sign without the eclipse or negation of its material referent. Rivera's *Zapatista Landscape* (Figure #5) is exemplary in both of these respects.

Cubist collage and modernist space end up critically exploring the cultural preconditions of Western representation itself — how images are produced in pictorial terms and how these images come to assume the status of signs. Such a self-critical investigation of *how* and *why* Western painting has traditionally worked, specifically, of how its system of representation has been culturally mediated, strongly disallows the common assertion that *modernism in all its forms* hegemonically privileges — *that is, naturalizes* — Western art at the expense of non-Western art.[101]

The Cubist contestation of Western cultural hegemony is precisely what allowed Diego Rivera to recruit Cubist collage and modernist space on behalf of the Mexican Revolution of 1910–20, with its unequivocal

commitment to constructing a non-Eurocentric and post-colonial national identity.[102] One of the legacies of Rubén Darío's particular concept of modernism was to salvage for progressive purposes whatever is still viable and valuable in the various class and ethnic legacies to which we are all heirs. Similarly, "use what you can" was Bertolt Brecht's advice, with the implicit corollary that what turns out to be regressive or beside the point in such lineages should be discarded without nostalgia.

In closing, it should be noted that one of the very first uses of the term "post-modern" was by the historian Arnold Toynbee in a book entitled *A Study of History*.[103] For Toynbee the term "post-modern" was a chronological one rather than a stylistic one and it denoted basically "post-Eurocentric" and "post-modernization" along Western lines, or more accurately, "post-colonial." Such a usage of "post-modern" is definitely not at odds with the ongoing legacy of the progressive, non-Eurocentric tendencies within modernism proper that were inaugurated in poetry and painting by Rubén Darío and Diego Rivera. While there is a sense in which we have entered a post-modern, post-colonial, and post-Western-centered period of history, there is another sense in which we still have yet to catch up with the post-colonial modernism of Darío and Rivera.

CHAPTER THREE

■

Diego Rivera and
the Beginning of the Mexican
Mural Renaissance in the 1920s

■

"[F]ar from repudiating modernism, the muralists together with other Latin American artists have used modernism to their own ends, or have expropriated or subverted it to produce an alternative modernism better suited to a Latin American context. . . .

In the 1930s, for many radical artists and intellectuals throughout the world, it was Mexico and not Paris that stood for innovation in the arts. Artists in Mexico were seen to have challenged the authority of a Eurocentric aesthetic and asserted the values of a self-consciously post-colonial culture. . . .

Diego Rivera was the most prolific and initially the most internationally acclaimed of the muralists, acting as a link between the avant-garde aesthetics of Europe and the growing Mexican debate as to the nature of revolutionary art. . . . To a certain extent similar concerns were emerging internationally, for example among the German Dadaists or the Constructivists in the Soviet Union."

> Oriana Baddeley and Valerie Fraser,
> *Drawing the Line: Art and Cultural*
> *Identity in Contemporary Latin América*
> (1989)[1]

The 1920s saw the emergence of various avant-garde and modernist groups throughout Latin America, the most influential of which was the Mexican Mural Movement, or "Mexican Mural Renaissance" as it has sometimes been called. The first manifesto of this public art program in Mexico was also the first great avant-garde declaration in the Americas to embrace the visual arts. This manifesto appeared in May 1921 and was the work of an unknown art student from Mexico, David Alfaro Siqueiros, who, as the views and language of his manifesto show, was deeply under

the influence of Diego Rivera, his older and much more accomplished compatriot. This would become quite clear when Siqueiros published a newspaper article in praise of Rivera, in July 1921.[2] (For an English translation of this essay, see Appendix #1.)

Before discussing the advent of the Mexican Mural Movement and analyzing the paintings by Diego Rivera that are central to it, I need to elaborate on two related concepts. First, it will be necessary to discuss the nature of Rivera's "alternative modernism," which has attributes that are both populist and epic in character. Second, it will be necessary to analyze the complex relationship of the Mexican Mural Movement and the patronage responsible for funding it. After having established a conceptual framework for adequately analyzing these issues, I shall then discuss the formal logic, iconographic programs, interventionary role, and ideological values of Rivera's major work from the 1920s.

RIVERA'S "ALTERNATIVE MODERNISM" AND THE ISSUE OF POPULISM

Entitled *"Three Appeals for a Modern Direction: To the New Generation of American Painters and Sculptors,"* the 1921 manifesto by Siqueiros was published in Barcelona in the journal *Vida Americana*. This declaration drew heavily on the variant of "alternative modernism" that was first articulated in the writings of Rubén Darío and first given visual manifestation in the "Anáhuac Cubism" of Diego Rivera. The manifesto by Siqueiros, which is sometimes credited with "crystallizing the Mexican mural movement," was formulated shortly after he visited with Rivera in Paris and not long after the new postrevolutionary government of Alvaro Obregón made clear its intention to support a national program of monumental mural painting.[3]

As did Rubén Darío in his earlier discussions of modernism, David Alfaro Siqueiros began his remarks by condemning the "marked decadence" of contemporary Spanish art and then he looked beyond the insular art world of Madrid towards the more internationalist group of modernists in or from Paris and Barcelona. In fact, an example of the type of Cézanne-inspired avant-garde art that Siqueiros praised in his 1921 manifesto was the exhibition of late 1920 in Barcelona at the Galerie Dalman that featured paintings by Diego Rivera and was entitled *"Exposicion d'art francais d'avant-garde"* (Exposition of French Avant-Garde Art).

Among the major artworks by Rivera from his neo-Cézannian period (1917–20) that showcase his considerable dexterity in using the distinctive *facture* (brushstroke) and *deformation* (compositional shifts or "distortions") for which the late Cézanne works had become increasingly celebrated are two fine canvas paintings, *Woman with Geese* (1918, 62.5 x 81.5 cm.), and *The Mathematican* (1918, 115.5 x 80.5 cm.)[4]

Siqueiros stated the following in the first of the three sections of his manifesto, which was called *"Detrimental Influences and New Trends"* and featured an emphatic Cubo-Futurist embrace of modernity that was clearly influenced in part by the Russian avant-garde art of the October Revolution to which Diego Rivera's own work had been strongly allied.

> We extend a rational welcome to every source of spiritual *renewal* born of Paul Cézanne: . . . the purifying reductionism of *Cubism* in its diverse ramifications; the new emotive forces of *Futurism*, . . . the absolutely new *appraisal* of "classic voices" (Dada is still developing) . . . [and] preparatory theories endowed with fundamental elements which have brought true plasticity back to painting and sculpture, enriching it with new admirable elements. . . .
>
> *Let us live our marvelous dynamic age!* Let us love the modern machine which provokes unexpected plastic emotions, the contemporary aspects of our daily lives, the life of our cities under construction, the sober practical *engineering* of our modern buildings. . . . Let us dress our *human invulnerability* in modern clothing: *"new subjects, new aspects."*[5]

Siqueiros went on to a second section, the *"Prevalence of the Constructive over the Decorative or Analytical,"* which was appropriately named since it demonstrated a clear debt to the period discourses of Vladimir Tatlin, Olga Rozanova, and other Constructivists as well as Supremacists.

> Let us, the painters, impose the constructive spirit on the merely decorative. . . . [T]he basis of the work of art, is the *magnificent geometrical structure of form*. . . . Whether ours be dynamic or static, let us first and foremost construct. Let us mold and build on our own personal emotional reactions to nature, with a scrupulous regard for the truth.[6]

At this point in his celebration of the possibilities of the present,

Siqueiros introduced a non-European emphasis on the concomitant need to reclaim aspects of the precolonial past. One of the few artists who had *already* produced noteworthy artwork that exemplified this particular hybrid of reconstituted elements from the past and the present in league with the future was Diego Rivera. His *Zapatista Landscape* (Figure #5) and *Portrait of Martín Luís Guzmán* are outstanding in this regard. The passages in Siqueiros' manifesto for which Rivera had already provided a compelling antecedent went as follows:

> An essential part of strengthening our art is bringing back *lost values* into painting and sculpture and, at the same time, endowing them with *new values!* . . .
>
> Understanding the wonderful human resources in "black art" or "primitive art" in general, has given the visual arts a clarity and depth lost four centuries ago along the dark path of error. Let us, for our part, go back to the work of the ancient inhabitants of our valleys, the Indian painters and sculptors (Mayas, Aztecs, Incas, et al.). Our climatic proximity to them will help us assimilate the constructive vitality of their work. They demonstrate a fundamental knowledge of nature which can serve as a point of departure for us. Let us absorb their synthetic energy, but avoid those lamentable archaeological reconstructions *("Indianism, Primitivism, Americanism")* which are so in vogue here [in Europe] today but which are only short lived fashions.[7]

Siqueiros's manifesto concluded with a brief summons: *"Let us abandon literary motifs. Let us devote ourselves to pure art!"* Calling for the production of "universal" art, rather than a recourse to "national art," he wrote of how ethnicity would unavoidably "show through in our work."[8] Siqueiros gave a fairly programmatic presentation of the "collage," or *mestizaje,* aesthetic that was intrinsic to the modernist work of Darío and Rivera, based on: 1) a multicultural combination of non-Western and Western art; 2) a multilateral (hence nonlinear and antipositivist) sense of historical development at once modern and mindful of the past; 3) a concerted reconsideration of the conventions of the visual language being used; and 4) a tacit commitment to anticolonialism enjoined with internationalism that was seen as being compatible with a certain type of national self-definition in art and culture.

In their discussion of this tendency that they designated as "alternative

modernism," Oriana Baddeley and Valerie Fraser have forced us to rethink whether or not the efforts of Diego Rivera and the Mexican Mural Movement would or would not be an example of "avant-garde" in the most profound sense. The answer is relatively quick in emerging if we simply summarize the two most comprehensive definitions to date of this phenomenon, namely, those found in the classic studies of Renato Poggioli and Peter Bürger.[9]

From their emergence in the 1830s until their demise in the 1960s, the various tendencies constituting what has become known as the *avant-garde* ("advanced guard") were concerned less with new styles *in* art, than with new styles for life *through* art. Involving movements rather than schools, avant-garde artists sought nothing less than the wholesale transformation of society, out of which everything would be conceived anew.[10] When painter Juan Gris declared in 1925 that Cubism had not been simply a manner but a "general aesthetic that was linked to every manifestation of modern thought," or when André Breton stated in 1924 that the Surrealist movement was committed to nothing less than "solving all the principal problems of life," or when Mayakovsky also contended in the 1920s that "Constructivism must become the supreme formal engineering principal of life," each of them was speaking of their respective avant-garde movements as an *advanced guard* of fundamental social transformation.[11] Each of them was advocating *a view of art as a formative force on behalf of a new society,* not just a notion of art as the reflection of existing society. New avant-garde movements were thus publicly announced by manifestoes that expressed both an alienation from, or even negation of, the present coupled with the affirmation of a radically different order that their art was intended to invoke.

One of the earliest uses of the term "avant-garde" in this sense was in 1845 by the French author Désiré Laverdant, who was a follower of the utopian socialist Charles Fourier. Along these lines, Laverdant wrote: "Art, the expression of society, manifests, in its highest soaring the most advanced social tendencies: it is the forerunner and the revealer. . . . *[T]o know whether the artist is truly of the avant-garde, one must know where humanity is going* [my italics]."[12] This quotation reminds us of what Renato Poggioli called two frequent themes of avant-garde movements: the agonistic sense of consecrating oneself for those who will come afterwards; and the desire for some type of clean cultural slate to locate the "primitive" or elemental conditions out of which everything can be created anew.[13]

In a significant study of 1974 entitled *Theory of the Avant-Garde,* Peter
Bürger drew on the ideas of T. W. Adorno and Walter Benjamin to
sharpen our sense of the critical, or even negative, aspect of the classic
avant-garde movements of the 1920s and 30s by defining them as a diverse
set of attacks on the *official status or role of art* in modern Western society.
What these different avant-garde groups negated was not simply an earlier
style, such as academic neo-classicism, but the very existence of art as an
official institution that was dissociated from the ordinary life of humanity.
When these various avant-garde movements demanded that art become
"useful" again, they were not merely interested in making the content of
their artworks more socially topical.[14] Often their demands for social
relevance were raised in terms of *how* their works functioned in relation
to existing values and established structures. Their work was meant to be
a critique of the way in which official art affirmed a mainstream society
that the movement was rejecting. These avant-garde critiques also entailed
a self-criticism of the internal formal logic and aesthetic conventions
intrinsic to Western art since the Renaissance. Avant-garde art was
opposed to the social ineffectuality of official art along with its bland
affirmation of the status quo.[15]

In all but one of these respects, the mural movement of Diego Rivera
and other Mexican artists would be considered avant-garde. Concerned
not merely with a new style, but rather with the formation and advocacy
of new revolutionary social values through a new visual language, this
movement was marked by an agonistic conception of the artist and a
negation of the institutionalized neocolonial art sanctioned by the Díaz
Dictatorship. Yet aside from manifesting their oppositional language
through an artistic self-criticism that featured a critique of the formal logic
as well as social function of this official art from the prerevolutionary
period, Diego Rivera and the Mexican Muralists also wished to make their
work very "useful," or socially topical in extra-artistic terms, through the
iconographic content of their paintings.

Unlike all other avant-garde artists — with the obvious exceptions of
John Heartfield, George Grosz and a few others — Diego Rivera and the
Mexican Muralists chose a type of directly engaged content for their
paintings, which must be characterized as "populist" in a sense that is not
normally associated with European modernism or with the avant-garde.
(To find a precedent for Rivera's work that is, at the same time, modernist,
populist, and avant-garde, we need to look to the nineteenth-century art
of Gustave Courbet, Francisco Oller, Camille Pissarro, and Georges

Seurat.) Consequently, Rivera and the Mexican Muralists forged an "alternative modernism" that we can also give the paradoxical label of "populist modernism." It was Rivera's populist use of figurative historical references that has caused many commentators to overlook the modernist components and avant-garde concerns of his murals and to label them simply as examples of "social realism," which they are not.[16] Since populism and modernism have normally been antithetical to each other, the antimodernist designation of "social realism" has served as a superficial and unsuccessful way for some people to "resolve" the interpretative problems posed by Rivera's murals, which are both modernist *and* populist in varying degrees depending on the mural in question.

This strong current of populism, which was melded with "collaged-together" compositions derived from Cubism, allowed Rivera to employ his distinctive version of "renovated classicism" to create a new type of history painting that was both epic in character and open-ended in structure. This meant that the usual linear narrativity of history painting from the academic past was *reconfigured and opened up to feature competing forces in history,* not just isolated vignettes of well-known historical figures, all of which were situated within the framework of *an uneven and even contradictory historical development* that had few precursors in traditional Western history painting.

This singular "populist modernism" of Rivera also functioned as a form of "epic modernity," that instead of just relating already resolved stories, called for new political choices at determinate historical crossroads in order to advance various causes yet to be fully defined or definitively told. This artistic operation of requiring active viewer involvement to make sense of the artwork — and in this case of history — is more a modernist strategy, than a populist one. The populist relation to the spectator is generally one that presents "resolved" stories that generally enforce viewer passivity. Put another way, "alternative modernism" initiates a dialogue with the viewer, while straight populism has a largely *didactic* or *tendentious* relationship with the viewer.

Scholar Meyer Schapiro, who was a friend of Diego Rivera and Frida Kahlo during the 1930s,[17] was one of the first art critics of the period to appreciate how Diego Rivera's paintings represented a variant of "engaged modernism" within the "radical cultural movement of the 20s" both in Mexico and beyond. In a 1937 review essay for *Marxist Quarterly* Schapiro singled out Rivera's "epic modernism" in such works as his murals for the Ministry of Education and the University in Chapingo:

The murals produce a powerful impression of the density of historical life, the struggles, heroes, festivals, labor and slogans of a whole people. No other painter of our time has been so prolific and inexhaustibly curious about life and history. With all its [populist or didactic] limitations, Rivera's art is the nearest to a modern epic painting.[18]

Schapiro went on, however, to pose some profound questions — which, to date, have been far too easily "answered" — about the institutional uses to which the "populist modernism" and "negative art" of Diego Rivera could be applied by the emerging postrevolutionary state in Mexico. In light of what Peter Bürger states about the role of avant-garde in negating all institutional or official art of the established order, we need to restate Schapiro's provocative questions from the 1930s and respond to them anew:

If Mr. [Bertram] Wolfe is correct in attributing the official socialism of the regime to a counter-revolutionary intention, what shall we say of the mural paintings [by Diego Rivera] . . . , nearly all of them on walls of public buildings and created under the patronage of this regime? . . .

[I]n the United States as in Mexico there was an apparent discrepancy between the work of the Mexican artists and their patrons. The latter in California, Detroit, and New York have included Republicans; yet the murals they commanded have been far more radical in symbolism than the works executed by radical American painters for the projects of the New Deal. . . .

What are the criteria of the revolutionary or even liberal character of a work of art or of its admittedly political content? Are these criteria to be found in the intentions of the artist or in the interests of the group who pays for the work?[19]

MEXICAN MURAL PAINTING AND THE MEXICAN STATE IN THE POSTREVOLUTIONARY PERIOD OF THE 1920s

What, then, was the relationship of Diego Rivera's "alternative modernist" murals to the official values of the Mexican government responsible for commissioning many of them? In short, what was the role of the Mexican Mural Movement in relation to the consolidation of the

national state during the 1920s and 30s? A common, yet hasty, view of this relationship is one that simply sees the murals as legitimating or representing official ideological values in Mexico. In a widely known and quite typical assessment along these lines, the Mexican poet Octavio Paz has contended that, while Rivera considered himself to be a revolutionary artist with Marxist views, that his murals in Mexico "were commissioned, sponsored and paid for by a government that was never Marxist and ceased being revolutionary. . . . [T]his painting helped to give it a progressive and revolutionary face."[20]

Yet no sooner has one restated this widely contested position, than one realizes that the very existence of a vigorous debate about the correctness of Paz's viewpoint clearly attests to the implausibility of it, at least in part. If Rivera's famous murals really only succeeded in generating legitimacy among the populace for the Mexican government, then we could not explain the prevalent position among many people that the murals, in fact, do otherwise, that is, that many people continue to respond to those elements in Rivera's murals that were *intended* to be a criticism of the government that paid for them.

If Rivera had only acceded in his paintings to the vision of José Vasconcelos, the Minister of Education from 1920–24, then Vasconcelos himself would not have disagreed so strongly with what many of the murals represented nor written so critically of their "negativity."[21] Similarly, if Rivera's murals in the National Palace merely generated legitimacy for Plutarco Elias Calles during *El Maximato* (The Period of the Maximum Leader) in the late 1920s and early 30s, then these murals would not have been closely identified with the forces of popular mobilization that clipped Calles's political wings in 1934–35 and led to the strongman's deportation from Mexico in 1936.[22] Nor should we forget that Rivera painted unflattering portraits in government buildings of both men as emblematic of reactionary forces, either while he was working for them or had done so only shortly beforehand.[23] Indeed, any serious look at the gap between the avowed intentions of the artist, the manifest values of the patrons, and the rather different set of views emerging from a mural's popular reception *alerts us to just how complex and still contested the meaning(s) of these murals by Rivera still are.*

Although it certainly gives official institutions an important role in trying to strongly influence the ultimate signification of artworks, patronage alone hardly endows the patron with unchecked authority or uncontested say in determining an artwork's meaning and ideological

deployment. The meaning of an artwork is a *site of contestation,* and never more so than when popular forces are mobilized, as they often were in the 1920s and 30s, against the policies of the government responsible for commissioning the public artworks. At least as important as the official line of the government patron has been the informal response by the public to the work and to the artist's avowed political position. Thus, the meanings of the monumental public murals by Rivera can hardly be reduced to the ideological needs of the Mexican state anymore than one can automatically assume that artistic intent alone matters.

As the various comments by Diego Rivera make clear, he knew that the meaning of his art was situated at the unsettled intersection of broadly contested interests both *within* a contradictory, nonmonolithic state and *between* this federal government and various popular movements periodically mobilized to influence its direction, sometimes with undeniable success. The final form of the powerful new nation-state that emerged in 1920 was by no means complete for over two decades, so that there was considerable space for maneuver within the public sphere. The violent upheavels from 1910–20 did not cause the national state in Mexico to have a single inexorable path of development. To the contrary, the less obvious but equally significant political and organizational struggles for power continued in a major way right up to the 1940s. Case in point was the armed and extremely dangerous counterrevolutionary insurrection in 1923–24 by the *hacendados* and church leaders allied to General Adolfo de la Huerta that was put down by the forces under the command of President Alvaro Obregón after considerable bloodshed with as many as 7,000 people killed in thwarting this right-wing insurgency. This counterrevolutionary uprising was aimed at stopping the ascension to the Presidency of Calles, who was seen as a major voice of the left and as one who was committed to consolidating the radical tendencies as represented by Article 27 in the Constitution of 1917. This provision, which was supported by Obregón and Calles but opposed by Carranza, permitted nationalization of private property, especially property owned by foreign companies. As such, it caused concerted United States-based opposition first to the Obregón Administration and then to the Presidency of Calles, until the latter was forced by the United States government to back down on its enforcement.[24] This change of position by Calles in the late 1920s is one of the many reasons that Rivera and other progressive artists would come to see him as someone who betrayed the revolution.

The dangerous counterrevolution of 1923–24 against the national government of Obregón and Calles was defeated only because the latter enjoyed massive popular support from two key working-class groups: the armed peasant militias under the former Zapatista leader Díaz Soto y Gama (who was then in the national legislature), and the "red battalions" composed of workers from the urban unions, particularly *The Regional Confederatión of Mexican Workers,* or *C.R.O.M.,* and the newly formed *Union of Mexican Workers, Technicians, Painters, and Sculptors,* which was then led by Diego Rivera and David Alfaro Siqueiros.[25] Nor should we forget that the definitive years for the emergence of the Mexican Mural Movement, 1922–24, were precisely the ones marked by these artists' alignment with the progressive struggle against the severe challenge of counterrevolutionary forces seeking a return to the old order before the revolution of 1910.

The nature of the Mexican federal state in the period from 1920–40 has been aptly described by James Cockcroft. To help us appreciate the unsettled, nonmonolithic, and dynamic character of this institution during these years, his analysis of the "corporativist state" in Mexico allows us to move beyond such cumbersome and overly reductive, categories as "the capitalist state" or "the socialist state," which have little or no power. Cockcroft's incisive summation of the Mexican state went as follows:

[T]he immediate post-revolutionary situation was one in which no major social class could assert total or clear-cut hegemony. . . . In such a situation, with no class or class fraction able to assert hegemony, the state emerged as a natural arbiter and central power. . . . Any recalcitrant bourgeois fractions could be broken, or at least disciplined [as was the case with the forces under Adolfo de la Huerta], by developmentalist and reformist currents within the state bureaucracy and national political party so long as the worker and peasant movements were not crushed.

But the use of the state as the key power resource, rather than the use of a single, united class (either the proletariat or the bourgeoisie), combined with the dependence of the Mexican economy . . . on external conditions . . . meant that there could be neither an independent "nationalist-bourgeois" industrialization program for autonomous economic development from above nor a thoroughgoing revolution from below.

The state could only introduce sufficient reforms to keep the class war under control. In the late 1920s and early 1930s, much of the countryside was engulfed in violence, with peasants engaged in a fierce war against the "white armies" of the *latifundistas*.[26]

Such a complex and never entirely centered corporativist state was not only a consequence of the ongoing negotiation of power, sometimes with violent means, among various classes and class fractions. It was also a result of center-left policies consciously pursued by President Alvaro Obregón from 1920–24.

Obregón's own non-Marxist and non-Bolshevik conception of "socialism" was one that saw the state as an instrument of national stabilization that both allowed the accumulation of capital by the private sector and also aided the working class as well as the peasantry in the defense of its interests. Obregón claimed that, "The principal purpose of socialism is to extend a hand to the downtrodden in order to establish a greater equilibrium between capital and labor."[27]

The very existence of such a situation in which no side enjoyed consistently unchallenged dominance meant that the possibilities of influencing the course of governmental development during the 1920s and 30s were far greater than most retrospective interpretations of the period would incline us to believe. *And, as Diego Rivera and the Union of Artists realized, one of the key sites in the public sphere wherein one could attempt to direct, alter, or contest governmental tendencies was in the domain of mural painting.* Although they were impacted by established governmental parameters, these murals were capable of playing a role in the structural formation of the government, such as when Rivera publicly allied himself through these paintings to the popular organizations that were periodically mobilized to influence state policy along left-wing lines. The most outstanding case in point, and one to which we shall return, concerns the radicalization of the Lázaro Cárdenas government through extragovernmental means from 1934–40.[28] Not surprisingly, Rivera's murals contain deep traces and even scars of the protracted popular struggle within this historical framework.

In an essay about John Mason Hart's *Revolutionary Mexico*, the novelist Carlos Fuentes observed that the "Mexican Revolution of 1910–21 was at least three revolutions" in one at roughly the same time.[29] The *first revolution* was the agrarian insurrection led by Zapata and, to a lesser extent, by Pancho Villa, which "favored a decentralized, self-ruling, communitarian democracy, inspired by shared traditions."[30] This

revolution was the one most deeply responsible for the reevaluation of non-Eurocentric, largely indigenous and popular-based cultural practices that became a prominent feature of *Indigenismo* after 1920.

The *second revolution* was allied more to the most enlightened sectors of the middle class (even as it was opposed vigorously by other sections of this same class). It was the "centralizing and modernizing revolution led by Francisco Madero, then by Venustiano Carranza."[31] This revolution was consolidated and shaped most by Obregón and Calles, "whose purpose was to create a modern national state, capable of setting collective goals while promoting private prosperity."[32]

The *third revolution* was an "incipient proletarian revolution" that was composed of landless urban workers in modern factories located in the cities. Its power came through such national unions as *Casa del Obrero Mundial* (The House of the World Worker) and the *C.R.O.M.*, which were alliances of self-governing unions that could marshall considerable fire power through armed "red battalions" and which generally sided with the urban oriented and modernizing project of the *second revolution* against the rural-based and communitarian *first revolution* led by Zapata and Villa. As a consequence of its alliance with the forces for modernization led by Carranza and Obregón, this "incipient proletarian revolution" proved to be the deciding factor in the defeat of the radically democratic, but largely agrarian, insurgency directed in its most progressive phase by Zapata.[33]

Yet, if the first revolution was strongly checked by 1920, it was not definitively beaten much less destroyed, as was demonstrated by its massive mobilization on behalf of the neo-Zapatista land redistribution program under President Cárdenas (1934–40) that saw over forty million acres of land in rural areas redistributed to almost one-third of the Mexican population by 1940. John Mason Hart concluded that "the masses made striking gains, [by] eliminating most of the vestiges of caste and archaic relations that still plague much of Latin America and [by] opening society up for public education and individual mobility."[34]

Where, then, did Diego Rivera stand with respect to this dense network of competing forces that included not one, but three different revolutions? *The answer is that Rivera championed a cause that had yet to emerge definitively,* that is, an alliance of *both* the first revolution of Zapata *and* the third revolution of the urban workers, against some — *but certainly not all* — aspects of the *second revolution* that was in favor of industrial modernization and capital accumulation. During periods of counter-revolution, Rivera strongly sided with the state government that originated

largely with the *second and third revolutions,* a state government that, in turn, commissioned him to paint murals which demonstrated the artist's paradoxical set of commitments, however unavoidable these competing commitments might have been.

Before leaving this portion of the book and moving on to a sustained analysis of Diego Rivera's murals during the 1920s and 30s, I should close by demonstrating just how interdependent the founding views of the Mexican Mural Movement were with the highly complex post-revolutionary situation sketched above. To do this we need to look no further than the celebrated text of the *Manifesto of the Union of Mexican Workers, Technicians, Painters and Sculptors* that was endorsed by Diego Rivera, David Siqueiros and José Orozco. This union was founded on December 9, 1923 and its manifesto was published in June 1924.

To reread this text in light of the abovenoted context of the fierce counterrevolution led by General Adolfo de la Huerta in 1923–24 is to gain a renewed sense of the manifesto's historical urgency and political contingency of its avant-garde and inventionary nature. Published in the Union's written forum, *El Machete* (which lasted form 1924–29 and in December 1924 became the official organ of the Communist Party with the demise of the artists' union), this manifesto both charted an artistic course and delineated a political trajectory. Commitment to one meant mobilization for the other. The manifesto was addressed as follows:

To the Indian race humiliated for centuries; to soldiers made into executioners by praetorians; to workers and peasants scourged by the greed of the rich; to the intellectuals uncorrupted by the bourgeoisie. . . .
On the one hand [there is] the social revolution, ideologically more coherent than ever, and on the other hand [there is] the armed bourgeoisie.

At this point, the *Union Manifesto* went on to call for a role in the struggle against the counterrevolution, with attention given to the cultural and artistic consequences of a victory by the ultraright in this armed struggle. The appeal of Rivera and others went as follows:

Because we are sure that victory for the working classes will bring a harmonious flowering of ethnic art, of cosmological and historical significance to our race, comparable to that of our wonderful autochthomous civilizations, *We will fight tirelessly to bring this about.*

Victory for Huerta, Estrada, and Sánchez will be, aesthetically and socially, a victory for a bookkeeper's taste; *criollo* and bourgeois [values] . . . the reign of the "picturesque," the United States "kewpie doll." . . . The counter-revolution in Mexico will, as a result, prolong the pain of the people and crush their admirable spirit.

The members of the Painters' and Sculptors' Union have in the past supported the candidacy of General Plutarco Elias Calles because we believed that his revolutionary fervor, more than any other, would guarantee a government that would improve the conditions of the producing classes in Mexico. . . . [We] put ourselves at the service of his cause, *the cause of the people*. . . .

[W]e urgently appeal to all revolutionary peasants, workers and soldiers in Mexico to understand the vital importance of the impending battle and, laying aside tactical difficulties, to form a united front to combat the common enemy.[35]

DIEGO RIVERA AND THE INCEPTION OF
THE MEXICAN MURAL MOVEMENT IN THE 1920s

As part of his commitment to popular literacy, the center-left revolutionary leader and President-elect, Alvaro Obregón, appointed José Vasconcelos as Minister of Education in the summer of 1920, not long after the previous and less progressive President Carranza was assassinated for trying to keep Obregón out of power. Earlier, while still the Rector of the National University of Mexico, Vasconcelos had urged Rivera (through the Mexican Ambassador to France, Alberto Pani) to go to Italy in order to study the public art of the Renaissance. In fact, Rivera had already refused to return to Mexico in 1918 to paint for the centrist Carranza Regime at a time when it was still fighting (with David Alfaro Siqueiros in its ranks) against the forces of Zapata and Villa. (Zapata was assassinated by an agent of Carranza in April 1919 and Villa was shot by an agent of Huerta in 1923.) About this moment in history, and his subsequent decision to return to Mexico, Rivera stated that "The landlord dictator, Venustiano Carranza, had been overthrown by the peasants and the workers who supported Alvaro Obregón."[36]

Rivera did go to Italy for seventeen months where he made 300 sketches of major works by Giotto, Ambrogio Lorenzetti, Mantegna, Uccello, Piero della Francesca, and Michelangelo.[37] Meanwhile, José Vasconcelos initiated a popular educational program that, despite the harsh economic

situation in 1920, would see the rate of literacy rise notably from 15% to 25% nationally. By the end of the Cárdenas Administration, this latter rate would be almost doubled through further educational reforms.[38] As part of this nationwide and federally funded literacy campaign, Vasconcelos planned to sponsor a public mural program. An exceedingly eclectic thinker who considered himself a neo-Pythagorean, Vasconcelos shared with Rivera both a strongly antipositivist conception of history and an unswerving commitment to popular literacy.

Although a centrist politically speaking, Vasconcelos was evidently influenced by the educational programs of Anatoli Lunacharsky, the Soviet Commissar of Education and friend of Diego Rivera from his Parisian days.[39] Accordingly, Vasconcelos established three new departments within the Ministry of Education: a national school system (before there had been only regional schools); a new national system of libraries; and, a National Fine Arts Program. Quite characteristically, Vasconcelos originated the program of publishing very cheap "people's editions" of Plato, Cervantes, Dante, and Homer.[40]

The first mural program to be commissioned by Vasconcelos and the Obregón government, however, did not lead to a very auspicious beginning for the program. The commission went to Roberto Montenegro (who was assisted by Xaviér Guerrero, Gabriel Fernández, and several others) for murals in the former Jesuit Church and Convent of St. Peters and Paul in Mexico City. The results of this project, which lasted from early 1921 to August 1923, were "genteel universalist allegories" that in no way pointed towards the impending storm in the visual arts.[41]

It was this promising, if not unproblematic, situation to which Rivera returned went he left his first wife, Angelina Beloff, in June 1921 to return to Mexico. Upon his arrival in July, Rivera was struck by the "inexpressible beauty" of Mexico and felt as if he were "being born anew."[42] While working several short-term jobs for the government and in a publishing house, he finished a study for a depiction of Zapatistas along with some portraits and genre paintings.[43] At the invitation of Vasconcelos, Rivera traveled in November 1921 to view the pre-Columbian sites of Chichen Ítza and Úxmal. This trip was notable not only for the opportunity it provided to study archaeological sites, but also because it permitted Rivera to see firsthand the *ligas de resistencia* (leagues of resistance) of armed campesinos in the State of the Yucatán that was then under a dynamic socialist governor named Felipe Carrillo Puerto. (Carrillo Puerto, who would be assassinated by counterrevolutionary forces allied to Huerta in

January 1924, would later be portrayed as a revolutionary martyr by Rivera both in the Ministry of Education and in the National Palace.)

Roughly six months after Rivera had been in Mexico, Vasconcelos made the fateful decision to commission him to do a mural in the elite *Escuela Nacional Preparatoria* (National Preparatory School) where Vasaconcelos had been a dissident student during the Díaz dictatorship. The most formidable and sought after of the initial sites in this building complex of the late Baroque mid-eighteenth century *Colegio de San Ildefonso,* was the new 900 seat Bolívar Auditorium *(Anfiteatro Bolívar)* that had been built between 1902 and 1908. It was this key site that was awarded to Diego Rivera by Vasconcelos.

Creation (Figure #6), as Rivera's resulting mural was named, was executed in the unusual medium of gold leaf and encaustic (and under the influence of Delacroix's murals in Saint Sulpice, as well as of Dr. Atl's usage of this medium). It was executed on the principal wall and niche of the theater's proscenium above the dado. The various figures or personifications are more than lifesize at around twelve feet in height, with the overall proportions of the work being approximately 4.36 x 5.85 x 2.75 meters resulting in a total surface area of 109.64 square meters.[44]

The general theme of the composition is genesis and it features a post-revolutionary, if also rarefied, allegory about "The Emergent Man" (or "The New Person"). The overall ensemble was intended to be a visual exposition of the ideas peculiar to Vasconcelos's own eclectic synthesis of Judeo-Christian thought with neo-Pythagorean philosophy, which had earlier been the subject of a book by Vasconcelos.[45] At the top of the proscenium arch is a neo-Byzantine symbol for "Primal Energy" or, as Rivera himself called it, "light one," which is a deep blue sky disk with stars and sunrays, all of which is crisply framed by a rainbow arc. Three half-closed hands point outward from the sky disk, with the folded fingers signifying the "father" and "mother" as the symbol of origins, along with the Pythagorean notion of the duality of life.[46] Within the sky disk are two constellations, a hexagon formation of stars on the left symbolizing the feminine principle, and a pentagon configuration on the right denoting the masculine principle.[47]

Below, in the niche, there is the "Emergent Man" or "New Person" who, as Rivera himself wrote, has the torso of a "hermaphroditic man" and represents "an entity prior to masculinity and femininity." This particular reference recalls the discourse of Aristophanes on gender and eros in Plato's dialogue *The Symposium.*[48] This figure also has a

Pantocrator-like look and recalls the agonistic theme of sacrifice for those who follow.[49] Beneath this quasi-religious human are the standard Christian symbols for the four Evangelists, Matthew, Mark, Luke, and John, namely, an ox, a lion, an eagle, and an angel. This same area features tropical flora that Rivera added after a brief sketching trip that he made to Tehuántepec (the home region of Vasconcelos) in December 1922.

On either side of the proscenium, above the seated Masaccio-esque figures and mestizo couple of Adam and Eve, ascend abstract symbols of the various virtues and creative forces that sustain humanity, according to this school of thought. Organized hierarchically in keeping with a Judeo-Christian and Classical heritage, these two fairly symmetrical groups on each side represent, respectively: "Emanations of the Spirit of Woman" and "Wisdom" (on the left); "Emanations of the Spirit of Man" and "Science" (on the right). See the diagram below of this iconographic program.

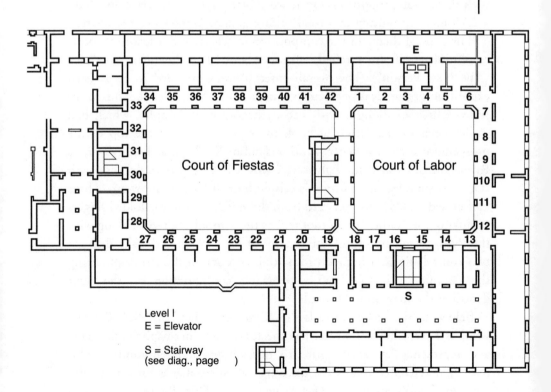

The seven figures below *Wisdom* — whose hands are indicating the symbols for the macrocosm and microcosm — are *Dance, Music, Song, Comedy, Charity, Hope, and Faith,* the most striking of which is *Dance.* She is a woman from Michoacán wearing a cream-colored tunic whose rhythmic movements impart a sense of understated movement to an otherwise calm, even static, group. Of the nine figures below *Science* — *Fable, Knowledge, Erotic Poetry, Tradition, Tragedy, Prudence, Justice, Strength, and Continence* — the most notable figures is *Strength,* who leans stargazingly on the edge of a bright shield that is carmine red, bordered with vermilion, and contains a golden sun in the center of it. As is true of other figures in the mural, this personification has eyes that seem to be modeled on those of Rivera's second wife, Guadalupe Marín (whom he met in 1922 while working on the painting). The shield signifies divinity and the dagger connotes defense against temptation.[50]

In sum, the metaphysical character of the iconographic program of *Creation* seems to embody fairly well Vasconcelos's philosophy, based on the "fusion of racial strains" that would be elevated through education and art, by means of the "practice of virtues taught by the Judeo-Christian religion, and the wise use of science to control nature" and, thus, "lead Man to absolute truth."[51] Furthermore, the emphasis on metaphysical truth *along with and not in opposition to science* (which is quite unlike the view of positivists for whom science was supposed to be the enemy of all metaphysics and subjectivity) was clearly meant to be a critique, as Stanton Catlin has observed, of the positivistic Díaz-era mural by Juan Cordero. Entitled *The Triumph of Science and Labor Over Ignorance and Sloth,* this academic wall painting had formerly been in the stairway of the same National Preparatory School during the student days of Vasconcelos.[52]

Because these philosophical views were more those of Vasconcelos than of Rivera, the muralist later declared the work to be unsuccessful both in execution because the use of encaustic proved to be unsatisfactory and in the "sentido interno" (internal sense), which he found far too Eurocentric in ideological terms.[53] Also the visual language for this mural, which was consecrated on March 9, 1923 to qualified public approval, is a common one for late Symbolist art or early Art Deco, with its schematic inclusion of neo-Medieval and neo-Byzantine elements.

The work itself is characterized by a broad color range featuring the resonant use of primaries (red, blue, yellow) and various tertiary as well as secondary colors derived from them. The frequent use of large flat passages of unmodulated color, as in the shield of *Strength,* along with

the regularized archaic-looking Greek drapery folds, is combined with a hieratic stance for some of the figures that in turn is connected to the early Byzantine mosaics by Ravenna that Rivera admired. Yet, for all the technical and formal resourcefulness with which it was done, the mural ultimately showcases a nonpolemical, bloodlessly abstract "universalism" that was situated along the lines of Vasconcelos's static philosophical abstractions and disconnected from the lively historical predicament of postrevolutionary Mexico in the 1920s.

Similarly, for all its supposed emphasis on the concept of the "New Person," this mural was really about old world cultural values with few, if any, innovative links or organic connections either to the popular forces responsible for the Mexican Revolution or to Rivera's own far more militant political views that had led him to join the Communist Party in late 1922 and to be a founding member in 1923 of the Artist's Union.[54] Conversely, while Rivera was dissatisfied with the mural (as he wrote in an article of 1925) and so-called "polite society" was begrudgingly approving of it, the Minister of Education was quite pleased with this allegorical painting.[55] Consequently, Vasconcelos gave Rivera a commission that allowed the painter much more latitude, to the increasing chagrin of the Minister himself. When allowed such an opening, Rivera made a radical left turn that was driven by insurgent ideals and also produced a staggeringly original group of murals that would quickly become *the* pivotal cycle in the 1920s for modern art in the Americas.

THE MURALS FOR THE MINISTRY OF EDUCATION
(1923–28)

These murals were commissioned for the imposing new *Secretaria de Educación Pública* (Ministry of Public Education) that was designed by architect Frederico Méndez Rivas and completed in July 1922 as the national center of the new federal system of education begun by the Obregón government. On March 23, 1923, Rivera began work on the walls of the east patio, the Court of Labor. (See the floor plan of the Ministry on the following page.) The entire project of 117 fresco paintings covering 1,585.14 square meters on all but one of the three stories of each courtyard, the Patio of Labor and the Patio of Fiestas, plus the stairway, would take Rivera over four years of prodigious labor (1923–28), sometimes entailing as many as eighteen hours in a day.[56]

1 Primal Energy

	11 Wisdon	22 Science	
Emanations of the Spirit of Woman	10 Faith 9 Hope 8 Charity	21 Continence 20 Strength 19 Justice 18 Prudence	Emanations of the Spirit of Man
	7 Comedy	17 Tragedy 16 Tradition	
	6 Song 5 Music 4 Dance	15 Erotic Poetry 14 Knowledge 13 Fable	

3 Woman 12 Man

2 Emergent Man

The iconographic program first suggested to Rivera by Vasconcelos for these murals was high-minded and anodyne. It was the unduly genteel theme of women wearing picturesque costumes from the various regions and states of Mexico. Yet, both the major upheavals of 1923–24 in Mexico and the militancy of Rivera on the international and national front conspired against, indeed overwhelmed, Vasconcelos's cautious iconographic program. In fact, by 1924 Vasconcelos himself, owing to differences with the more left-leaning leadership of Obregón, felt compelled to resign his position as Minister of Education. In the end, he strongly disapproved of the murals that Rivera executed for the Ministry of Education, as we shall later see. Furthermore, in 1928, Rivera even included a parody of Vasconcelos's quaint "exoticism" and abstruse "orientalism" in the panel *Los Sábios* (The Wisemen), a scene that also contained a criticism of positivism.[57]

The liberality of Vasconcelos as Minister of Education meant that Rivera was, at times, given virtually *carte blanche* to compose the themes and to forge a visual language appropriate for them. The result, as is now widely recognized, was an epic look at the popular classes in Mexican history and beyond. In audacity, range, and originality, Rivera's murals for the Ministry of Education far exceeded anything that could ever have been directly sanctioned by the patron's rather diffident plans for the mural cycle. How all of this could have happened is something to which we shall return later.

After having worked on the murals for around two years, Rivera published an article about them in the September 1925 issue of *El arquitecto* in which he both defined *art as a form of labor and identified labor as one of primary themes of his art*. In addition, he linked his own *"trabajo cómo una obra revolucionaria"* (artistic labor as a revolutionary work) to a vision of the future that was allied to popular art forms in the life of the people ("el pueblo") during a process of social renewal.[58] His depiction of the daily life, including the quotidian dress, of the popular classes led him to thematically treat various labors of the peasantry and urban workers, along with their struggles for social justice and celebrations of popular festivals. He also showed some of the roadblocks confronting their drive to change society's hierarchical structure.

The theme of these murals in the Ministry of Education ideologically coupled a representation of the first, or agrarian revolution, of Zapata with the third, or proletarian revolution, of the "red battalions." Ironically enough, it was an embattled state emerging from the ascendancy of the

second, or economically modernizing, revolution led by Obregón and Calles that uneasily financed and halfheartedly embraced the huge cycle of murals by Rivera in the Ministry of Education. That such a situation of patronage occurred tells us much about how weak this new national state was and how necessary it was for this state to draw on the more radical forces of the first and third revolutions to withstand the grave threat that it faced from the ultra-right-wing army of the old order in the mid-1920s.

The liberal patronage under Obregón and Calles was a direct consequence of a need to orchestrate a new united front of the entire left at a critical moment in the early life of the postrevolutionary state. A range of viewpoint was unavoidable in such a situation, since this guaranteed a public space in which allies on the left could have room to maneuver even to the extent of criticizing leaders of the very same government that commissioned the public art in these years. The price of this broad, at times even unwieldy, united front of often competing forces was considerable tolerance for criticism by some sectors in certain public spheres. It is highly instructive to recall here that Rivera's murals in the Ministry of Education from 1923–28 became more and more critical, as well as polemical, at precisely the moment in history when his mushrooming international fame made it ever more difficult for the Mexican government to destroy these artworks without embarrassing itself on the international front.[59]

The first set of murals that Rivera executed, the eighteen main panels on the ground floor in the Court of Labor entitled "Labors of the Mexican People," start at the north end of the crossing and move clockwise around the courtyard. Depicting various aspects of physical labor, the subjects of these panels are based on the agricultural, industrial, and artisanal economies characteristic of Mexico's diverse regions. Throughout attention is given to anonymous people engaged in popular cultural practices.

The first six panels on the north wall focus on the people and production in the state of Oaxaca, with special emphasis being given to the *Tehuánas,* the impressive women of a matriarchal society near the Southern Pacific coast on the Isthmus of Tehuántepec. Rivera's celebratory representations go much beyond the folkloric peculiarities of official *indigenismo* to highlight the combative cultural resistance by this indigenous community to exploitative conditions such as those depicted in the sixth panel, *The Sugar Factory.* As Alberto Híjar has noted, the

result is a type of dissident, or alternative *indigenismo* (Indianism), that was much more allied to the unfinished project of self-determination by Native Americans and in line with Rivera's own radically democratic politics, than it was with the vague ideals of ethnic unity put forth by government officials like Vasconcelos.[60]

The next six panels, those on the east wall, are among the earliest and the most celebrated, along with being among the most groundbreaking. Furthermore, the accompanying texts include four overdoors that feature poetry in Nahuatl (the language of the Aztecs) that, in turn, remind us of Rubén Darío's early *modernist* claim that "if there is a poetry in our America it is to be found in the old things."[61]

Interestingly enough, the first major controversy to engulf Rivera's work resulted from one of the modern texts that in 1923 he incorporated into the panel *Leaving the Mine* (4.78 x 2.15 meters). The offending lines were originally painted over the mine's exit and they came from a poem by the socialist writer Carlo Gutiérrez Cruz, and went as follows:

> *Campañero miner,*
> *Bowed under the weight of the*
> *earth,*
> *Thy hand does wrong*
> *When it extracts metal for money.*
> *Make daggers*
> *With all the metals,*
> *And thou wilt see*
> *How after, all the metals*
> *Are for thee.*[62]

Like his father before him in Guanajuato when the elder Rivera defended miners in a conservative city, Diego found himself in the middle of a firestorm of controversy with some people demanding the complete erasure of these paintings when these lines were published in the conservative newspapers of Mexico City.[63] At this point, Vasconcelos pleaded with Rivera to eliminate this verse, claiming that the paintings were problematic enough for many people without the incendiary lines being included. The Artists Union met and decided that the panel was sufficiently strong without this poetic "call to arms," and supported Rivera in acceding to Vasconcelos's request. One of the artist's assistants then smashed the offending lines off the wall and Rivera repainted the timbers

at the mouth of the mine.[64]

In the next panel, *El Abrazo* (The Embrace), Rivera incorporated more verse by Gutiérrez Cruz on a rock in the foreground of the panel (Figure #7). These lines, while not calling for the armed overthrow of industrialists, urged the industrial worker and the peasant laborer to join in a fraternal embrace of solidarity. Thus fortified, it claimed, they could control the fruits of their own labor.[65] Although controversy flared up again, Rivera was not forced this time to eradicate the provocative lines in question.[66]

Of all the paintings in the Ministry of Education, few are more justifiably famous than *The Embrace and Seated Campesinos* (Figure #7). Here, Rivera arrived at an entirely new stage in the conception of an "alternative modernism" that deftly synthesized the diffused lighting and figurative elements of proto-Renaissance mural painting with the distinctive dress and two-dimensionality of pre-Columbian fiber arts and subsequent popular culture. In addition, he fused these two visual traditions, which are crisply articulated by means of an unerring neo-classical line, through a "collaged," or "montage," spatial configuration that derives, in part, from Cézanne and Cubism (as in the cityscape of the overdoor). The visual language that emerged from this broad transcultural synthesis was one of sophisticated simplicity. In terms of graphic design, it is highly intelligible visually and acutely intelligent historically.

The Embrace is a painting of warmth yet one without sentimentality, since it is a mural of quiet dignity and one of understated emotional resonance. Particularly noteworthy for the graphic design is the stark contrast between the generally high value of the yellow ground and the low intensity of the somber earthy tones that sit upon it. Consequently, there is a superb effect of silhouetting that enhances the tautness of the tightly arranged composition as a whole. The dark, almost slate-like, gray of the sky, which is a telling foil for the yellow ground, clearly derives from the sky in Ambrogio Lorenzetti's *Allegory of Good and Bad Government* (which is a work that would also be directly influential on Rivera's murals at Chapingo).[67]

The remarkable semi-Cubist city in the center of the background aptly underscores the geometric affinity between proto-Renaissance space (such as is in Ambrogio Lorenzetti's work) and the post-Renaissance space of early modernism (such as in the later paintings of Cézanne). Nor is it by chance that Rivera arrived at his variant of alternative modernism by

drawing both upon precolonial European art (when the Renaissance concept of one-point perspective had not yet been invented) and post-colonial European art (when linear perspective and the linear conception of history had begun to be undermined in the early Cubist paintings of Picasso and Braque).[68] In contesting the hegemony of perspectival space while, nonetheless, containing references to the national landscape, Rivera's *The Embrace* also recalls his own Anáhuac Cubism of the teens.

As one moves from *The Embrace*, with its invocation of unity among workers from both rural and urban areas, one sees several panels after it that represent, in rapid succession, both the barriers to such advances — as in *The Foreman* or *La Cápataz* (4.78 x 2.13 meters) — and the rough-hewn nobility of those who struggle against these repressive forces — as in *Liberation of the Peasant* or *Liberación del Peón* (4.38 x 3.48 meters) and *The Rural Schoolteacher* or *La Maestra Rural* (4.38 x 3.27 meters). The latter work is considered to be among the most beautiful of all the panels in the Ministry.

With its limited but deeply resonant color range, that includes an extended caramel ground (somewhere between cadmium yellow and yellow ochre) that throws all the figures into striking relief, *The Rural Schoolteacher* (Figure #8) demonstrates how the use of understated color interaction in order to accentuate the graphic design manifests pictorial values in keeping with the visionary ideological concerns that mark this work. The ovoid shapes of the campesinos encircling the teacher seem to derive simultaneously from Giotto's distinctively volumetric figures and also from the deftly nuanced, but largely monolithic, forms of Olmec art.[69] As such, these simple formations of campesinos visually anchor the foreground somewhat off-center.

From the exquisitely silhouetted bust of the teacher one moves visually to the alert and also off-center mounted guerrilla whose vertically projecting rifle and head are thrown into relief in a splendid manner. At first moving from bottom right to upper left, the spectator's vantage points then planes-off and quickly recedes back into a lean, even austere, background for which two clusters of laboring campesinos provide spatial cues and the promise of plenitude. Quietly dynamic, calmly militant, austerely sensuous, and earthly visionary, this mural is a monument to popular mobilization and a masterpiece of the multicultural populist modernism that he would originate at the Ministry of Education.

If the pictorial logic of *The Rural Schoolteacher* is compelling, the extra-

aesthetic signification of the painting was no less moving in the mid-1920s. Literacy was a major issue of self-empowerment at this time motivating the consolidation of one of the key concerns that had triggered the agrarian Revolution of 1910 (along with the issue of land redistribution at a time when 97% of the population was landless and 80% worked for only 20,000 haciendas).[70] Before the Revolution of 1910, national literacy stood at only 16%.[71] This fact helps us to grasp the historical importance of the founding of the very Ministry of Education in which Rivera's murals were being painted.[72] To grasp the potentially revolutionary meaning of Rivera's *Rural Schoolteacher* of 1923, we need only consider the following assessment of the 1920s and 1930s in Mexico:

> In the countryside, the peasants organized themselves into unions and agrarian leagues, constantly pressuring the state for agrarian reform and for arms to defend themselves against the *hacendados'* hired gunmen. Obregón and Calles sought to bring the peasants under their tutelage by granting the demands of some of the more militant villages and by tying them in to a system of state credits for seeds, fertilizers, and tools. On the other hand, they launched attacks on more independent groups. . . .
>
> *Often the peasants' only allies in demanding implementation of agrarian reform were . . . the schoolteachers, more than 200 of whom were shot down by the large landholders' hired* pistoleros [my italics].[73]

It was precisely the gender of this schoolteacher and the interventionary role of Rivera's mural in the 1920s that allowed art critic Raquel Tibol to describe *The Rural Schoolteacher* as a test case for the programs on behalf of social reconstruction in the postrevolutionary period.[74] This was Rivera's first painting in which women assumed a fundamental task in the consolidation of revolutionary programs and on behalf of their own changing position within Mexican society. Furthermore, as Tibol has observed, Rivera was no doubt influenced in his interpretation of this theme by the trip to Mexico in the spring of 1921, at Vasconcelos's invitation, of Gabriela Mistral, the celebrated Chilean author who would later win the Noble Prize in Literature. And, in fact, Rivera did illustrations for Mistral's "El poema de la madre" (The Woman Poem), which was published in Mexico City in the October 1921 issue of *Maestro, Revista de Cultura Nacional* (The School Master: Review of the National Culture). While visiting in Mexico and observing the more active postrevolutionary

role of women in education, Mistral declared that, "The Mexican school program corresponds almost totally to my ideal of education for women *de nuestra raza* (of our ethnicity)."[75]

In ending the smaller Court of Labor cycle on the first floor with a panel about industrial labor; *The Foundry: Pouring the Crucible* (4.38 x 3.16 meters), Rivera recapitulated the idea of the harmonious — and historically uneven — coexistence of urban industry with artisanal work, rather than a view of the simple supercession of one by the other in a linear progression. Thus, he reinforced the theme of *The Embrace* (Figure #7) and its conception of a future social order more equitable than the one of the 1920s. Rivera did not see himself as a mere passive chronicler of this envisioned unity, but as an active participant in its formation. This point was made several years later by Rivera in a way that reaffirmed the sense of shared public values that he first confirmed in this iconographic program for the Ministry of Education:

> For me, the artist is a worker, and unless he expresses his work as a worker, he is not an artist. I must remain with the people. . . . By worker I mean anyone who contributes physically or mentally, I do not discriminate. Perhaps, though, I do mean especially the ones who create with their hands.[76]

Rivera executed the murals for the second floor of the Court of Labor, the "Intellectual Labor" series, at a particularly difficult moment when government funding (that had always been modest at best — Rivera earned the equivalent of $2.00 per day) was suspended for virtually all the artists, which led to the collapse of the Artists' Union in December 1924. Rivera somehow managed to convince the new Minister of Education, Manuel Puig Casauranc, who replaced Vasconcelos in late 1924, that his mural commission and that of his assistants Pablo O'Higgins, Xaviér Guerrero, Alva Guardarrame, and Máximo Pacheco should be extended.[77]

The twenty *grisaille* personifications on this second level of the Court of Labor represented intellectual and scientific work as a compliment to the manual labor on the first floor. Rivera felt that it was necessary to employ *grisaille* in a false base relief harmonized with the tone grey, owing to the dimensions and transitional look of this arcuated mezzanine loggia. He felt that "it was not possible to use color, since this would have debilitated the idea of resistance and also the appearance of the structure."[78]

This series was thus designed as an intermediary, simulated architectural frieze of individually framed "sculptural" reliefs.

Significantly, both here and on the third level of the Court of Labor where *grisaille* figures are painted in some but not all of the panels, there is the recourse to an "alternative *indigenismo*." Scenes of modern science, as in *La química* (Chemistry), are balanced with scenes of ancient pre-Columbian science, as in *La geología* (Geology), so that one is denied a monodimensional sense of linear historical development in science from so-called "pure" non-Western superstition to "pure" Western science. Rather there is more a complex sense of science as the collective achievement of both non-European and European cultures, which attests to a view of historical development as multilateral and uneven. As Stanton Catlin has observed, the series of twenty panels on the second level of the Court of Labor can be "seen as a scientific-industrial-socialist 'zodiac' " that was also meant to function as a foil to the real sculptural reliefs representing Plato, Buddha, Bartolomé de las Casas, and Quetzalcoatl, which face the courtyard.[79]

The twenty-one fresco panels on the third level portico of the Court of Labor were painted in 1928 and entitled "The Apotheosis of the Mexican Revolution." For some of the panels Rivera again used *grisaille* personifications in a hybrid, or *mestizaje,* visual language that is at once neo-Egyptian, neo-Toltec, neo-Mesopotamian and quasi-Archaic Greek, even as it exemplifies what has come to be called "Art Deco." Two particularly good panels in this manner are the personifications for the visual arts, *Painting* (2.05 x 3.35 meters) and *Sculpture* (2.07 x 3.26 meters). The former features an artist presented in a combination of frontal and profile views that are distinctly Egyptian in character, flanking cleanly demarcated shapes representing the cone, the cylinder, and the sphere. The inclusion of these elemental shapes reminds us that Rivera later spoke of how his teacher, Santiago Rebull, used to quote from Plato's *Philebus,* regarding "the forms that architects draw and construct: the cylinder, the cone, and the sphere."[80]

On this third floor, there are also five imposing panels in color among those smaller ones in *grisaille.* Three are on the north wall and they are sober portraits of revolutionary martyrs: Felipe Carrillo Puerto, Emiliano Zapata, and Otilio Mantaño (the author of the Plan de Ayala and the chief theoretical advisor to Zapata in the commune of Morelos). All three are painted in an hieratic, resolutely symmetrical, and uncompromisingly frontal manner, in keeping with the schematic folds of drapery à la archaic

Greece. An ovoid mandorla in a neo-Byzantine style gives each of them a sanctified quality as befits heroic icons for the revolutionary cause.

In many respects, the best antecedents for these portraits are the great portraits of revolutionary martyrs during the Revolution of 1789 in France that were done by Jacques Louis David, especially his depiction of the martyred Jean-Paul Marat. (It is also worth mentioning that Rivera's teacher, Santiago Rebull, painted a portrait of Marat's martyrdom at one point.)[81] As is the case with David's portrayal of Marat, Rivera's portraits of Carrillo Puerto, Zapata, and Montaño feature a tonic austerity and an almost iconoclastic stringency that render the panels as uncompromising in countenance as they are revolutionary in commitment.

Complimenting these three portraits on the north wall is a large allegorical painting that re-imagines the future in visual terms that are in keeping with the visionary position shared by these fallen heroes. *Fraternity (La Fraternidad)*, at 2.04 x 6.46 meters, is the largest painting on the third floor. It is an "allegorical presentation of the theory of the mutual interests of these two sectors" that shows a rural worker, or campesino, shaking hands with an industrial worker under the outstretched arms of an Apollonian "New Person" who represents the genesis of new people based on working-class concordance — a projected concordance that was first depicted on the ground level in the panel entitled *The Embrace*.

Rivera's imposing contribution to the larger Court of Fiestas in the Ministry of Education was, however, not as complete. He did twenty of the twenty-four main panels on the first level (two each were done by Jean Charlot and Amado de la Cueva) and none on the narrow intermediary second level (which consists of the escutcheons of the various states of Mexico, except for Baja, California, that were done by Charlot, de la Cueva, and others). Nonetheless, Rivera did execute all twenty-six panels on the top level of the Court of Fiestas between 1926 and the end of 1928, after interrupting his work on them with a nine-month trip to the Soviet Union in 1927–28 that would notably impact the panels done after his return.

The twenty panels by Rivera on the ground level represent the popular festivals, both religious and secular, which Rivera saw as communal celebrations that carried on the ritualistic lineage of the ancient Mexicans. In a way that was analogous to his own sense of his artistic practice as a constitutive force in society, these rituals, or cultural practices, were depicted as progressive *social bonds* that, as the contemporary Peruvian thinker José Carlos Mariátegui was also saying of popular religious values

in his writings of the 1920s, could function as means both for critically reevaluating the past and thoughtfully reconstructing the present along more equitable and socially just lines.[82] In this Court of Fiestas, as in his other cycles, the panels facing north and south are coordinated with the cardinal points of the compass so as to place the depictions of festivals in a position that faces the exact direction of the region in Mexico from which each festival comes.[83]

This idea of using an iconographic program oriented to cardinal points was derived from Aztec codices. It also reminds us that in the stairway of the Ministry of Education Rivera produced the first archaeologically correct depiction of a pre-Columbian deity in modern art.[84] This is his evocative representation of *Xochipilli*, the Aztec Prince of Flowers and the God of Dance, who is shown in precisely the same pose that he assumed in the surviving Aztec statue of him from between 1200 and 1500 A.D.[85]

Among the most noteworthy of Rivera's paintings on the first level of the Court of Fiestas are the nine panels on the south wall that focus on the popular festivals of north central Mexico, specifically, the corn harvest and the "Day of the Dead."[86] The large three panel sequence at the center of the series, *The Distribution of Land* (4.15 x 2.38 meters; 4.15 x 2.38 meters; 4.15 x 2.38 meters) commemorates the call to restore the Indian communal lands, or *ejidos,* that had been a major demand of the Plan de Ayala and which had also reemerged in a different form in the Constitution of 1917 at the insistence of forces allied to Obregón.[87]

In this large painting of land redistribution, one sees wave after wave of campesinos attending a meeting at which Otilio Montaño gestures with outstretched hand on the right, while Zapata is almost hidden from view in the lower right-hand corner. Compositionally it is important that the two most notable leaders in the work are so unimportant. As such, they are denied the type of heroic isolation and hierarchical significance that came to distinguish depictions of Lenin or Stalin by "socialist realist" painters in the Soviet Union from the late 1920s onward. Just as the theme of Rivera's painting is about equality, so the composition itself is also egalitarian in its disposition of formal components. As Rivera's biographer Bertram Wolfe noted, Rivera's paintings were genuinely influenced by the Russian Revolution and quite at odds with the official Russian images of this event that prevailed after 1932:

Only after the Russian Revolution could this history [by Diego

Rivera] of Mexico have been conceived, although ironically, nothing like it could be painted in the land where the revolution occurred. In the Soviet Union, "revolutionary painting" consists of glorified Lenins towering larger than life over obedient and worshipful humanity . . . or of bemedaled Stalins looking like Gulliver in the midst of Lilliputians. . . .[88]

The most acclaimed of the adjacent paintings is *Day of the Dead — The Offering* (4.15 x 2.37 meters), which is celebrated on November 2nd in the cemeteries of Janitzio, Mixquic, and other places of the Republic (Figure #9). It is in this work that, as Justino Fernández has observed, "the lesson of Cubism" has been most self-consciously accommodated in the Ministry murals. The shallowness and all-over quality of the space, despite the scene's location outside, in conjunction with regularity of the orange arcs that rhythmically tie the work together, gives it a sense of the repetitiveness of ritual that is further underscored by the somber palette and half-illuminated figures compacting the picture throughout. Visually centering the work in the upper register is a type of crucifixion that recalls the famous *Cruz atrial* (Atrial Cross) at Acolman, which evolved from an integration of indigenous sculptural elements with images of Christ's Passion.[89]

The third floor walls of the Court of Fiestas go from rituals that communally bind to struggles that collectively unite. The symbolic celebration of community through carnival, with its playfully subversive intent to turn the existing order upside down through parody gives way to the sober commitment to rearranging society through armed insurrection.[90] Rivera's remarkable idea of using the textual format of a *corrido,* a popular musical ballad for transmitting news through song and verse to mass audiences, to accent the panels thematically was a noteworthy artistic innovation for a monumental framework. To a considerable extent, Rivera attempted the transposition of the sensibility of the *corrido,* which is at once sentimental and satirical, as well as tendentious and ironic, into visual terms assumed to be analogous to the oral tradition for relating history along popular lines.

Characteristically, Rivera actually combined three different *corridos,* which were about rural guerrillas and urban proletarians. He began with verse from a ballad about Zapata, then added to it the best stanzas of a ballad by José Guerrero on the Revolution of 1910, and then, subsequently, placed before both of these fragments of *corridos* another

corrido by Martínez entitled *"Así Será la Revolución Proletaria"* (In This Way Will Be The Proletarian Revolution).[91] Rivera painted the lines of the three *corridos* in black on a bright red band over a gray ground, with the ribbon, or banner, rising and falling in graceful festoons that accent in verse the architectonic rhythms of the arcades, all of which imparts a convivial ballad-like quality to the serious business of painting revolutionary insurgency. The lines of the ballad go as follows:

"In This Way Will Be The Proletarian Revolution"

The sound of workers' voices rude,
Hoarse and full and strong
From many-throated multitude,
Rings out our freedom song.

Of slavish growth we've cleared
 the ground
And burned the evil weed.
Now with our song the fields
 resound
As we plant a better seed.

We fought until our cause was
 won,
A fight that none could shirk
Now, if he'd eat, the idle drone
Will have to go to work.

Now mines and mills without a
 boss
Are by the workers run.
Nor do we have to "mourn our
 loss,"
As better work is done.

Now to him the earth is free
Who works it with his hand.
Gone is the age-old misery,
For all who wish there's land.

The freedom we at last have won
We could not win until
We formed a strong united front
Of barrack, farm, and mill.

None want for roof, for clothes,
 for bread,
For useful work to do;
Where justice reigns and
 greed is dead
Our ways grow better too.

No king, no boss, no bureaucrat
To serve the bosses' cause.
Now rules the proletariat
Its councils and its laws.[92]

"Corrido of the Agrarian Revolution"

In Cuautla Morelos there
 was an uncommon man
As just as those silvery
 descriptions of him,
He was Emiliano Zapata,
 much loved by everyone . . .
Now all are of the same party
 and there is none to fight.
All of us are campañeros, so
 there is no war,
 And we all work together.
The same is true for the proletarian,
 as for the artisan.
Union! that is the sacred force
 on behalf everyone worldwide,
 Peace, Justice and Freedom!
In this way the soldiers,
 have served in war,
As have those who enrich

the nation and work the land.
Who doesn't feel fortunate
 When it begins to rain?
For this signals very clearly
 that we shall all eat.
If the countryside becomes
 verdant again
 with the help of the tractor,
It is for the fruits of our labor
 that we give our sweat.
Gold counts for little, if there
 is no food to buy.
This is the tie that binds
 our generation.
Whoever would be a wiseman
 of much wisdom,
Knows that it is much better
 to eat well.
From the one to the other,
 while the rich always
 think only of doubling their money,
By seven at night,
 the poor are reclining
 dreaming in their sleep
 a tranquil dream
 since all are tired.
Blessed is the tree that
 provides ripe fruit,
My friends, and brings in
 hard currency as well.
It is better welfare that
 the Mexican desires,
 who works hard in order
 to be happy.
They want neither a flash-in-a-pan
 nor nonsensical words
 but guarantees for
 the beloved hearth
 at the homeplace. [93]

The entire series is normally treated as a bipartite complex entitled the *"Corrido of the Agrarian Revolution"* and the *"Corrido of the Proletarian Revolution."* The latter, which was executed nearly two years later than the former, begins on the south wall with *Distributing Arms* (2.56 x 3.58 meters) and contains portraits of Frida Kahlo, Rivera's partner whom he would marry in 1929, photographer Tina Modotti, Cuban revolutionary Julio Antonio Mella, who was assassinated by right-wing agents or Stalinists less than a year after this portrait, and painter David Alfaro Siqueiros. Done after his return from the U.S.S.R. and his attendance in 1927 at the celebration of the tenth anniversary of the Bolshevik Revolution, the mural by Rivera could not be more transcultural or internationalist in nature. So densely packed with mobilizing workers and campesinos in the process of arming themselves it presents the viewer with a human barricade and was meant to conjoin and even harmonize the Russian Revolution with the Mexican Revolution.

Aside from the hammer and sickle flag of the Bolsheviks in the middle ground, there is the *"Tierra y Libertad with Machete"* banner of the Zapatistas in the right background. The pervasive uses of primary blue (for its identification with blue collar workers who look Slavic) and red (for its socialist signification) are combined with the white of the Mexican campesino's clothing to unite coloristically a work that seems almost overwhelmed by the profusion of details. This, in turn, does more to heighten the psychological urgency of the scene than do the highly rhetorical gestures that play across the surface of the panel.

The nine major scenes immediately following the distribution of arms include depictions of fighting, of cooperatives being established, of consolidating the united front, of community (as in the especially moving *"Reparto del Pan"* or "A Worker's Daily Bread"), and concludes with a portrait of Emiliano Zapata. These ten panels on the south wall make up the *"Corrido of the Proletarian Revolution,"* despite the fact that it concludes quite revealingly with a nonproletarian leader from rural Mexico. These proletarian scenes are more sharply linear in defining contour, more acutely focused in terms of shapes, more meticulous in detailing, and brighter in their use of color, with an almost "photographic" clarity being present in the rendition of certain personalities. In short, the visual language here seems much indebted to the humorless *"Neue Sachlichkeit,"* or New Sobriety, then prevalent in Europe when Rivera traveled there in 1927–28. This series, the last, is markedly different in its generally stern and bracing visual language from

all the other paintings in the Ministry of Education.

The *"Corrido of the Agrarian Revolution,"* which consists of sixteen major panels on the western and northern walls of the third floor and which was executed in 1926, is more satirical, or even caricatural, in its visual language. In some cases dating almost two years before the "Proletarian Corrido," the "Agratian Corrido" begins on the west wall with a woman, Concha Michel, singing this corrido. While the six panels on the west wall depict rural labor, the literacy campaign, and community organizing, the ten panels on the north wall involve a number of very pointed caricatures of the "enemies of the people." These include sardonic scenes of John D. Rockefeller, Henry Ford, and J. P. Morgan in the *Wall Street Banquet* (2.05 x 1.55 meters), along with a lampoon in *The Wisemen* (2.07 x 1.55 meters) of both Vasconcelos and the positivists.[94] The series ends with the destruction of capitalism in one panel and the emergence of the "liberated and fulfilled social order of the future" to use Rivera's own characterization of this scene.[95]

RIVERA'S APPROACH TO FRESCO PAINTING AT THE MINISTRY

Among the noteworthy historical consequences resulting from Rivera's decision to use the traditional technique of fresco was its subsequent revival during the 1920s and 1930s within the Mexican Mural Movement and beyond. If Jean Charlot had been the first to use fresco, in 1922–23 at the National Preparatory School, Rivera was the one most responsible for its large scale revival, which would be a signal attribute of the Mexican Renaissance.[96] A painterly medium associated both with Renaissance Italy and also with pre-Columbian procedures of the Aztecs and Mayas, *buon fresco* is one of the most labor-intensive methods in art for producing visual images. As such, *it concretely confirmed Rivera's concept of art as a form of manual labor.* Furthermore, it did so at a time when, since the invention of industrially manufactured tubes of oil paint in the 1840s, painting had become somewhat removed, technologically speaking, from the type of basic and broad ranging artisanship responsible for producing the painter's materials even before producing the artist's painted images.[97]

Involving painting with waterbased paint on freshly laid yet still wet plaster, the absorption of the pigment into the plaster occurs through capillary action. The resulting chemical process entails the reaction of the

pigment on the wet plaster with *calcium hydroxide,* which is the pure lime in the plaster mixture, acting as a binder. Although the pigment only minimally penetrates the wet plaster, it becomes permanently bonded with the plaster surface when the *calcium hydroxide* is converted into *calcium carbonate* by the absorption of *calcium dioxide* from the air. When set, the pigment becomes petrified and waterproof, so that the painting is as durable as the wall, being a sort of microscopic mosaic set in a new limestone-like wall.[98]

Aside from a knowledge of chemistry and geology, fresco painting necessitates masonry skills for the laying on of successive coats of wet plaster. A wall used for fresco painting must be entirely dry, since any dampness will not permit the plaster to adhere. Furthermore, a new wall should set at least for a year before being used. Prior to painting, the wall should be hosed down everyday for a week in order to effect a firmer bond of the plaster and to eliminate any *nitrate of potassium,* or saltpeter, which would ruin the pigment. A mixture of slaked lime, sand and/or marble dust with water (Rivera generally used 2 parts marble dust to 1 part lime), the plaster is applied normally in three coats: 1) the *trullisatio* ("rough coat") applied by the trowel that is generally one-half inch thick; 2) the *arriciato* ("brown coat") of around one-third inch thickness; and 3) the *intonaco* ("finished coat"), a thin final coat that covers only that section of the wall to be painted during the day's working session, a period of eight to sixteen hours depending on temperatures and humidity.[99]

In his first efforts at using fresco, Rivera actually attempted to use *nopal juice* (the viscous fluid of nopal cactus) as an "indigenous" binding agent. This experiment did not turn out well, since this organic juice subsequently decomposed and produced stains in these frescoes.[100] Aside from being free of any organic matter, the plaster must contain no salts, amoniates or nitrates, as these discolor the pigments. In the procedure that Rivera ultimately worked out, lime that had been woodburnt and slaked for at least three months was shipped to prevent contact with carbon dioxide in the air. Upon arrival, it was chemically tested and the desired amount of ground marble dust was then substituted for sand.[101] The pigments were then tested in a *sodium-hydroxide* solution to determine whether or not they would be altered by the lime and then further examined for resistance to discoloration through exposure to light and other chemicals. When approved, the pigments were ground by hand, normally by assistants, on a marble slab with a small quantity of distilled water to form a pasty material. The pigments were then placed upon

Rivera's "palette," which was an old "graniteware" plate, and he applied them with a paint brush moistened in distilled water to avoid impurities.

The colors used by Rivera in his frescoes were primarily organic earth colors — oxides of iron, manganese, aluminum, and copper — that blended appropriately with the lime and marble dust that were also of the earth. The specific colors he used were: yellow ochre (as well as golden and dark ochre), raw sienna, Pozzuoli red, red ochre, Venetian red, *almagre morado* (a Mexican red from oxide of iron), burnt sienna, oxide chromium, cobalt blue, and vine black.[102] The fact that these materials for fresco came so directly from the landscape gave Rivera a further sense of "cultivating" the earth to produce something of value to humanity in a way that was analogous to the productive labor of the campesino who worked the land in another more ordinary sense.

Aside from the necessity of using pure pigments and accurately matching them for each day's work, fresco painters must take into account another fact: pigments applied to wet plaster lighten considerably as they dry. This means that the artist must first paint in much deeper and more intense hues than is intended for the final result. Rivera laid his fresco colors on in the classical manner, starting with the lightest areas, then adding the darker colors to the degree of their intensity and finishing with the darkest colors. It should be noted that, owing to the way that Rivera applied the medium, the *intonaco* coat appears through the superimposed pigment and water to produce exquisite tints without any further addition of white. In this manner, Rivera gradually built up a richness and luminosity of tone that are quite distinctive, as in his 1934 mural for the Palace of Fine Arts.[103] In addition, Rivera's normal use of this time-honored procedure was qualified in this case by his effort to integrate the paintings with the way in which the Ministry of Education is illuminated by natural light. As he admitted later:

> Before beginning to paint, I studied the quality and intensity of the sunlight which hit a particular wall, and the architectural details — arches and columns — and how they broke the sunlight and framed the space. Like [those of] the building itself, my colors were heavier, solider, and darker at the base than they were as the structure rose toward the luminescent sky.[104]

Before the final coat of paint was applied, an extended series of steps were necessary in the *buon fresco* procedure. After Rivera executed sketches

on paper that were done in the studio and enlarged to scale in a *cartoon* (which comes from the Italian word for *cartone,* meaning "rough paper"), he then sketched with red chalk or charcoal directly on the "rough coat" of plaster. Assistants then traced this sketch on translucent tracing paper onto the wall and ran a perforatory wheel over its lines to produce a stencil. They then put on a final coat of plaster and, through the stencil perforations, they sifted lampblack, reproducing faintly on the wet plaster surface the part of the sketch that had been covered up by the final coat, with the rest still remaining on the rough "brown coat." Finally, they tested the new plaster till it had dried to the required degree of humidity and then they went to wake Rivera. Usually, this was just before dawn, the masons having worked through the night.[105]

The plaster would remain at the necessary degree of wetness for six to twelve hours, depending on the warmth and dryness of the day. Rivera would then apply his colors in the classical light-to-dark manner mentioned above. An eyewitness account of Rivera working includes the following observations:

> All day he works, if conditions permit, straining his eyes on into the fading evening light. . . . At last, heavily, wearily, he climbs down. The patio is deserted by then, except for his wife or a friend and perhaps one or two helpers to receive orders for the night. He has worn out a squad or two of masons, several assistants, hundreds of observers, scores of friends. You breathe a sigh of relief and exhaustion yourself. . . . [Yet] often I have seen him, after a day's work was done, lose his temper at the result and tell his assistants, "Clean it all off and put on fresh plaster! I'll be back tomorrow morning at six!"[106]

It should be noted of this extremely labor-intensive technique used by Rivera that even with the impressive revival of mural painting in revolutionary Nicaragua during the 1980s there was a recourse to the far less cumbersome medium of acrylic paints for most large murals executed by Alejandro Canales, Leonel Cerrato, and the other artists at the forefront of this movement.[107] The prodigious nature and awesome range of Rivera's technique, along with the intimidating scope of his artistic achievement, led critic Arthur Danto to meditate on how Rivera's larger-than-life project is as inaccessible to artistic practice at present as the life of the knight was to Don Quixote.[108]

In considering Rivera's accomplishments, Danto said he was reminded

of something John Maynard Keynes wrote about the type of geometrical proofs that Isaac Newton used in his *Principia*. They were, Keynes felt, like great and ancient weapons in a museum of history and he marveled about Newton's technique, as he did about medieval armor, "that people could fight with what he could hardly pick up."[109] This is analogous to the way in which contemporary artists look back on Rivera's "museum-piece" technical procedure for his huge mural paintings.

THE RECEPTION OF RIVERA'S MINISTRY MURALS AND
RIVERA'S POLITICAL ACTIVISM IN THE 1920s

But how were Rivera's murals in the Ministry of Education received by the variegated groups contending for power in the unsettled period of the 1920s? The answer is a predictably complex one. Right-wing sectors, both in and out of the government, were implacably hostile to the murals and routinely called for their destruction from 1924 onward. The 1923–24 controversy over the verse of Gutiérrez Cruz occurred at a time when rightist students were vandalizing the murals of Orozco and other artists in the National Preparatory School. The conservative press in Mexico City referred to the murals of Rivera as examples of *feismo* (uglism). An example of this vantage point can be found in an essay by Alvaro Pruñeda for *El Universal Ilustrado* on the inauguration of the stairway murals in 1925:

The obsession of Rivera in these murals is the feminine nude. It seems as if he has only selected from various horrible women the most repugnant lines and colorings. . . . I could not contain my indignation. . . . The self-portrait of the painter forms part of a group of workers and adopts the sad situation of an imbecile.[110]

In 1929, Governor Benítez Terrones of Durango demanded their removal in the daily *Excelsior* and, in 1930, *El Universal Gráfico* carried the title story "Time, Accomplice of the Students in the Destruction of the Works of Don Diego Rivera," which read:

The rumor that direct action is to be exercised against the pictorial work of Diego Rivera caused us to interview some of the students of the Faculty of Architecture who were the initiators of the campaign

let loose against the *discutido* (much-debated) painter.

The attackers of Diego Rivera told us that they would not exercise violent direct action against paintings of Diego Rivera which misadorn the walls of the Secretariat of Public Education . . . which are suffering a great deterioration, thanks, according to the opinion of the future architects, to the *deficiencies of the encaustic process in which they were executed* [!][111] (my italics).

Just as some, but certainly not all, members of the Calles government expressed strong misgivings about these murals to the point that Bertram Wolfe assumed that they would be destroyed in the late 1920s, so none other than José Vasconcelos denounced the murals when they were completed in 1928 with the execution of the Russian-influenced *"Corrido of the Proletarian Revolution."* This was about two years after Rivera had painted his satire of Vasconcelos in the Ministry of Education. The first patron of the Ministry murals wrote as follows about Rivera's works, which illuminates well how centrist Vasconcelos's politics had always been:

It was believed till quite recently that the economic transformations which are taking place in society would produce a great art — proletarian in Russia; popular in Mexico. For lack of a religious spirit, these movements remained incomplete, both socially and artistically. In Russia they have fallen into the grotesque, and in Mexico into the abjection of covering walls with portraits of criminals [that is, Zapata, Montaño, Carrillo Puerto].[112]

In an interview with United States author Katherine Anne Porter for *The Arts* (January 1925), Rivera had tried to put the controversy then engulfing his works in larger terms that involved the problem of *Eurocentrism* as well as that of simple ruling class *hauteur*. Rivera's observations went as follows:

As intellectual arrogance and spiritual understanding are always enemies, the bourgeois [in Mexico] has not really comprehended anything, and has remained insensible to the atmosphere of art about him. He has not only aspired to be altogether European in the manner of his ill-chosen masters of art, but he has attempted to dominate and deform the aesthetic life of the true Mexico (the Indian who possesses his own heritage of classic art). . . . If you should ask him for a reason,

he would answer in effect: "Indian art?" Absurd! What can a peasant know about beauty?" For, being in the main Spanish, he even now confounds race with class and has not learned the difference between an Indian and a peasant.[113]

So, with such intense and extensive opposition to the murals, how did they survive? The answer is, I think, twofold. The first and generally accepted one was that the *international celebrity* increasingly enjoyed by Rivera murals caused a begrudging acceptance even in the conservative circles of the Calles regime, which, as noted above, was not a monolithic state politically speaking. In 1925, for example, Rivera won a prize for his splendid painting *Flower Day* (Figure #10) in the Pan-American Exhibition of the Los Angeles County Museum of Art. In 1929, Rivera was awarded a Gold Medal by the American Institute of Architects, and became only the second non-United States citizen to be so honored. Again, in 1929, he was the subject of a book in English by Ernestine Evans entitled *The Frescoes of Diego Rivera: 1922–29*, while in that same year the United States Ambassador to Mexico, Dwight Morrow, commissioned Rivera to paint an impressive mural series for the Palace of Cortéz in Cuernavaca. Two years before, in 1927, Rivera's work had already been strongly praised by novelist John Dos Passos in the left-wing publication, *New Masses*, where he wrote that Rivera's murals stood as a challenge to all other artists of the time in every other country. Dos Passos then concluded that if the public murals (of Rivera and Orozco) did not constitute a revolution in art, then he did not know what did.[114]

In France in one of the most well-known art history texts published at this time, André Michel's comprehensive *Histoire de l'art* (1929), Rivera was singled out for praise as one of the greatest painters alive. French scholar Louis Gillet, who contributed the entry on Rivera's work, wrote:

One sees the importance of these paintings in which Diego Rivera has created the first revolutionary imagery, the *geste* of his people and the national legend.

This is work which one will seek in vain for an equivalent, not only in the rest of America, but also in Europe and in Russia. By chance Mexico has become the place in which the first of the great works of art born from Socialist and agrarian materialism have appeared.[115]

Yet one must respond that most of this acclaim arrived only in the late 1920s. What allowed Rivera's work to survive in the more tumultuous period of the mid-1920s? The answer, which has generally been overlooked, is that Rivera enjoyed deep support among a variety of armed and militant popular organizations that were frequently mobilized in the streets of Mexico City and elsewhere throughout the country to protect their interests. Rivera was, after all, an activist *par excellence* whose political affiliations were quite extensive. When *The New York Times* published a short piece about Rivera's marriage to Frida Kahlo in August 1929, the title was *"Diego Rivera Marries: Noted Painter and Labor Leader Weds Frida Kahlo."*[116]

Of what labor groups was Diego Rivera a leader? The answer is a very large number of different organizations. Aside from being a member of the Mexican *Communist Party* from 1922–29 and a founding member of the *Artists Union,* he had also helped organize guerrilla bands during the intense fighting in 1923–24 against the counterrevolution.[117] A highly visible public speaker, Rivera was often a skillful polemicist in many of the major publications of the day. In 1926 he was involved with the *League of Agrarian Communities and Peasant Unions of the State of Tamaulipas,* which is an organization for which he executed seven albums of drawings of their National Labor Meetings in 1926, 1927, 1928, and 1930.[118] Also in 1926, Rivera was especially active in public with the *Hands-Off Nicaragua Committee (Against United States Intervention in this Central American Country from 1926–33).* In 1927, Rivera drafted the theses and served as National President of the *Anti-Imperialist League of the Americas,* was a member of the *National Peasant League,* and wrote statues, as well as manifestoes, for the *Workers' and Peasant League Bloc,* for which he was elected president in 1927.[119]

In addition, Rivera was head of the Mexican labor delegation to Moscow for the Tenth Anniversary Celebration in 1927 of the Russian Revolution, was director of and did drawings for *El Liberador,* while *El Machete,* the official organ of the Communist Party after December 1924, carried a photograph of Rivera's work on a weekly basis during the mid-1920s. In 1928, Rivera was made Secretary General of the *Anti-Imperialist League of the Americas* and, in 1929, he was elected President of the Executive Committee of the *Workers' and Farmers Bloc.*[120]

In short, even if Rivera's murals had not enjoyed considerable popularity within the popular classes, his leadership of various mass organizations would unquestionably have insured a strong public response

to thwart forcibly an organized rightist attack on one of his public murals. Furthermore, some of these mass organizations were allied to the Obregón and Calles governments at a time when the latter needed support from the left to defend themselves against counterrevolutionary uprisings. And, of course, the Mexican government since 1920 has supported autonomy movements and national liberation movements in Latin America, such as the guerrilla movement of Augusto Sandino in Nicaragua from 1926–33, so that the public position on foreign policy and anti-imperialism of Obregón and Calles was often quite close to that of Rivera and virtually everyone else on the left in Mexico.

For a variety of reasons both political and artistic Rivera became an "institution" in the public sphere. Government officials who spoke of whitewashing his frescoes could never make good on their threats, while even the sharply disapproving conservative press in Mexico learned to speak of *"nuestro muy discutido Diego"* (our much discussed Diego) with a certain degree of begrudging acceptance. In turn, Rivera's national prominence allowed him to intervene nationally to protect political prisoners on the left, including members of the Communist Party, so that he was seen "more than once opening the doors of a cell for one who had been imprisoned."[121] His public stature was such that he could, and did, denounce Calles publicly in May 1929 after there were government attacks on the *National Farmers' League.*[122]

Yet even though he had been closely linked to the Mexican Communist Party from 1922–29, which generally gave qualified support to the national government in those years, Rivera was always a maverick, or "ultra-leftist," who refused to go along uncritically with the party line. Even when he visited the U.S.S.R. as an honored guest, Rivera could not resist criticizing what he thought were misguided government policies in the early years of Stalin's ascendancy when the state was far less repressive than it would later become. Although he was given a commission by his old friend Lunacharsky to paint a mural for the Red Army Club in Moscow, this job never materialized and he was ultimately invited by Stalin to go back to Mexico under the pretext of a "greater calling" for political work at home. He did not do so, however, without expressing his disappointment at what had happened in the arts in the U.S.S.R. He was shocked to learn that the Cubo-Futurist, Suprematists and Constructivists he had known in Paris were exiled or silenced. In 1932, for an article in *Arts Weekly*, he spelled out what he had only intimated indirectly before being expelled from the Communist Party in 1929. Rivera wrote:

Present-day Russian artists . . . struggle at the same time against the incomprehension and the petty-bourgeois bad taste of the Soviet functionaries — a taste formed, like the artists, within the bourgeois European culture . . . inept functionaries who, with the coming of the NEP, restored the academic Russian painters — the worst academic painters in the world. . . .

This is one of the varied results of the actual descending curve (transitory degeneration) of the Russian Bureaucratized Communist Party . . . [under the] intellectual lackeys of Sir Joseph Stalin.[123]

But the above was written after he was publicly thrown out of the Communist Party in 1929. What were the reasons for his much publicized expulsion? Although the reasons are still not entirely clear, I think three key sources of conflict between him and the party leadership help explain a great deal. First, Rivera was highly upset to discover when he was in Germany in 1927 that the Communist Party, in order to thwart the "reformism" of the Social Democrats who enjoyed greater support than they did, had entered into an alliance with the Nazis with the wildly mistaken assumption that the fascists posed no real threat.[124]

Second, Rivera, who was always a proponent of a united front on the left, totally opposed the Communist Party's new tactic in 1929 of splitting up all the trade unions along lines of "political correctness" to form special, and obviously far smaller, "Red" or "Communist" trade unions that soon came into open conflict with other unions that represented different left-wing tendencies.[125] Needless to say, this strategy of 1929 that splintered the working class left in Mexico played right into the hands of a Calles government that was increasingly looking to maintain power through playing off different groups against each other.[126]

Third, Rivera "the anarchist" always opposed the strict enforcement of "party discipline," since to hold a view at variance with the party line meant that "one incurs the enmity of friends to whom the slightest difference of view appears as betrayal."[127] Later, in the late 1940s when, for reasons we shall analyze below, he was seeking readmission to the Communist Party, Rivera unabashedly stated "that my re-admittance would encourage Party intellectuals who stood for free, progressive expression and attract new members to the Party who were opposed to excessive discipline."[128] Nor did he doubt when he was finally readmitted in 1955 that this decision of the Party was connected to the death of Stalin in 1953 and the beginning of de-Stalinization in 1956.[129]

In sum, from 1929 until the mid-1940s, Rivera was a nonaligned socialist (and until 1940 a Trotskyist) in an increasingly bipolar world. No friend of the right, he was a *persona non grata* for many on the left as well. His political autonomy was seldom in doubt even as his efficacy as a leftist was hotly debated. Just as his artworks existed at the crossroads of many different visual cultures, so Rivera's political stand situated him at the paradoxical intersection of "none of the above" when, according to the majority viewpoint, you were either with the United States or the U.S.S.R., in keeping with a crude binary framework that spawned Cold War thinking after 1945 and considerably narrowed the period political options.

On the one hand, his somewhat ambiguous location as an "ultra-leftist" or "anarchist" (to use two pejorative terms assigned to him by the Communist Party) made him acceptable to certain powerful sectors in the West for commission — and, some would say, to the compromises concomitant with them. On the other hand, the very indeterminacy of Rivera's political location from 1929 to 1940 allowed him to articulate positions that were often overlooked, with consequences that were sometimes explosive. Rivera's great achievement from this position of double marginalization was to be forever in the messy middle of the debate, especially where the clean polarities of the period broke down and debate was still possible. Particularly in the period when he was a Trotskyist and critical supporter of the sweeping Cárdenas changes, Rivera's brand of visionary "negative thinking" served to affirm certain views that otherwise would have been suppressed.

To a greater degree than was true of most other artists and intellectuals of this period, he avoided the paradoxes of a type of binary thinking involving two supposedly "pure" and monolithic alternatives known to ideologues of both sides far too simply as "capitalism" and "socialism." As E. J. Hobsbawm has noted of the period 1917–89, the collapse of the Soviet Union along with the East/West contradiction and the continuation of the North/South conflict make clear that the Cold War conception of the period options was "an arbitrary, and to some extent artificial one, which can only be understood as part of a particular historical situation."[130] To the great and ironic merit of Diego Rivera, his complicated ideological position is not fully explicable by means of the old Cold War view of things. This is the meaning, above all else, of Alberto Híjar's characterization of Rivera's position as one of "voluntarism," with all that this implies in the way of both undeniable failings and incontestable successes for Rivera's remarkable career.[131]

CHAPTER FOUR

∎

Humanity at the Crossroads: Rivera From the Late 1920s Through the 1930s

∎

Who built the seven gates of Thebes?
The books contain the names of kings.
Was it really kings who carried the craggy stones?
And Babylon, so many times razed,
Who rebuilt the city every time? In which houses
Of gold-glittering Lima lived those who built it?
On the evening the great wall of China was complete,
Where did the masons go? Imperial Rome
So full of triumphal arches. Who erected them?
Over whom did the Caesars triumph?
Did oft-sung Byzantium have only palaces for houses?
And even in legendary Atlantis the night the sea rose,
Drowning men still called their slaves.

The young Alexander conquered India.
He alone?
Caesar beat the Gauls.
Was there not even a cook in his army?
Philip of Spain wept as his fleet
Was annihilated. Were there no others who cried?
Frederick the Great triumphed in the Seven Years War.
Who triumphed with him?

Each page a victory.
What human price for each.
Every ten years a "great man."
But who paid the piper.
Many accounts.
So many questions.

Bertolt Brecht, *Fragen*
eines lesenden Arbeiters, 1939
(Questions of a Worker Who
Reads History)[1]

For the first time in the history of monumental painting, Mexican
muralism ended the focus on gods, kings, and heads of state.... [F]or
the first time in the history of art, I repeat, Mexican mural painting
made the masses the hero of monumental art. . . . [O]ur mural
painting attempted to represent in a unified and dialectical
composition, the historical trajectory of an entire people.

Diego Rivera, On Murals in
the 1920s and 1930s, *Arte y*
Política (1957)[2]

In a manner largely without historical precedent in world art, Diego
Rivera and several other modern artists in Mexico chose to paint the
popular classes as embodiments of larger social forces on a heroic scale in
monumental murals for the public sphere. By depicting the vigilant
struggles of the popular classes for self-determination, rather than some
languid and rustic poor in folkloric vignettes, Rivera raised some
provocative questions about the mainstream presentation of history both
then and now. By representing the leaders of the popular classes in a
non-dramatic, imbrecated manner as tropes for transpersonal causes,
rather than as heroic figures in splendid isolation, Rivera contested the
standard conceptions of history as either a parade of transcendent
individuals or as a set of predetermined forces sweeping everyone
irresistibly along. In both of these cases and others, the closest parallel in
Europe for Rivera's epic modernism was probably the "epic theater" of
German author Bertolt Brecht.[3]

Like Brecht, Rivera had to grapple through his art (sometimes
successfully, sometimes not) with how a commitment to tendentiousness
in representing popular mobilization at times ended up being less about
popular self-representation, and more about a populist presentation of
these classes. It was this paradox that Rita Eder evidently had in mind
when she wrote that for all his strikingly internationalist efforts "to bring

the country into the realm of modernity," the result of Rivera's work was not necessarily the "democratization of art." Rather it sometimes ended up being little more than "didactic, sometimes doctrinaire painting." [4]

It should be noted that the didacticism in Rivera's art cannot be considered an automatic consequence of populism and its related failure to represent the popular classes in their own terms. This is the case, since art of the popular classes — such as the ballad-like *corrido* or the prints of José Guadalupe Posada — often features didacticism in a strong way. It is this latter popular source, rather than the academic rhetoric of populism proper, that most often served as the source for didacticism in Rivera's own artistic practice. Furthermore, it must be underscored again that Rivera did not merely paint the popular classes from some superior vantage point *above* their concrete day-to-day struggles, which would be a basic precondition for populist images. Rather, Rivera painted the popular classes to a certain extent from *within* mass organizations, as one who engaged in concerted efforts on behalf of popular struggles. The validity of this point will be further demonstrated in the discussion that follows. As such, Rivera was hardly some armchair leftist who produced popular images disconnected from popular mobilization in the public domain. Thus, the undeniably problematic features of Rivera's *sometimes* didactic art had more to do with flawed attributes of concrete popular practices, than with any "abstract" populist rhetoric.

In this chapter I shall concentrate largely on the mural cycles of Chapingo, San Francisco, and Detroit, as well as on those in the National Palace in Mexico where Rivera created "one of the most compendious visual displays of historical matter in near human scale in the history of art, inviting comparison . . . with Trajan's Column, the Bayeaux Tapestry, . . . and Michelangelo's Sistine Ceiling." [5] To analyze these works by Rivera with the requisite rigor, it will be necessary to assess not only the iconographic programs originated by the artist in relation to concomitant period politics that influenced the patronage of his art. It will also be important to look at the traditional nature of the epic in art and how Rivera, like Brecht, gave the epic a new inflection that constituted a critique of this genre from within.

Similarly, it will be equally important to examine Rivera's decade-long identification with Trotsky (1929–39) and his significant collaboration with André Breton's anticolonialist aesthetic in the late 1930s and early 1940s. To do so will allow us to gain an adequate sense of the political position occupied by Rivera in this the most important period of his entire

artistic output, which began to fall off in a qualitative way only after 1940 (although he still produced some major works during the last decade and a half of his life). Such a historical survey will take us up to the conclusion of the sweeping popular gains of the Cárdenas years (1934–40), the tragic assassination of Trotsky in 1940, and a worldwide victory over fascism that was, nonetheless, followed by such disturbing developments as the onset of the Cold War and the reinvigoration of United States military intervention in Latin America.

All of these events and others spawned a stalemated world situation that was quite different from the dynamic future on behalf of social justice that had been so luminously invoked, if not baldly forecasted, in Rivera's magisterial and visionary artworks from the late 1920s through the 1930s. Nor is it by chance that after 1945 Rivera's work often went from being visionary to being nostalgic.

THE MURALS OF CHAPINGO (1924–26)

The agrarian ideal of social change that precipitated the rural phase of the Mexican Revolution of 1910 would find realization, to a limited extent, during the Obregón presidency (1920–24), to a lesser extent in the Calles years (1924–34), and to a much greater and highly impressive degree during the profound structural changes of the Cárdenas administration (1934–40), which carried out one of the two or three largest programs of land redistribution in the history of the hemisphere.[6] Because of his very progressive leadership in this era, Cárdenas has come to be considered one of the greatest political leaders of the first half of the twentieth century.[7]

This revolutionary ideal of agrarian change found its most masterful manifestation in the visual arts in the remarkable murals for the National School of Agriculture located in a rural area outside of Mexico City. This was the *Universidad Autónoma Nacional de Chapingo* (National Autonomous University of Chapingo), which had been established in 1920 by the Obregón government. The noteworthy, some would say improbable, theme of the murals is to be found in a text that Rivera painted in the principal stairway of the university's administrative building. This statement was based on a popular saying of Zapata as follows: *"Aquí se enseña a explotar la tierra y no a los hombres"* (Here one

is taught to exploit the land and not humanity.)[8]

The literal setting for Rivera's murals (Figure #12), which were predicated on the theme of redistribution of the land along more equitable lines, was an example of just such a commendable achievement in the postrevolutionary years of the Obregón presidency. Originally built in the late seventeenth century as the Convent of San Jacinto, the land around the complex was established by the Jesuits as a *reducción,* an agriculturally productive religious community in which the Indians worked the land under Jesuit management.[9] As *The Mission,* the film by Robert Bolt about the Colonial Period in Latin America, so justifiably demonstrates, there was intense opposition by the wealthy private sector to the often utopian, if also paternalistic, communities created by the Jesuits.[10] These communities were indebted both to the pre-Columbian *eijido* (communal landships) and to the ideas of Sir Thomas More as well as Tommaso Campanella. No doubt as a way of gaining greater allegiance from the *hacendados* and also of enhancing capital accumulation for itself, the Spanish Crown expulsed the Jesuits from Mexico in the 1760s with the result being the acquisition of these ecclesiastical estates for a more profitable use of the Indian labor force. It was in this period that the Hacienda of San Jacinto was established and subsequently became the residence of Manuel González, one of the most powerful *hacendados* of the Díaz dictatorship.[11]

In 1920, after converting the *haciendo* into a public university, the Obregón government expropriated the land and redistributed it to the campesinos who had formerly worked it. Indeed, this particular episode in Mexican revolutionary history is the subject of one of the four main panels done by Rivera in 1924 beginning in the foyer on the second floor of the university administration building. This building also contains other works by Rivera: four honorary portraits executed in the 1940s, subsidiary decorations, and thirty-five geometrical decorative motifs.

In *Dividing Up the Land* (Reparto de Tierras), 2.99 x 5.12 meters, Rivera depicts a large group meeting, which is segmented compositionally in accordance with the "golden section" and compacted in the foreground with traditionally-clad campesinos who are shown both as Indians and *mestizos.* They surround the business-suit-attired government official overseeing the land transfer. The disgruntled former wealthy landholders simply look on angrily as the land, having already been expropriated, is reassigned to the former landless rural wage-laborers. The middle ground shows a building being constructed, thus signifying national

reconstruction. The background features rural communities, a mountain range, and a sky that are painted in pastel colors that go from light yellow and brown to light sandia red and light blue.

A calm, classically composed work, it reminds us of the classical Greek emphasis on the *polis* (the city-state) as central to art and then relocates this theme in *"Mexico Antiguo"* (as Rivera termed it), with the new sense of community re-imagined in the postrevolutionary period. The Mexican campesinos, who have the calm dignity that one associates with the peasant paintings by Louis Le Nain in seventeenth-century France, are, nonetheless, much more ethnographically precise, much less abstract in attitude in Rivera's panel. Here, as elsewhere, one is reminded of Rivera's polemical claim (following in the tradition of José Martí and Rubén Darío) about the nature of his own "renovated classicism":

> The antique, the classic of America, is to be found between the Tropic of Cancer and the Tropic of Capricorn, that strip of continent that was to the New World what Greece was to the Old. Your antiques [people of the Americas] are not to be found in Rome. They are to be found in Mexico.[12]

Two facing panels on the east and west walls address the complimentary themes of good versus bad government and they clearly recall Rivera's admiration for Ambrogio Lorenzetti's mid-fourteenth-century frescoes of the same subject in the Palazzo Publico of Siena, Italy. *Bad Government*, 2.99 x 9.74 meters, portrays a despoiled coastal landscape under siege from without by battleships (a reference to United States military intervention in the domestic affairs of Mexico) and undermined from within by death squads of *pistoleros* in the ploy of the remaining *hacendados*. *Good Government*, 2.98 x 9.46 meters, represents the obverse, namely, a flourishing agrarian sector cooperatively worked, plus a thriving industrial harbor (possibly that of the oil fields in nearby Tampico). Again, we encounter a visual summons by Rivera to solidarity between urban and rural workers in order for the public good, as well as local community concerns, to be advanced structurally. Along with Rivera's political views, these murals were also motivated by his ecological considerations, a "deep personal feeling for the land," in tandem with his belief that its protective husbandry was essential to a healthy community.[13]

Framed by the ashlar doorway of the former door, which was walled in to provide more space for a mural, and by the fresco *Good Government*

that surrounds it, the portrait of Obregón (which was added by Rivera in 1940) came at a time when the changes of the Cárdenas years had greatly extended the more tentative reforms of the Obregón years and, no doubt, deepened Rivera's own nostalgia for the mid-1920s. The verbal description that best encapsulates the visual portrayal by Rivera of this warm, yet dignified and even commanding, image of Obregón, which is a masterpiece of *trompe l'oeil* illusionism, is the one found in Bertram Wolfe's second biography of Diego Rivera. This literary portrayal was one with which Rivera was in agreement. It discusses Obregón as corpulent, candid and witty, as well as unassuming in his personal behavior, while being a forceful leader in his public life. He is remembered as someone who shared the idealism of Rivera and the Artists Union, since time had not yet forced him to confront the most vexing and debilitating problem of all for Mexico: "that of recementing the broken-down relations with the United States."[14] Accordingly, Obregón fought heroically against "the illiteracy and rudeness of the times, laying the foundations for schools" and promoting democratic changes, as well as modest land redistribution.[15]

If the administrative area series of Chapingo was one of the earliest of Rivera's works to assume this tutorial role in the public sphere, his brilliant frescoes of 1926 in the former chapel (now auditorium) of Chapingo (Figures #12 and #13) constitute a splendid balance between a celebration of the vitalistic sensuality of unfolding human development *and* a sober assessment of the highly directed struggle by humanity on behalf of an emancipated society. As such, it was called the "Sainte Chapelle of the Revolution, [the] Sistine Chapel of the new age" by French critic Louis Gillet.[16] It was also this series and others that drew praise from the French novelist André Malraux in an essay of 1938.[17] Furthermore, Malraux's superb novel about the Spanish Civil War, *L'Espoir* (Humanity's Hope), contains a passage on mural painting that was probably influenced by Rivera's frescoes.[18]

Far from being positioned as merely dichotomous, evolution and revolution are seen here as mutually determining. The cohesiveness of the iconographic scheme, along with the masterful technical skill used to render it and the consummate fluency of the visual language manifesting it, are matched by an integration of images and structure with a coherence that is rare in art history. Despite the structural problems posed by the tripartite nave and vaulted ceiling of the Spanish baroque building, Rivera was able to harmonize his paintings with the building in a way that solved the complicating problems of this particular architectural space. In this

regard, the *entire* interior of the chapel has always been a "painter's painting" in the most comprehensive sense.

The four main panels on the left side of the nave, entitled "Social Revolution," show successive stages in the structural transformation of society, while the corresponding number on the right nave wall are entitled *"Canción a la Tierra"* (Song to the Earth, or Natural Evolution). Prior to the nave frescoes, there are two smaller paintings in the narthex of the chapel leading into the sanctuary. These are *The Birth of Class Consciousness* (2.44 x 5.53 meters) on the left wall and the striking *Blood of Revolutionary Martyrs Fertilizing the Earth* (2.44 x 5.53 meters) on the right wall. (Figure #13).

The latter mural is particularly notable for the way in which it combines a lean, symmetrically-balanced classical composition with a type of almost clairvoyant visual legibility that is reminiscent of the *retablos* by popular artists in Mexico. These *retablos* are pictures of "miraculous survival" by amateur artists and they were the subject of an incisive, as well as laudatory essay by Rivera in 1925.[19] Once again, Zapata and Montaño are martyrs in red shrouds whose agonistic sacrifice for the future has renewed the impetus of revolutionary struggle. In this case, Rivera has invented the superb motif of interring the two in a maize field and having their bodies literally nourish the crops that sprout from the ground. Above this scene there is the neo-Baroque device of a painted setting sun that frames the circular window through which natural light illuminates the interior.

In all, Chapingo Chapel contains fourteen main panels, twenty-seven subsidiary themes, and various motifs simulating architectural elements. Among the more noteworthy images along both walls are the poignant Giottesque figures of grief in *The Continuous Renewal of Revolutionary Struggle* (3.54 x 3.67 meters) and the nude woman on the opposing wall (for which Tina Modotti was the model) in a tightly simplified ovoid shape seen from the back. This figure unquestionably recalls Diego Rivera's admiration for the photographs of Edward Weston, such as *Nude* (1925), which, likewise, depend upon looking at the body from a restrictive, postpicturesque, and unorthodox viewpoint that, nevertheless, opens up the perceptual act of looking by focusing upon the austere structures of things that are normally lost from view by a profusion of surface details or a soft-focus atmosphere.[20] Accordingly, Rivera remarked to Jean Charlot that "Weston did blaze a path for a better way of seeing and, as a corollary, of painting."[21] In a 1926 essay about the photographs of Modotti and Weston, Rivera wrote of how he preferred the photographs

of Weston to the paintings of almost any other contemporary artist, since the transnational Pan-Americanism of his photos synthesized "the extreme *modernidad* (modernity) of the visual arts from the North and the vitalistic tradition born in the lands of the south."[22] (For an English translation of this essay, see Appendix #2).

Covering the entire wall of the chapel's apse is the largest mural in the entire building at 6.92 x 5.98 meters, entitled *The Liberated Earth and Natural Forces Controlled by Humanity* (Figure #12). It is dominated by a voluptuous female nude (the model was his second wife, Guadalupe Marín). Around her are various nude male and female figures, each of which represents an attribute of nature, such as water, electricity or fire. These are seen as forces which humanity can harness for the social good and use to sustain civilization along socially just lines. The apsidal mural, like all the others, is marked by a distinctively muscular delicacy with few other parallels in modern art. Similarly, throughout the work there is a remarkable alternation of unrestrained dynamic movement with classically constrained sensuality. This "uneven" interplay reminds us of how Rivera spoke of "dynamic symmetry" as an important principle behind his artistic practice.[23]

In a theoretical sense, Rivera's avowed use of a Marxist framework for the Chapingo murals is quite revealing. For, despite the emphasis throughout the panels on natural forces per se, it is also clear that there is a counterbalancing message that underscores how society is historically constructed through struggle, rather than being just naturally mandated by some "timeless" order of things. Accordingly, just as people make history in the course of being shaped by it, so nature is mediated by society even as nature does place limits on the process of mediation. All of this was aptly summed up later in the writings of Raymond Williams from within the same intellectual tradition on the left that helped shape Rivera's iconographic program.

In a well-known study of classical Marxism, Williams discussed two decisive moments in modern intellectual history. The first involved the eighteenth-century concept of culture that proposed a sense of human development at odds with any appeal to a static "natural order." The second involved the nineteenth- and twentieth-century idea of socialism that provided a critical counter to the idea of civilization as something permanently fixed, which would render it incapable of any further human progress through structural change beyond capitalism. This latter insight was related by Williams to a momentous insight by Marx concerning

modern social theory. This theoretical intervention allowed the possibility of overcoming the traditional dichotomy distinguishing society from nature, by disclosing the constitutive relationships coupling the two and capable of mediating between them. As explained by Williams, this meant *that Vico's original notion of "humanity making its own history" was given a radical new twist by Marx to mean "humanity making itself"* through the material, cultural, ideological, and spiritual reconstitution of itself in the course of making world history.[24]

This idea is compellingly manifested (whether self-consciously or not) by how Rivera's painting at Chapingo interrelates "social revolution" with "natural evolution" within a process of uneven historical development. The dynamic interaction of the two in the construction of the subject was summed up in a famous passage by Marx that directly corresponds to the overriding theme of the murals in Chapingo Chapel:

> [T]he meaning of an object for me goes only so far as my senses go. . . . [F]or this reason the *senses* of the social person are other than those of the non-social person. Only with the objectively unfolded richness of humanity's essential potential is the richness of *subjective human sensibility* (a musical ear, an eye for the beauty of form . . .) either cultivated or brought into being. For not only the five senses but also the so-called mental senses . . . come into being by virtue of their objects, that is, by virtue of *humanized nature. The forming of the five senses is a labor of the entire history of the world down to the present* [my italics].[25]

THE NATIONAL PALACE MURALS
(1929–35)

The aim of Rivera's next project was to paint "the entire history of the Mexico from the Conquest through the Mexican Revolution . . . down to the ugly present of Plutarco Calles."[26] The epic depiction that resulted when, in 1929, he was given a commission to paint this subject in the National Palace (which is the office of the Mexican President and the Department of Treasury), has few parallels in modern Western art and only a small number in world literature. In Latin America, the idea of approaching the Americas on an epic scale as a source of modern identity has only been embraced in poetry by Pablo Neruda of Chile, in his *Canto*

General (for which Rivera executed illustrations), and by Ernesto Cardenal of Nicaragua in his *Cántico Cósmico* (Cosmic Canticle).[27] In painting, Rivera's mural cycle is the outstanding example. The precise nature of this epic modernism is something to which we shall return later.

The huge allegorical portrait of Mexico in the National Palace is organized into three parts in keeping with the physical structure of the stairway and the entire history of this site itself. The location of the National Palace, which is a building that, in part, dates back to the Colonial Period, is that of the former site of Moctezuma's Aztec Palace.[28] First, on the right, or north wall, is shown *The Aztec World* (7.49 x 8.85 meters), which was executed in 1929 (Figure #15). Second, on the main, or west wall, with its five vaulted bays terminating in ornate corbels to mark each section, there is the enormous fresco *From the Conquest to 1930* (8.59 x 12.87 meters) from 1929–30 (Figure #14). Third, on the left there is *Mexico Today and Tomorrow* (7.49 x 8.85 meters), which was painted later (Figure #16), in 1935, at a time when the Calles administration was seriously embattled by the mobilized popular forces sustaining the much more reform-minded Cárdenas administration. Subsequently, from 1943–51, Rivera added eleven interdoorway panels on the north wall of the patio corridor on the second level of the building. These latter works focused on the pre-Hispanic world, as in the portrayals of the Zápotec and Tarascan Civilizations (1942) and, subsequently, in those of the Huastec (1950) and Aztecs (1945) that led up to the caustic presentation of the Spanish disembarking at Veracruz (1951).

The main wall, which one encounters directly when ascending the stairway, confronts us with a truly epic expanse of personages and events whose primary precursors in the visual arts would be the very large High Renaissance frescoes of Michelangelo and Raphael in the Vatican or the huge ceiling paintings of the Baroque and Rococo periods, most notably Tiepolo's painting of "The Four Continents" in the Würzburg Residence.[29] If Rivera's enormous mural in the National Palace enjoys an affinity with the almost overwhelming Baroque profusion of figures, it is also quite different because of the *decentered* and nonchronologically ordering logic of the work. It is, at once, indebted to the montage aesthetic of Cubism and Soviet film in the 1920s and 30s, as in the cinema of Dziga Vertov and Sergey Eisenstein, and also aligned with certain compositional conventions of pre-Columbian art.

As Dawn Ades has noted of the overall format for the National Palace paintings (Figure #14), they were derived by Rivera, at least in part, from

the panoramic organizational structure of the snake-like narrative boustrophedon form of the screen-fold.[30] This was the logic of the picture writing in which the Toltec, Mixtec, and Aztec manuscript illuminators recorded their history as well as rituals. Through a use of the modernist opposition to any sense of a linear narrative, coupled with a pre-Conquest mode for organizing memorable events, Rivera has placed the viewer in a very active role. When confronted with the "disordered" composition on the main wall, spectators have no choice but to organize interpretatively the conflicting accounts of competing historical events.

In broad terms, the local iconography of this overall riot of imagery on the main wall (Figure #14) in the two outermost of the five bays treats the two major nineteenth-century invasions of Mexico: in 1847 by the United States, which is on the right, and in 1862 by the French, which is on the left. The other three upper registers of these bay areas in the central portion of the main wall represent the following from right to left, which is, of course, the normal direction in the West for "writing" a linear narrative: *The Porfirian Era* (1876–1910), *The Legacy of Independence* (1810–1930), and *Reform and the Era of Benito Juárez* (1855–76). In addition, this uneven temporal framework, that involves the "doubling back" of events, features a very subtle grouping of personages from within and across each of these historic moments to establish a sense of competing historical forces at issue in each of these jumbled periods. Significantly enough, in the first of these eras there are as many nameless people included as there are big name leaders. Rivera also depicts these leaders in a "post-heroic" way that does *not* directly spotlight any of them to emphasize their importance unduly or arrange the composition hierarchically.

No less revealing is how Rivera not only orchestrates forces to imply conflict in *The Porfirian Era*, but also strikes a deft ideological note by clustering the apostles of positivism (Barreda, Sierra, Limontour, and *los Científicos*) in front of Porfirio Díaz and Victoriano Huerta, behind whom are signs for foreign owned corporations such as Standard Oil. As is the case with the central panel forces in 1810 and 1910, Rivera implicitly identifies leaders in this second bay by showing reactionary forces on the viewer's left half (Díaz, et al.) and progressive leaders on our right half (Zapata, Montaño, Pancho Villa).

The third — and also central — bay area of the main wall contains portraits on the right side of revolutionary leaders from Hidalgo and Morelos through Zapata and Carrillo Puerto. (Not surprisingly, Zapata

is the only historical figure to appear twice in the upper register of these five bays.) With adroit understatement, Rivera has placed his patron Calles on the "reactionary" left side of this panel, both opposite and below Zapata and immediately behind Emperor Augustín de Iturbide. Iturbide was the first head of state after Independence in 1821 and he was driven from power in 1823 — just as Calles himself would be exiled from Mexico by Cárdenas in 1936, around five years after Rivera had finished this mural! Armed popular militia, with their backs to us, anchor this area visually to a certain extent.

Yet no sooner has the spectator become accustomed to this way of dividing up the second and third bays into a reactionary left side and a progressive right half than the format is reversed in the fourth bay. There Benito Juárez, who holds the liberal Constitution of 1857, is placed on the left side, while two ultra-conservative figures (Archbishop Labastida and Miguel Miramón) are located on the formerly "good" right side in opposition to Juárez. Along with the *metalepsis,* or chronological reversal, that structurally accounts for the nonchronological order of these five bays, there is also a reversed placement that occurs as well. Below the upper register of these five bays is a huge sweeping and densely interwoven kaleidoscope of figures, both good and bad, from the Conquest through the early Colonial Period.

Far from being arranged in some easily identifiable Manichean framework of progressive and regressive forces in Mexican history, though, this expansive foundational area in the lower and middle sections on the main wall of the stairway, entitled *Spanish Conquest and Colonization,* gives us traces of a very irregular process of historical development entailing, simultaneously, both gains and losses by forces not entirely at one with themselves. Contrary to the standard view of Rivera's work, there is no one-dimensional vilification of the Church. Instead, Rivera portrays both progressive figures, such as Bartolomé de las Casas and Bishop Vasco de Quiroga, and regressive ones, as in his depiction of the Inquisition and the burning of Indian manuscripts.

Similarly, Rivera neither idealizes pre-Columbian Indians here nor does he represent them as mere victims of history. In a key position on the lower left of the main wall, the Tlaxcalan are shown to be allies of the Spaniards during their conquest of Mexico. Along these lines, and in a prominent part of the central area, Rivera has painted the image of an Aztec with his back to us who offers a human heart to the National Eagle in the middle of the composition, thus acknowledging the practice of

human sacrifice (and, by implication, the repression on which it was based), even as the same area of the mural also depicts the heroic resistance of the Aztec warriors to the horrors of the Spanish Conquest.

The complexity of Rivera's viewpoint offers a notable point of departure for analyzing the very impressive and compositionally "clarified" fresco on the right, or north wall, with its crisper outlines, bold flat passages of color, and stark silhouettes (Figure #15). Actually the first of the three walls to be executed, this painting is both the earliest in historical time and the last in terms of Western chronological placement from right to left. This panel, *The Aztec World*, was Rivera's first panoramic presentation of pre-Columbian civilization and attests to the remarkable range of Rivera's research into the country's past.[31] This mural is compositionally centered to a greater extent than are the other two, although it would be erroneous to see this work as being centered in any conventional manner. Overall, it is still a montage of richly interlaced scenes.

The upper middle part of the painting is centered on the "good priest" Quetzalcoatl, the feathered serpent, who is shown as bearded and fair. According to accepted accounts, he was driven from the Toltec imperial capital of Tula and he vowed to return on an anniversary of his birth in the year Two Reed. (The fact that the fair and bearded Cortéz arrived in Mexico in a Two-Reed Year made Moctezuma afraid of him for religious reasons.) Here, Quetzalcoatl is shown seated in front of his pyramid-temple with a crowd of white-robed Indians who kneel calmly before him. He is depicted with his traditional attribute of a curved staff and wearing a commanding headdress of green quetzal feathers. A pectoral in the shape of a cross-sectioned conch shell is on his chest. Subsequently, this symbol is normally associated with Quetzalcoatl's avatar, the God of winds, Ehecatl.[32]

Above the group in the sky, Quetzalcoatl is depicted again, only this time astride a huge serpent that flies away from the central solar disc. Along with the image of the erupting volcano, this disc is shown upside down so as to portend catastrophic things to come. The clothing of the serpent-riding Quetzalcoatl was derived from the indigenous representation of this figure in the *Codex Florentina*. Here he flies towards the east, in the distance of which is shown the morning star, Venus, a manifestation of Quetzalcoatl.[33]

Arranged around Quetzalcoatl are various groups that signify through their activities the productivity and sophistication of pre-Columbian civilization: dances before ripe cornfields; music with percussive

instruments; weaving on backstrap looms; artists and artisans producing paintings, sculpture, and featherwork. Conversely, Rivera balances this affirmative view of the advances of the Aztec period with criticisms of the repression during the pre-Hispanic period. As such, Rivera concretely attests to the dictum on history by Marx that he painted on the opposite wall, namely, that the history of the world is the history of class struggle.[34]

One scene that demonstrates this particular reading of history, whatever the culture, is on the north wall and shows Indians carrying tribute to an authoritarian warlord. Another scene in the *Aztec World* (Figure #15) shows actual armed resistance to the Aztec warriors who are depicted in the wardrobes of their military castes. This unequivocal treatment of "aboriginal class struggle" again reminds us of how Rivera has not idealized the pre-Hispanic people in this mural, thus confirming his alternative *"indigenismo"* (Indianism) during this period of his career. As one commentator has aptly noted, Rivera here represented the pre-Colonial period of the Valley of Mexico "from the social revolutionary perspective that is indissociable from Mexico's historical experience and its new consciousness as a self-governing people."[35]

The third and final wall of the pictorial trilogy in the stairway to be completed was the south wall on the viewer's left (7.49 x 8.85 meters). It is located directly across from the *Aztec World* and, though the last chronologically of the three paintings, it is the first one in chronological placement when one is reading the three from left to right in keeping with Western tradition. This painting, which features yet another idiom of the overall visual language that he used in the National Palace, is a montage arranged in a much more grid-like compartmentalization of space than are the other two.

This fresco, which is more tendentious than the other two, does not read from right to left, but reads roughly along the sinuous line of a reverse S-curve, beginning at the base and moving upward. The lower area features a look at the roots of social conflict: campesinos working in the fields and also being martyred there; laborers being exploited; students disputing ideas; and union members rejecting conservative thought in the university. Higher up in the center area there are sections partitioned by the pipelines that frame the causes of social insurrection: the antidemocratic role of foreign capital (which features portraits of John D. Rockefeller, Jr., J. P. Morgan, Cornelius Vanderbilt, and Andrew Mellon); the triad currently leading reactionary forces in Mexico in 1934–35 (military leaders, conservative clergy, and traitorous politicians — thus, *Calles is portrayed*

here); corrupt journalism; and the decadence of high society.

On the upper right workers are repressed and then, slightly above this scene, they are shown rising up in armed revolt in *downtown Mexico City*. (The fact that such armed mobilizations by the popular classes were actually occurring while the mural was being painted is a key consideration in the interventionary role of this painting to which we shall return.) Above everyone else there is a large portrait of Karl Marx that is clearly the compositional keystone both thematically and formally for the mural. He holds a copy of the *Communist Manifesto* and points towards a future when class conflict has ended during a period of general prosperity for all of humanity. In a certain sense, this portrait and its message about the role of class struggle in *all* historical epochs also functions as a coda for the iconographic program of the stairway murals as a whole.

What then of the historical position of this concluding mural, which was done during the Cárdenas years (1934–40) and, indeed, at a moment when the popular forces allied to Cárdenas were engaged in a crucial power struggle with the increasingly right-wing forces of Calles, the strongman of Mexican politics? Was Rivera simply painting didactic images of abstract gestures? Or, was he, in fact, painting a mural destined to have a concrete, interventionary role in one of the most notable popular struggles of modern Mexico? Was he simply using populist rhetoric at a time when the acquisition of power by the majority was not at issue? Or was Rivera painting a mural that was part of the mobilization of popular forces during a time when a momentous shift for a half dozen years or so did actually occur in Mexico?

THE HISTORICAL LOCATION OF
RIVERA'S NATIONAL PALACE MURAL IN 1935

The answers to all of the above questions emerge easily enough, if we simply recapitulate what was occurring in the streets of Mexico City simultaneously with the making of this mural by Rivera. Owing to the onset of the Depression worldwide, the progressive tendencies of the highly reform-minded United States Ambassador to Mexico for the Roosevelt Administration, Josephus Daniels, and the increasingly loud clamour for deep structural change by the popular classes in Mexico, the left-of-center Lázaro Cárdenas, then Governor of Michoacán, was elected President with Calles support. (Calles, no doubt, erroneously assumed that he could

moderate Cárdenas' policies and dominate the country's chief executive as he had done for the previous decade.)

The sweeping changes that Cárdenas either initiated or consolidated were accompanied by the very astute maneuvering of the military into a position of neutrality, all of which allowed him to outflank Calles. The dramatic changes associated with Cárdenas' "Six-Year Plan" included the following: 1) a reduction of Mexico's dependence on foreign markets; 2) the institution of deep structural change in the agrarian sector specifically, an historic program of land grants to rural wage labor; 3) the enforcement of a minimum wage law passed in late 1933; 4) the development of Mexican enterprises at the expense of foreign corporations; and 5) the consolidation of constitutional reforms in 1934 that made national education "socialist" (that is, based on the aim of "educating to community responsibility") and also greatly expanded education's scope through a national literacy campaign.[36]

Far from moderating the calls for change on the part of the popular classes, these measures by Cárdenas emboldened the laboring classes to demand much more, as well as to take up arms to obtain it, and frightened the affluent sectors, which included Calles. In this sense, Cárdenas both inspired popular mobilization and was himself propelled forward by it. This particular combination of heightened class militancy from the working classes and Cárdenas' own need to marshall additional support *outside of government* — if he were to carry out a radical program of social and economic transformation over the opposition of Calles and the forces allied to him — led the new President to align himself with the left wing of the labor movement. This meant backing the main force behind the labor unrest, in Mexico, namely, the *General Confederation of Workers and Peasants* (C.G.O.C.M.) of which Rivera was a supporter.

By recognizing labor's right to strike and by aiding the further development of the C.G.O.C.M. through a series of legal decisions against the private sector, the Cárdenas administration both extended and radicalized the state-labor alliance that had been begun more tentatively by Obregón before being largely co-opted by Calles in the late 1920s. A consequence of this notable shift to the left by Cárdenas was that by 1936 the C.G.O.C.M. — which was under the leadership of Rivera's close friend, General Secretary Lombardo Toledano, and included 3,000 unions with over 600,000 members — became the officially recognized national labor union and was renamed the *Confederation of Mexican Workers* (C.T.M.).[37] All of these changes came at the expense of the far smaller

and more conservative "official" labor unions associated with Calles.

When Cárdenas seemed to waver at times about carrying out his radical program of 1934–35, militant elements in the working class organizations stepped up the pace of strikes and mass mobilizations, thus forcing Cárdenas to deepen his alliance with the urban working class *and* the campesinos, along with certain sectors of the middle class (intellectuals and professionals). This move, in turn, encouraged more mass actions that were directed at the wealthy sectors of Mexican society. It was in this situation that on June 11, 1935, Calles reentered the public arena to denounce all strikers and to call for the government suppression of the strikes. In his public speech, Calles both red-baited union leaders, like Toledano, and challenged Cárdenas to "restore order," *or else.*[38]

On June 13, 1935, Cárdenas responded with a public address in which he declared that many of the demands of labor were reasonable and that meeting them, rather than suppressing them, would be the best way to create genuine stability, especially if all of this were done realistically "within the economic possibilities of the capital sector."[39] Subsequently, Cárdenas both encouraged workers to form a "united front" and warned capitalists that if they tried to cease production or decapitalize "because of the demands of the unions," that the factories would be expropriated by the government and either turned over to the workers or left in the hands of the state.[40]

A powerful, even awesome, popular response to this public debate was quickly registered. The working class, led by leaders of the railway workers and electricians unions, reacted to Calles' threats with a huge general strike and branded Calles as a traitor to the Revolution. Conversely, these unions applauded Cárdenas' speech. The situation of 1935 and its long-term results have been aptly described by historian James Cockcroft:

> Throughout the class turbulence of 1935 and early 1936, many political figures previously loyal to Calles noted the changes. . . . They grew increasingly awed by the sight of tens of thousands of workers marching in the streets, threatening a general strike in support of Cárdenas. They understood the shift in political balance when they saw the president arming 100,000 peasants and lesser numbers of workers to form peasant and worker militias in the name of resisting armed reactionaries and an "imperialist threat." . . .
>
> Overcome by the deterioration in their own ranks and by the newly fashioned labor-government alliance, Calles and C.R.O.M.'s

Morones the conservative labor leader] were put to rout, or, more precisely, deported (in April 1936).

Once again, a new political leadership had met the rising demands of the workers part way, and in so doing had replaced the older, more recalcitrant political leadership. . . . Once again it was the actions of the working class, through large-scale strikes and demonstrations, that had precipitated the change.[41]

This historical context for Rivera's 1935 National Palace mural (Figure #16) helps us to appreciate just how much the painting was done in organic relation to the same popular insurgency that is portrayed in the fresco itself. The mural is marked by a chilly, even shrill, use of high-value blue throughout that is notably at odds with the color scheme of the other two National Palace murals. In addition, the painting is characterized by a briskly taut composition and a bracingly crisp neo-classical line that distinguishes it as well. All of these formal attributes have to do with Rivera's sense of historical urgency on behalf of popular demands, rather than with the isolated posturings of an armchair populist as is sometimes erroneously assumed about Rivera.

In this case, the one hand, the didacticism is defensible, since it is the pictorial manifestation of a mobilized labor movement with a clearly defined set of demands for which a public dialogue *had already taken place*. On the other hand, the visual language of this mural neither refined nor expanded the communicative resources of Rivera's aesthetic. Stranded somewhere between "alternative modernism" and "socialist realism," this mural was in no sense an artistic breakthrough, even though its political import can now be seen to have been considerable. As such, it remains a period piece in the most profound sense, owing to the tight fit between its topical aims and the period goals of the labor movement. Yet the very nature of this tight linkage between the art and period politics perhaps explains the relative lack of admiration now elicited by this mural, in relation to some of Rivera's other murals.

THE NATIONAL PALACE MURALS
AND EPIC MODERNISM

As Dawn Ades has observed, an epic project such as the stairway murals of the National Palace (1929–35) is allied to the common Latin American

belief in the "social purpose and responsibility of the artist," which is hardly surprising given the "vast and inescapable problems haunting the southern half of the hemisphere," and it is "most evident in the work of the Mexican muralists."[42]

What about the epic nature of the National Palace murals in more international terms? In a strict sense, an epic is a lengthy narrative poem on a great subject conveyed in an elevated style and centered around an heroic figure on whose actions depend the fate of a people. In English literature, John Milton's *Paradise Lost*, which deals with the spiritual fate of humanity as a whole, is the most famous example in this elevated, high-minded manner. Earlier, Virgil had addressed the destiny of the Roman people in *The Aeneid*, an epic that influenced Milton's great work.[43]

Yet these two "secondary epics" were, in turn, based on the earlier and more traditional "primary," or folk, epics, such as *The Illiad*, *The Odyssey*, and *Beowulf*, which were shaped by literary figures from historical and/or mythic materials that had been developed through the popular oral traditions of an entire people or nation. Ranked second in importance after tragedy by Aristotle and considered the highest ranking category of all during the Renaissance, the epic makes immense demands because of its scope, grandeur and variety on the inventiveness, knowledge, and skill of the artist. Not surprisingly, the successful epic is quite rare in modern literature and hardly more common in the visual arts.[44]

In order to better understand how Rivera both used and went against the epic at the same time, it will first be necessary for us to outline the characteristic and organizing conventions of the epic. The primary features of the traditional and secondary epics are generally: 1) the hero is a figure of national or even cosmic importance; 2) the setting is sweeping in scale; 3) the action involves a long and arduous journey or heroic deeds in battle; 4) the actions are of interest to the gods; and 5) the style is ceremonial and proportional to the grandeur of the subject (Milton's "grand style," for instance, involved Latinate diction, sonorous allusions, and epic similes).[45]

Commonly used conventions for organizing the epic are: 1) the narrator begins by stating his argument or theme, invokes a muse or guiding spirit, and asks the *epic question* that will be answered; 2) the narrative begins *in medias res*, that is, "in the middle of things," at a critical point in the action; and 3) there are extensive lists and catalogs of the principal characters that lend an imposing quality to the conflict or trial at hand.[46]

How, then, do all of these qualities and conventions of the traditional epic relate to what Meyer Schapiro called the "epic modernism" of Diego Rivera? The complex relationship enjoyed by Rivera's epic modernism to traditional modernism is revealing. For example, "heroes" are depicted in the National Palace, but not in epic terms, since they merely denote larger historical forces — which are the real epic protagonists of Rivera's murals. Furthermore, these historical forces are neither predestined nor simply "natural," since they actually function as critiques of what has been called the "natural order" within society. Similarly, even when Zapata appears he functions more as a trope for anonymous popular forces than as an individual agent in his own right.

What is the epic scope of Rivera's murals? Nothing less than several centuries of conquest *and* resistance to it that cover all of Mexico and beyond. Does the action of Rivera's epic murals involve a long journey or great struggle? Of course, and this national struggle for a non-Eurocentric identity (which nonetheless contains European elements) corresponds to a larger class struggle on behalf of all humanity. The end of this historic struggle and long march for humanity's redemption is found in the lines beside Karl Marx in the "last" mural: "The history of *all* hitherto existing societies is the history of class struggle. . . . It is not a matter of reforming existing society, but of forming a new one."[47]

Is the visual language of the murals in a standard epic style, that is, a ceremonial or grandiose one? Yes and no. The sheer range and density of the syntax on a continuous surface of 275 square meters is unquestionably *grand* in several senses, especially when one ponders the exacting medium employed to execute it. Conversely, the huge mural on the central wall is nonclimatic (though not anticlimatic), because the painting is a huge montage, or "collage," of various moments in Mexican history without any linear development, standard plot, or clear resolution. This splayed and riotous competition of disparate, sometimes conflictual, figures and events reminds us that the theme, like the visual language, is conjunctural in the broadest sense.

If it is a "grand style," it is grand by virtue of the considerable number of visual languages that Rivera has synthesized to form it: from "renovated classicism" with its distinct contours to the all-over nature of montage and Cubism, along with the densely imbricated space characteristic of pre-Columbian art, all of which generates a spatial tension between two dimensions and three dimensions, between space that threatens to expand and forms that constrain, between events that are actual and those that

embody the promise of the future. All of these hybrid and nonlinear formal attributes remind us that the murals all begin *in medias res,* in the middle of things, without any one line of development or conclusive resting point.

Quite literally, to walk up the stairway is to see the murals in the middle of Mexican history, which is not only in keeping with the traditional epic but also with the collage aesthetic of "alternative modernism." The sense of being visually in the middle of epic forces powering to the fore and featuring *metalepsis,* or chronological reversal, along with an all-over and decentered field, is probably the most elemental perceptual experience yielded by the mural for spectators. In fact, Rivera's decision *not* to center the painting with a huge allegorical figure of Mother Mexico nurturing her children (as is shown in a study for the mural) led to censure by the Communist Party. However open-ended the Mexican Government had left the commission, the Communist Party had not, and it wanted a traditional symbol anchoring the entire painting — which would have made it hierarchical in nature.[48]

What "epic question" is asked? The question posed is nothing less than the ultimate course of human history, with Mexico being the particular place where this development is concretely known. The trilogy of murals in the National Palace (Figures #14, 15, 16) feature a tragic past, an undecided present, and a hopeful vision, which, if realized in the "classless future," will redeem all the rest. As for great lists or catalogs of the protagonists involved, Rivera's mural is overflowing with images of them. Yet in "post-heroic" fashion there are no abstract personifications, like the Statue of Liberty or Washington crossing the Delaware, to be seen in dramatic isolation. Too grand for these grandiose images, Rivera's densely packed murals dwarf all heroic figures, with the exception of the mural cycle's muse, namely, Karl Marx. If Marx is the main historical muse of the murals, there is, nonetheless, a secondary "guiding spirit" in the center of the main wall. This is the huge allegorical eagle from Aztec mythology that holds in its beak the red and blue banners representing the Aztec symbols for war — with war itself being a consequence of *class-based* societies.[49]

In conclusion, it is worth noting that there is a striking overlap between what Brecht considered the innovative attributes of his own "epic theater" and what we have analyzed here as the "epic modernism" of Rivera. In an essay of 1930, Brecht summed up how his own particular mixture of modernist formal ambiguity and political didacticism added up to a new

"non-Aristotelian" chapter in the history of the theater. If we simply enumerate the attributes that he outlined for "epic theater," we end up with a set of characteristics that, in virtually every major case, correspond precisely to what was so distinctive about Rivera's "epic modernism" in painting.

According to Brecht, "epic theater" of the 1920s and 1930s entailed the following critique of traditional theater: 1) the use of an open-ended narrative rather than the use of a closed plot; 2) the desire to arouse the spectator's "capacity for action" in life rather than the wish to absorb the spectator into an imaginary situation disconnected from life; 3) the delineation of a "picture of the world" that forces spectators to "take decisions" rather than the provision of an illusionary experience for viewers that promotes contemplative passivity; 4) the presentation of the human being as "the object of the inquiry" in art and one that is "able to alter," rather than the standard move of taking the human being for granted as "unalterable;" 5) the use of *montage* rather than a framework of organic growth; 6) the uneven representation of history "in curves" and in "jumps" rather than a reliance on the standard concept of "linear development" that is, in turn, based on a conception of "evolutionary determinism;" 7) the presentation of "man as a process" rather than the belief in "man as a fixed point;" and, 8) an appeal more to reason than to feeling.[50]

This latter point about "epic theater" was elaborated upon by Brecht as follows:

> Once illusion is sacrificed to free discussion, and once the spectator, instead of being enabled to have an experience, is forced as it were to cast his vote; then a change has been launched which goes far beyond formal matters and begins for the first time to affect the theater's social function.[51]

The remarkable affinity between Brecht's "epic theater" and Rivera's "epic modernism" occurred because both artists produced examples of a hybrid "alternative modernism" that was adroitly based on a resourceful deployment of the ideas of classical Marxism. If John Heartfield (whose work Brecht admired) was the visual artist in Europe closest to Brecht, then Rivera was the non-European artist whose achievement most closely approximated that of Brecht. Accordingly, the two related epigraphs by Brecht and Rivera about the proper *subject of history and of art*, which

were at the beginning of this chapter, were each intimately related to a
critical assimilation of the epic and of modernist montage.

RIVERA'S MURAL IN 1934 FOR
THE PALACE OF FINE ARTS

Another work that Rivera produced in the early Cárdenas years remains
one of his greatest and most epic murals, though not one of his largest.
This is the superb fresco from 1934 in the *Palacio de Bellas Artes* (The
Palace of Fine Arts) in Mexico City. Entitled *"Humanity, Controller of the
Universe"* (4.85 x 11.35 meters), it is the second version of a mural (Figure
#17) that was originally designed for Rockefeller Center in New York
City but was censored in 1933 and then destroyed in 1934. Upon his
return home in late 1933 the Mexican Government gave Rivera a
commission to duplicate the mural, albeit on a smaller scale.[52] This
contract for the painting was a result of the popular resurgence that had
already begun with the P.N.R.'s national convention in December 1933
at Querétaro, where the "Six-Year Plan" was unveiled and Cárdenas
became the party's presidential candidate.

In March 1934 *L.E.A.R.* (The League of Revolutionary Artists and
Writers) was founded with Diego Rivera as advisor to Leopoldo Méndez,
Juan de la Cabada, and Pablo O'Higgins. Their first periodical *Frente a
Frente* (Face to Face) expressed scepticism about Cárdenas' candidacy and
whether or not he would really follow through with his radical program,
since both had first been endorsed by Calles. Nonetheless, with the
radicalization of the Cárdenas administration, there would soon be new
opportunities for public mural art, with this particular group of artists
gaining from these new developments. In fact, in 1935 Rivera would be
placed in charge of approving all of the designs for public murals
commissioned by the Cárdenas government.[53]

In November 1934, when Cárdenas was assuming the presidency,
Rivera began his mural for the National Palace of Fine Arts. Completed
before the end of the year and located in the symbolic center of Mexico
City's cultural life, this mural is "the work most symptomatic of Rivera's
distinctive way of thinking, along with being one of the most unified and
refined examples of his particular expressive mode."[54] One of the most
compelling murals in the direct lineage of his own Anáhuac Cubism,
Rivera's painting also owes an obvious debt to Soviet cinema of the late

1920s. Dziga Vertov's *Man with the Movie Camera* comes to mind immediately, because of the way that different strata of figures going in competing directions have been spliced together in the Rivera mural. Furthermore, Sergey Eisenstein had been in Mexico during the early 1930s in order to make his film *Que Viva Mexico!* — a film that he dedicated in part to Rivera whom he had first met in 1931.[55]

Easily one of the most masterful compositions of Rivera's entire oeuvre, this fresco (Figure #17) shows both humanity at the crossroads of history and situates the entire ensemble in a dense network of converging forces. The specific choices demanded of the spectator at this particular historical juncture by Rivera clearly were seen to have profound implications for whether or not scientific thought and modern technology would be employed to progressive or reactionary affect, that is, in favor of social advances or on behalf of social repression. The mural is about the necessity of critical thinking and the need to make momentous, even epic-making, decisions.

Just as the soulful Soviet-looking worker dressed in overalls and representing humanity hovers in the center of this mural, so the direction of history also appears to hang in the balance in 1934 within Rivera's *tour de force* composition based on what he called "dynamic symmetry."[56] Notwithstanding the optimism of the title and Rivera's own hopes that were then buoyed by what was happening with the popular mobilization in Mexico, the painting is actually about *the promise,* or *the potential,* of the present — and not about some preordained future victory by the left — at a time when the successive victories of fascism in Europe (especially that of the Nazis in Germany in 1933) would have moderated or clouded Rivera's sense of any immanent victory by progressive forces. In the best tradition of "epic modernism," this painting uses a montage of colliding forces, the resolution of which depends upon spectator intervention.

The motifs that manifest Rivera's iconography about the contingency of history in relation to human praxis (hence, Rivera's "voluntarism") are quite original ones. The urban worker signifying humanity and ensconced in the center of an imposing, if not intimidating, technological setting has one hand on a lever or throttle, the other on a panel of control buttons. Two great ellipses, in a propeller-like configuration, intersect diagonally behind the worker/pilot protagonist in the middle of everything. This mechanical setting consists of huge wheels in the background that recall similar motifs employed by the Russian Cubo-Futurists or by North

American photographers like Lewis Hine. The ellipses symbolize, respectively, the microcosm as seen through the microscope and the macrocosm as seen through the telescope.

Below this "collage," Rivera introduces both botany and geology into the frame by depicting plants indigenous to Mexico and the local geological strata beneath the soil that sustains them. In the competing compartments on each side are, on the viewer's right, Lenin surrounded by urban workers *and* campesinos of various ethnic groups. Counterbalancing this on the spectator's left is a nightclub scene of the wealthy at leisure, which includes a portrait of John D. Rockefeller, Jr. Behind and above these two compartments are yet more areas seen from varying vantage points and diverse distances, all of which are spliced together in a manner that recalls Vertov's masterful use of montaged scenes in his finest film.

The "portals" around Lenin depict crowds of "red" workers mobilizing and lines of female dancers or athletes performing. (There is an important passage about the physical prowess of female athletes in Vertov's *Man with the Movie Camera*.) Surrounding the nightclub compartment on the opposite side are scenes of workers being attacked by police, above which are shown lines of gas mask-wearing soldiers surging towards the advancing workers in the upper register of the other side, with the machine complex in the center separating them.

Further flanking Lenin on the viewer's right is a large section portraying revolutionary leaders, both living and deceased, of the working class, which includes Marx and Engels, as well as Trotsky, Jay Lovestone, and Bertram Wolfe, all of whom carry a banner proclaiming the Fourth Socialist International (to which Rivera belonged at this time). Across from this passage we are given a glimpse of the antihuman uses of both technology and science (soldiers using poisonous gas and war planes). Below on the left, however, we see a salutary application of science and technology in an area where there is an audience of mannerly people representing various ethnic groups who look intently through the huge telescope. Further to the viewer's left is the figure of Charles Darwin who simultaneously points both to the x-ray of a human skull and to a monkey below it, thus linking humanity scientifically to the animal kingdom.

The demands made by Rivera's mural on the spectator, owing to the complexity of the work and the competing directions at hand in it, mount an appeal to the spectator that is more intellectual than emotional, despite the urgency of the situation. This largely cerebral appeal — again in

keeping with Brecht's rational aims in his "epic theater" — contrasts decidedly with the nature of the spectatorial appeal to be found in two other great mural paintings across from that of Rivera's in the Palace of Fine Arts.[57] These murals are *Catharsis* (1934) by José Clemente Orozco and *The Birth of the New Democracy* (1945) by David Alfaro Siqueiros, the first of which is about an apocalyptic convulsion (fascism?) and the second of which is convulsively triumphant. Each of these three paintings is a masterpiece in the corpus of the artist who produced it, so that the artist in each case is shown to best affect.[58]

Aside from the way that both the Orozco and the Siqueiros unremittingly appeal, indeed at times overwhelm, the viewer in emotional terms, there is also an apocalyptic quality that emerges from both of these huge works. These apocalyptic overtones cause both of these paintings to operate quite differently from the urgent but nonmessianic fresco by Rivera. Each of these other two paintings compellingly charts the impersonal sweep of history and it is not by chance that both the Orozco and the Siqueiros show figures in colossal or superhuman scale, unlike the Rivera where people appear in slightly larger than human scale.

In doing so, neither the Siqueiros nor the Orozco relates to the spectator in terms of rational choice or individual agency, while the Rivera does both. Hence, Siqueiros offers the viewer a free ticket on the train of history, which supposedly operates according to its own predetermined schedule, while Orozco gives the spectator a searing glimpse at the catastrophe called "historical progress," which holds little hope for the future and no possible redemption for humanity. It was this point to which Bertram Wolfe was referring when he made the following comparison between Rivera and Orozco:

> If Rivera has painted what the Revolution should be, what it should have become if it were to realize the visions of its Flores Magóns and Zapatas, Orozco has painted what the Revolution [often] had been. . . . Negative criticism of the Mexican Revolution is contained in Rivera's work too, but it is subordinated to an emphasis on dreams of fulfillment. Orozco's outlook was pessimistic and skeptical. . . . [I]n all his Mexican Revolution series there is no sign of recognition in its unhappy present of any seeds of a better future.[59]

If the Rivera fresco mural in the Palace of Fine Arts is optimistic, it is guardedly so, because Rivera does not assume here that history *necessarily*

will work out, whatever humanity does. Rather, he appeals hopefully to the spectator to make the choices whereby it will work out owing to a type of human intervention that will create the conditions for humanity's historical redemption. The future course of history is then understood in nondeterminist terms to be *contingent* upon concrete human choices. This, in turn, reminds us of the interventionary role repeatedly assumed by Rivera's "voluntarist" artworks. At once composed and unsettled, the Rivera mural is about the contradictory unfolding of history, which discloses both the negative features of society to date and the positive promise for overcoming them in the future. Conversely, for Siqueiros's orthodox Marxist and messianic message the "true" course of history ultimately transcends any of its current contradictions, while for Orozco history is simply consumed by its horrible contradictions.

To the hackneyed Nietzschean question — is Rivera's work Apollonian or Dionysiac? — we must answer: it is neither; it is both. A remarkable formal means whereby Rivera maintains this paradoxical, or contradictory, sense of humanity at the crossroads is through his unsurpassed use of color interaction to create counterbalancing perceptual affects. Seldom in modern art has the interplay of cool colors and warm hues been used so aptly to generate both a sense of cool critical detachment and a matching sense of human warmth through solidarity. Primary hues prevail in the densely impacted central area and are in evidence in the various side compartments. The metallic quality of the machine looming above the person representing Humanity is achieved through a use of yellows and greens that impart a hard clean look that is, nevertheless, not without a certain resonance, or even coloristic, warmth.

Below the ellipses, high-value blues and high-value yellows (in conjunction with browns) are counterposed with a red at normal value in the leaping flames of the sun to harmonize the whole in terms of the primary colors seen at generally high value. The result of this color interaction seems guardedly celebratory. The icy high-value greenish blue of the x-ray image in the left area denotes scientific detachment, while the pervasive use of red seen at normal value on the right side signifies a sense of social proximity through the mass mobilization of Russian workers who advance singing "The International."

Overall, then the color range, like the value range, is extremely broad and highly nuanced. Here one may speak of a "dialectical" use of color interaction to foster a perceptual experience that is analogous to Pablo Neruda's contention that profound art links solitude with solidarity,

critical detachment with human nearness.[60] Finally, this subtle use of color, like the compositional complexities noted above, finds a compliment in the deft, even delicate, neo-classical line that delineates forms so tellingly throughout the entire painting. Thus, just as Rivera has a claim on being one of the great draughtsmen of the twentieth century, he should also be considered one of the greatest colorists of the first half of our century as well.

It is hardly surprising, given the internal merits of this 1934 mural and its larger extra-artistic associations at a key moment of the Cárdenas-Calles conflict, that President Cárdenas would have valued the Rivera painting highly. In a tribute to the painter shortly after Rivera's death in 1957, Cárdenas spoke of how Rivera's compassion for humanity, commitment to social justice, and "combative brush" both revalorized working-class indigenous culture and anathematized the legacy of colonialism in Mexico.

> In his [Rivera's] murals, it is as if he is a *campesino* reclaiming the land, as if he is a leader of May Day demonstrations, yet is at the same time imparting scholarly talks in the halls of public buildings, in which he wished to place his talent in the cause of social justice on behalf of the laboring classes, who have been condemned by an exploitative and sterile minority. . . . In the Auditorium of the Preparatory School, in Chapingo, and in the Palace of Fine Arts, he interpreted the genesis of humanity sprouting forth from primal energy, and shaping its own biological and social evolution, before inaugurating the final victory of science and technology in the peaceful aftermath of the future atomic age.[61]

RIVERA'S MURALS IN
THE UNITED STATES

However different from the relation of Rivera's work to the public domain in Mexico, there is an eloquent, as well as lengthy, preamble to *Humanity, Controller of the Universe* that is to be found in the United States in a series of outstanding murals that Rivera executed from 1930–33. Not long after painting the very impressive series of frescoes in 1929 at the Palace of Cortéz in Cuernavaca (which thematically related to the frescoes in the National Palace), and which were commissioned by United States Ambassador Dwight D. Morrow, Rivera was invited to the United States to paint a series

of public murals in San Francisco.[62] Both José Clemente Orozco and David Alfaro Sigueiros would also execute murals in the United States during the 1930s.

As a lifelong partisan of the left, Rivera was deeply ambivalent about the United States because of its history of military intervention throughout the Americas, especially its invasions of Mexico. He felt both antipathy and admiration for the powerful neighbor to the north. As one author summed up Rivera's perspective, "It was the land that had robbed Mexico of half of its territory, bribed and bullied, fomented disorder [in Latin America]. . . . Yet he knew that it could not be regarded merely as an oppressor."[63]

Rivera's ambivalence towards the United States was reciprocated in a country where esteem for Rivera's art was often coupled with a repudiation of his politics. Not long after Rivera accepted the invitation from architect Timothy Pflueger and Arts Commissioner William Gerstle to execute a series of murals in San Francisco, the Mexican artist was denied admission to the United States in 1929 by the State Department. Ironically, at the time that Rivera was being increasingly denounced by the Communist Party as "an agent of North American imperialism" and as "petty bourgeois Zapatista," the United States government declared him a *persona non grata*. Shortly thereafter, the artist wrote to Albert M. Bender, an insurance broker in San Francisco of liberal views who was also an astute patron of Rivera's canvas paintings, to see if the ban could somehow be lifted. A letter of July 15, 1929 by Bender to Rivera stated: ". . . the trouble is on account of Anti-American activities on your part which have found their way to the State Department. . . . [T]he first move should be made by you through the American Consul in the City of Mexico who must visa your passport. Should you receive it and be detained at the port of entry, your friends here will have to render fullest assistance. . . ."[64]

Subsequently, Bender was able to determine through powerful political connections that the ban on Rivera's entry into the United States had come directly from the State Department. At this point, Bender and others appealed to the government to lift this ban on Rivera and to allow him a temporary work permit in the United States. They succeeded in their lobbying efforts and a month later Bender would write to Rivera (August 13, 1929) that "I think that I can advise you to come through to California whenever you are ready. . . . I feel sure that there will be no further trouble."[65] Aside from this crucial intervention, Bender also proved to be the most generous of Rivera's private patrons in San Francisco and the

FIG. 2. *Classical Head*, 1902, oil on canvas, Guanajuato, Mexico, Museo Digo Rivera (INBA). *Photograph © Dirk Bakker.*

FIG. 1. *Head of a Woman*, 1898, pencil on greenish blue paper, Mexico City, UNAM, Escuela Nacional de Artes Plásticas. *Photograph © Dirk Bakker.*

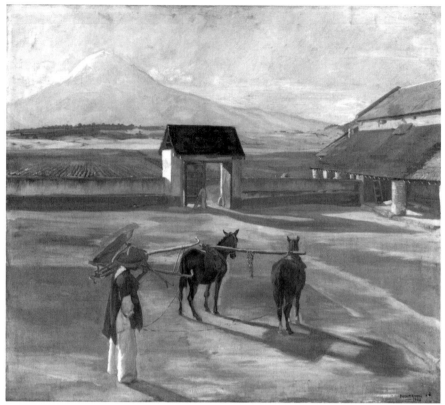

FIG. 3. *La Era (The Era)*, 1904, oil on canvas, Guanajuato, Mexico, Museo Diego Rivera (INBA). *Photograph © Dirk Bakker.*

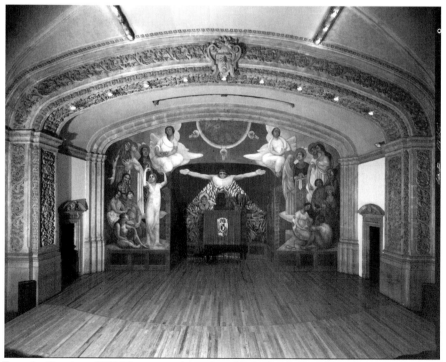

FIG. 6. *Creation*, 1922/23, encaustic and gold leaf, Mexico City, Escuela Nacional Preparatoria, Anfiteatro Bolivar. *Photograph © Dirk Bakker.*

FIG. 5. *Zapatista Landscape: The Guerrilla*, 1915, oil on canvas, Mexico City, Museo Nacional de Arte (INBA). *Photograph © Dirk Bakker.*

FIG. 4. *Portrait of Adolfo Best Maugard*, 1913, oil on canvas, Mexico City, Museo Nacional de Arte (INBA). *Photograph © Dirk Bakker.*

FIG. 8. *The Rural School Teacher*, 1923, fresco mixed with nopal juice, Court of Labor, Ministry of Education, Mexico City. *Photograph by Bob Schalkwijk.*

FIG. 7. *The Embrace and Seated Peasants*, 1923, fresco mixed with nopal juice, Court of Labor, Ministry of Education, Mexico City. *Photograph by Bob Schalkwijk.*

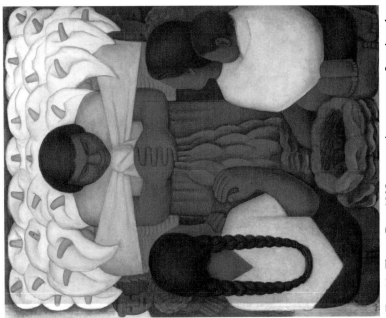

FIG. 10. *Flower Day*, 1925, encaustic on canvas, Los Angeles County Museum.

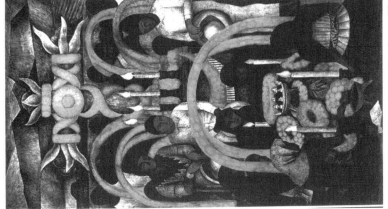

FIG. 9. *The Day of the Dead — The Offering*, 1923/24, fresco, Court of Fiestas, Ministry of Education, Mexico City. *Photograph by Bob Schalkwijk.*

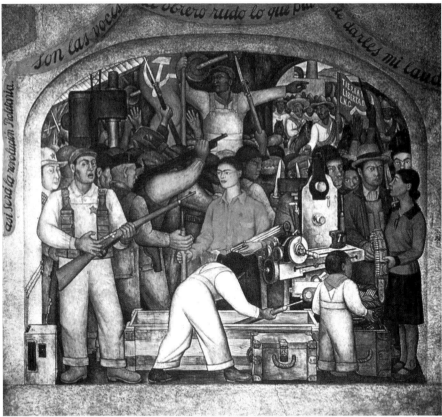

FIG. 11. *The Distribution of Arms*, 1928, fresco, Court of Fiestas, Ministry of Education, Mexico City. *Photograph by Bob Schalkwijk.*

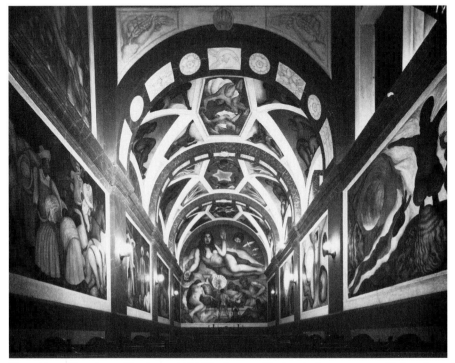

FIG. 12. *Chapel at Chapingo*, 1926/27, fresco, National Autonomous University of Agriculture, Chapingo. The mural on the endwall shows *The Liberated Earth and Natural Forces Controlled by Humanity. Photograph © Dirk Bakker.*

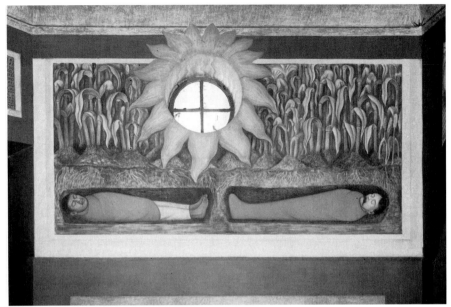

FIG. 13. *Blood of the Revolutionary Martyrs Fertilizing the Earth*, 1926/27, fresco, Chapel, Universidad Autonoma de Chapingo. (This image depicts the buried bodies of Emiliano Zapata and Otilio Montaño fertilizing the soil.) *Photograph © Dirk Bakker.*

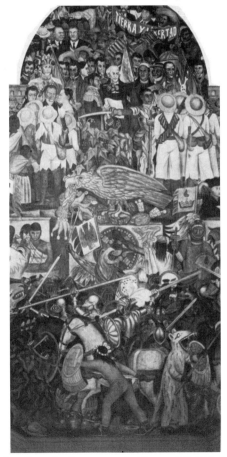

FIG. 14. *History of Mexico: From the Conquest to the Future*, 1929/30, fresco, West Wall (detail), Palacio Nacional stairway, Mexico City. (This detail shows the central bay of the five overall that make up the mural.) *Photograph © Dirk Bakker.*

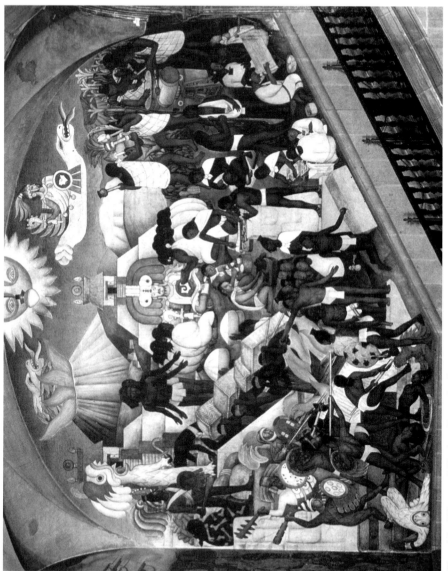

FIG. 15. *History of Mexico: From the Conquest to the Future. The Aztec World*, 1929, fresco, North Wall, Palacio Nacional stairway, Mexico City. *Photograph © Dirk Bakker.*

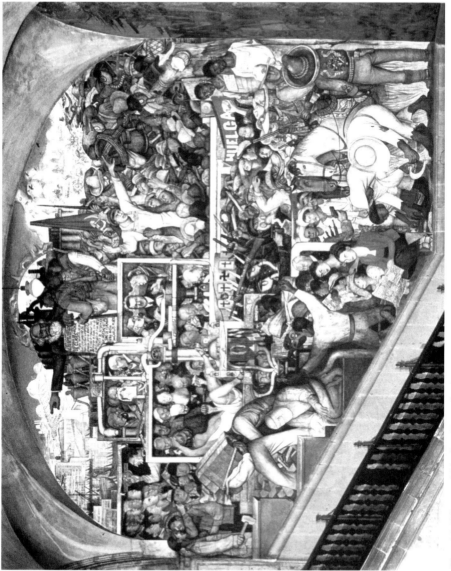

FIG. 16. *History of Mexico: From the Conquest to the Future: Mexico Today and Tomorrow,* 1935, fresco, North Wall, Palacio Nacional stairway. Mexico City. *Photograph © Dirk Bakker.*

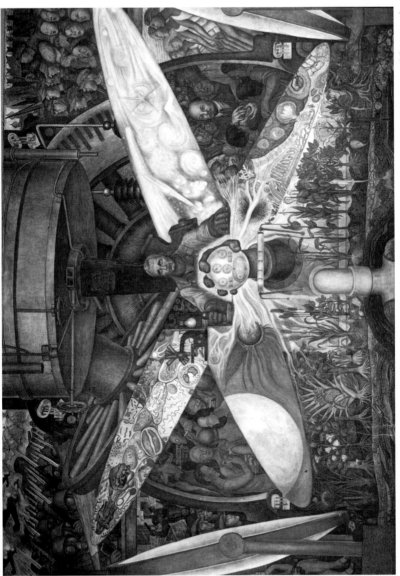

FIG. 17. *Man, Controller of the Universe*, 1934, fresco, Mexico City, Museo del Palacio de Bellas Artes. *Photograph* © *Dirk Bakker.*

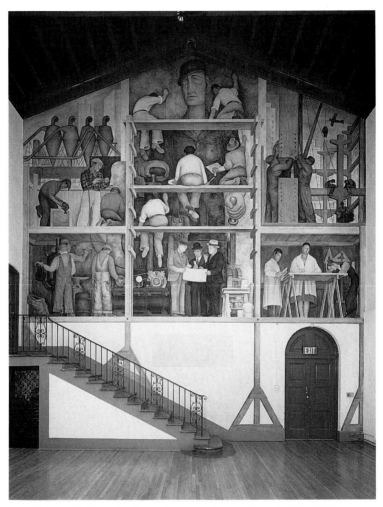

FIG. 18. *The Making of a Fresco Showing the Building of a City,* 1931, fresco, San Francisco Art Institute. *Photograph by David Wakely.*

FIG. 19. *Detroit Industry: East Wall*, 1932/33, fresco. *Photograph © 1997 The Detroit Institute of Arts. Gift of Edsel B. Ford.*

FIG. 20. *Detroit Industry: West Wall*, 1932/33, fresco. *Photograph © 1997 The Detroit Institute of Arts. Gift of Edsel B. Ford.*

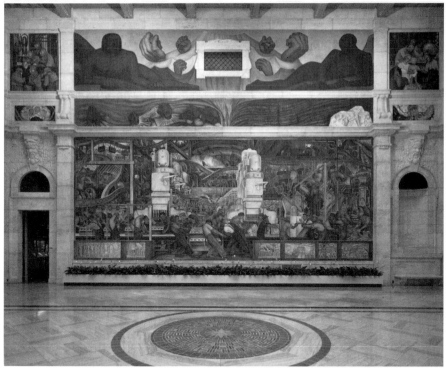

FIG. 21. *Detroit Industry: North Wall,* 1932/33, fresco. *Photograph © 1997 The Detroit Institute of Arts. Gift of Edsel B. Ford.*

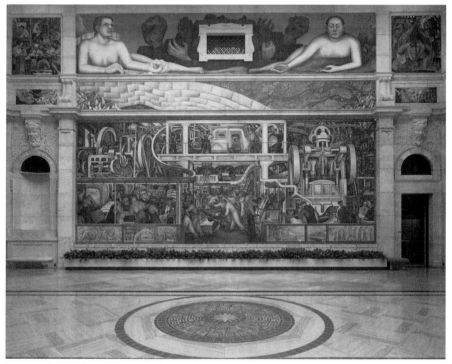

FIG. 22. *Detroit Industry: South Wall,* 1932/33, fresco. *Photograph © 1997 The Detroit Institute of Arts. Gift of Edsel B. Ford.*

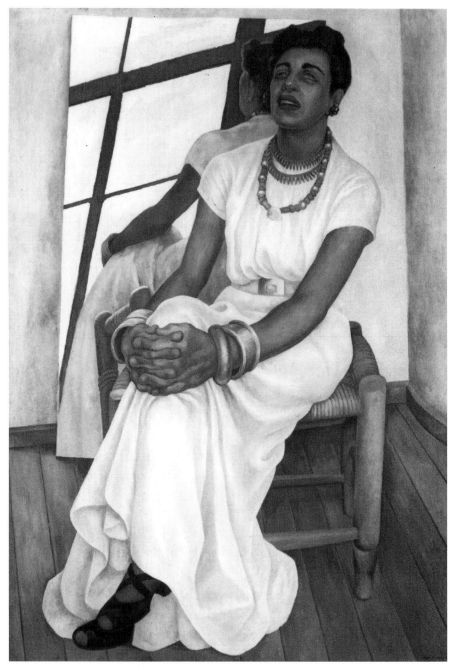

FIG. 23. *Portrait of Lupe Marín*, 1938, oil on canvas, Mexico City, Museo de Arte Moderno (INBA). *Photograph © Dirk Bakker.*

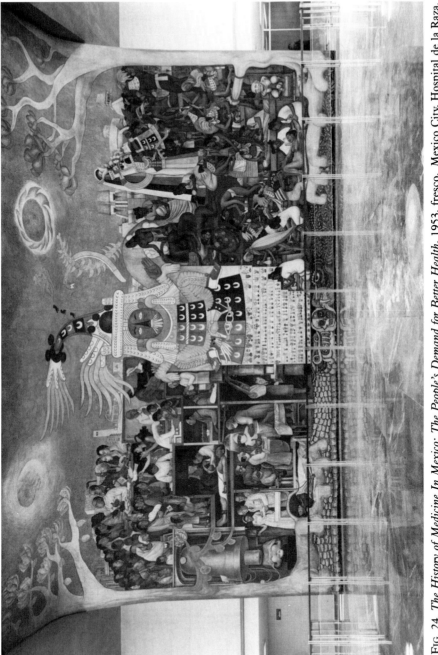

FIG. 24. *The History of Medicine In Mexico: The People's Demand for Better Health*, 1953, fresco, Mexico City, Hospital de la Raza. Photograph © *Dirk Bakker.*

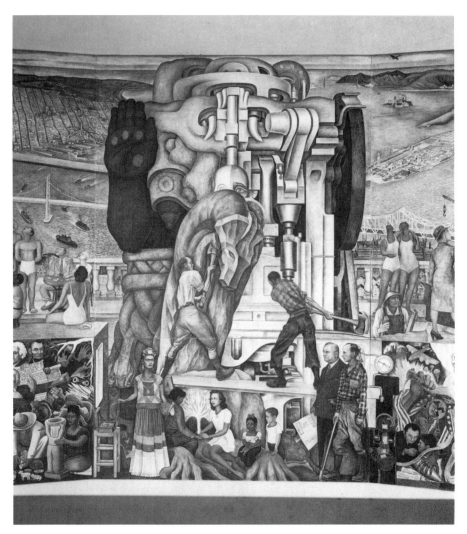

FIG. 25. *Pan-American Unity: Plastification of the Creative Power* . . . , 1940, fresco, City College of San Francisco. (One of five panels in this series.) *Photograph © Dirk Bakker.*

fine collection of Rivera's works in the San Francisco Museum of Modern Art is, in large part, a benefit of his patronage.[66]

Hardly had the problems with the State Department concluded when Rivera was engulfed in a local controversy within the art world of San Francisco. The announcement in September 1930 by Timothy Pflueger that Rivera would be coming to the city to execute a mural for the new Stock Exchange Building triggered an adverse reaction in the local press and art journals. In an interview with United Press, one regionalist painter, Maynard Dixon, declared that "The stock exchange could look the world over without finding a man more inappropriate for the party than Rivera. He is a professed Communist and has publicly caricatured American financial institutions."[67] At this point, the main newspapers of the city, such as the *San Francisco Chronicle* and the *San Francisco News*, began to reproduce the anticapitalist panels by Rivera in Mexico City, so as to stir things up further.

Nonetheless, Rivera's genial and unassuming manner, along with his candid but seldom strident presentation of his left-wing politics, proved to be both charming and disarming, as did the wit of Frida Kahlo, who was usually attired in traditional Mexican dress during their stay in *"Gringolandia,"* as she called it.[68] Rivera's lectures on art and politics, which were given in French to Anglo audiences and in Spanish to audiences of Latinos, proved to be more thought provoking and less easily dismissed than his instant critics had imagined. Local artists of note, such as Viscount John Hastings (an English lord who was an anarchist), Clifford Wright, Matthew Barnes, Albert Barrows, and Ralph Stackpole all became assistants. The more enlightened portion of "high society" that included several Rivera patrons (Albert Bender, Mrs. Sigmund Stern, Annie Meyer Liebman) feted Rivera and Frida Kahlo with great generosity and fanfare, and from November 15–December 25, 1930, a large retrospective exhibition of 120 works by Rivera in various media showed at the California Palace of the Legion of Honor.

The three murals that Rivera produced in San Francisco from November 1930 to June 1931 proved, despite minor controversies here and there, to be well received. The *San Francisco News* observed the following not long before Rivera's departure: "His influence has been sane and healthy. . . . His own work is in the great tradition of painting . . . [and] it has meant an enormous stimulation of public interest in art."[69] The local artists and *cognoscenti* were amazed at Rivera's prodigious capacity for work, which left his assistants from the United States utterly

exhausted. Nor were most people upset, but rather generally challenged, by Rivera's persistent attacks in public on Eurocentrism. An exemplary summation of this position was written by Rivera in 1931 and it included a dialogue between "Myself, My Double, and My Friend the Architect, with brief interventions by the Shade of Renoir." Among the more memorable parts is the portion in which his double makes a modernist proclamation of the artistic emancipation of the Americas. This passage by Rivera goes as follows:

> Listen Americas! Your country is strewn over with impossible objects that are in no way beautiful, not even practical. . . . Most of your houses are covered with copies of European ornament. . . .
>
> Your antiques are not to be found in Rome. They are to be found in Mexico. . . .
>
> Become aware of the splendid beauty of your factories, admit the charm of your native houses. . . . Do not ask them [the Architects] to give you copies of the edifices you admired while touring Europe. . . .
>
> Take out your vacuum cleaners and clear away those ornamental excrescencies of fraudulent styles. . . . Clear your brains of false traditions. . . . And be sure of the immense possibilities latent in America: PROCLAIM THE AESTHETIC INDEPENDENCE OF THE AMERICAN CONTINENT. . . .[70]

All three of Rivera's murals in San Francisco were certainly about "the immense possibilities latent in America" — which is a theme that allowed him to emphasize the *positive potential* of contemporary United States society, while also being true to a basic tenet of Karl Marx (although not necessarily a common claim of 1930s orthodox Marxism). This fundamental position of Marx was that socialism is the *positive potential inherent to capitalism,* yet, paradoxically, this potential within capitalism can be fully realized only by transforming capitalism into another system that is far more rational and equitable. Marx's considerable admiration, if not awe, for the unprecedented use of labor power by capitalism to transform the past was captured in his memorable ode to the revolutionary nature of capitalism. In fact, as a mere recollection will show, this assessment of capitalism is precisely the one that informs the iconography of all of Diego Rivera's murals in San Francisco. Marx's panegyric to capitalism, which was also accompanied by a stringent analysis of its

shortcomings, went as follows:

> The bourgeoisie cannot exist without constantly revolutionizing the instruments of production, and thereby the relations of production, and with them the whole of relations within society. . . . All fixed, fast-frozen relations, with their train of ancient venerable prejudices and opinions are swept away, all new-formed ones become antiquated before they can ossify. All that is solid melts into air. . . .
>
> In place of the old local and national seclusion and self-sufficiency, we have intercourse in every direction, universal interdependence of nations. . . . National one-sidedness become more and more impossible. . . .
>
> The bourgeoisie, during its rule of scarce one hundred years, has created more massive and more colossal productive forces than have all preceding generations together. Subjection of Nature's forces to humanity, machinery . . . whole continents for cultivation, canalizations of rivers, whole populations conjured out of the ground — what earlier century had even a presentiment that such productive forces slumbered in the lap of social labor?[71]

In a manner very much like Marx, Rivera was awed by the technology and productivity of the United States economy even though he never shied away from voicing public statements about the ongoing existence of inequality, racism, and poverty in this land of plenty. While there are indeed subtle hints in his two public frescoes in San Francisco and in his masterful mural series in Detroit that he viewed the potent capitalist present in the United States as a mere prelude to a postcapitalist order of evenly distributed wealth, Rivera, in general, focused on the "immense possibilities latent in America" in such an ambiguous way as *to invite both procapitalist and anticapitalist readings in almost equal measure.*

After all, Rivera's pictorial celebration of the productivity of labor could just as easily be construed as uncritical praise for the system, as it could be seen as critical respect for a stage in history leading beyond this phase to a more equitable and no less affluent one. And, in a country such as the United States, where the spirit of pragmatism and positivism encourage a nonvisionary conception of the future as simply an extended present with more of the same, it is obvious which reading of Rivera's murals would have been ascendant among the museum-going public. Perhaps the most intriguing question to explore in terms of public

reception would be how a populace that was generally without a socialist vision of the future, as was the case in the United States, would have responded in the 1930s to Rivera's own publicly persistent claims that his art was centered on socialist *values*.

Since the official position of the Communist Party in this period, which consistently attacked Rivera as a "counter-revolutionary," was to represent only the negative aspects of capitalism, the Communist Party actually encouraged the mainstream conservative reading of Rivera's murals as less a look at a momentary phase in history, than as a depiction of the end of history. Thus, Rivera's "ultra-leftist" use of Marx's ideas allowed his paintings to be acceptable to conservatives and to be unacceptable to the Communist Party *for precisely the same reasons*. As such, the orthodox right and the orthodox left ended up with a similar reading of Rivera's works. Similarly, Rivera's works in the United States — which were largely disconnected from the type of popular mobilizations that occurred in Mexico during 1924–25 and 1934–35 — had their critical edge blunted, or perhaps muted, by their lack of links to any mobilized mass organizations that would have enabled an alternative response to these paintings.

Rivera's two public murals in San Francisco, then, attest to how works that were meant to be both a celebration and a criticism of capitalism ended up being seen only as the former. *The Allegory of California* (43.82 square meters), is an elegant, if shifting, montage of the industrial prowess, manifold natural resources, and technological advances of this huge state. Even though this painting in the stairway of the Pacific Stock Exchange focuses entirely on workers, engineers, and scientists *without even one businessman in sight,* the interpretation that Rivera would have made of this deliberate deletion in the portrayal of economic forces is hardly the one that would have been common in the halls of the Stock Exchange on a business day.

Furthermore, the huge lapidary portrait of tennis star Helen Wills Moody (who uses one hand to hold a giant cornucopia of agricultural products and her other hand to part the earth to expose a mining operation underground) gives a golden glow to the entire scene that seems to elicit more a sense of satisfaction with what has already been achieved, than to encourage thoughts about all that has yet to be accomplished in the future. Such an uncritical reading of the mural is further encouraged by the painting's location in a posh high Art Deco-style stairway that features marble terrazzo walls.

The ideological values of Rivera are more easily in evidence in the commanding mural that Rivera painted from April to June 1931 in the San Francisco Art Institute (Figure #18). But, even here Rivera's broad ranging and visionary view in his art of the historical process has little to do with social realism's single-minded focus on the inequities of the present moment in history. An excellent exercise in an alternative modernist recourse to "medium self-criticism," this fresco mural that is about the making of a fresco mural is, in turn, about the building of a city in relation to it. As such, the fresco is about various types of labor in a modern urban setting, among which would be the production of a mural painting. The work is appropriately titled *The Making of a Fresco, Showing the Building of a City* and is sizable (5.68 x 9.91 meters).[72] As Alicia Azuela has rightly noted, the thematic concerns of this mural (Figure #18) elucidate all that was so unusual about Rivera's position on the left along with his distinctive conception of art as first, and foremost, a form of manual labor. Her important summary of Rivera's mural along these lines goes as follows:

> By representing art as a form of work, the composition embodies several crucial points in the Marxist aesthetic: 1) art plays a fundamental role in the creation of the new worker's society; 2) art is thus capable of transforming history; 3) the artist is a worker in the field of culture who labors in the public service. . . . A corollary idea is implied: painters and sculptors also contribute to the world of ideas by defining the self-image of the worker.
>
> Although the ideas are essentially Marxist, they are treated in such a way as to make them acceptable to the American public.[73]

The visual language employed by Rivera is conjunctural to a noteworthy degree. He managed to create a variant of modernism that used a neo-Cubist grid, or breakup, of the pictorial field (through the illusionary scaffold and through the compartmentalization of the pictorial plane), while still using perspectival space and a triptych format characteristic of Italian painting from the thirteenth century onward. The diverse yet coordinated activities of workers and engineers (many of whom are portraits of Rivera's assistants) are viewed through a *trompe l'oeil* scaffold that supports a fresco painter at work that is Rivera seen from the back.

As the team of painters paints a colossal blue-denim-clad worker (on

whose chest pocket is a hammer and sickle emblem) the artists are flanked by exterior views of a city in construction and of interior views of various others at work as well.[74] Their combination here, in conjunction with the synthesis of Renaissance, Cubist, and Baroque elements, implies a dynamic simultaneity, the axis of which is the enormous eagle-eyed worker who, ironically enough, seems to be more in keeping with Soviet art of the period than with the type of social realism dominant in the United States. (Rivera no doubt appreciated this little undetected bit of irony in the painting.)

While in San Francisco, and before returning to Mexico City, Rivera had already begun corresponding with patrons from Detroit and New York City. These negotiations led to Rivera's return trip to the United States in November 1931, just prior to the opening of his large retrospective at the Museum of Modern Art. It included 143 paintings and works on paper, along with eight "portable" fresco murals. Five of these "portable" murals were recreations of themes from the Ministry of Education and Cuernavaca cycles and the other three represented New York City themes.[75] Despite the fact that one of these later murals, *Frozen Assets* (1931), caused controversy because of its unflinching reference to United States capital's culpability for the Depression, the retrospective set an attendance record for the Museum of Modern Art with almost 57,000 viewers, thus outdistancing the previous Matisse Show at the Museum of Modern Art.[76]

Although understated because of the absence of either pathetic, or defiant, gestures and owing to the chilly palette of cool, yet somber, tints of primary color, *Frozen Assets* (239 x 188 cm.) remains one of the few works by Rivera that concentrates almost entirely on the problems of the present without any reference to a transformation of them in the future. In that sense, this painting closely approximates the social realism of the 1930s more than does almost any other work by Rivera. Interestingly enough, the aforementioned links to Italian Renaissance altarpieces find an echo here in the way that Rivera has stratified into zones below the earth, on it, and rising above it.

Formally uncomplicated and reading quite easily from top to bottom, the fresco shows on the lowest level a bank vault where wealth is securely kept, or rather imprisoned, thus reminding us of what Marx called "the contradiction of overproduction" and the concomitant rise in the organic composition of capital with the resulting consequence of massive unemployment.[77] On the grey second level are the corpses of thousands

of workers in a drab warehouse of mortality, while looming overhead in the upper register are the skyscrapers, that for Rivera, denoted both the embodiment of economic power and monuments to misguided greed. As such, the calm forcefulness of *Frozen Assets* derives ironically from its lack of dramatic force.

Significantly, the idea of the moveable fresco panel used for *Frozen Assets* dates from 1931, the year of this painting. To produce the "sample" frescoes for his retrospective, Rivera devised a technique whereby composition board mounted on a wooden armature was then overlaid with a coat of concrete (which was composed of cement, goat's hair, marble dust, and lime). Prior to the concrete's drying, a wire mesh grid was placed over the entire surface of the panel, into which it would sink about half its depth, with the entire ground then setting. After it was dry, the panel then received a first coat of plaster preparatory to the completion of the fresco process. Afterwards, the finished panel was generally mounted in braced steel frames. This innovative technique was next used by Rivera in his 1933 murals for the New Workers School and, from then on, almost all of his frescoes were painted on panels mounted in movable steel frames.[78] This was the framework used for his 1947–48 mural fresco for the Hotel del Prado, which proved to be stronger than the building which housed it during the 1985 earthwork in Mexico City. Even though the building was almost entirely destroyed, Rivera's mural was hardly damaged and it was subsequently relocated to another site especially constructed for it, the *Museo Mural Diego Rivera,* where it is located at present.[79]

It was at this point in the early 1930s when Rivera, despite his critique in *Frozen Assets* of capitalism's failings, was subjected to a series of strident and manifestly misinformed articles in the *New Masses,* the cultural journal of the Communist Party in the United States. The first of these pieces by avowed Stalinists was authored by Joseph Freeman (under the penname of "Robert Evans") and appeared in the January 1932 issue. Freeman declared that the allegorical figure originally centering the main wall mural in Rivera's study for it (and which the Communist Party had tried to force Rivera to retain in his "decentered" mural painting) had been replaced in the National Palace by "harmless objects such as grapes and mangoes."[80] In fact, Rivera had substituted the figures of Zapata, Felipe Carrillo Puerto, and José G. Rodríguez (another agrarian leader who was assassinated) plus portraits of Hidalgo, José María Morelos, and other independence leaders in the nineteenth century.

Rivera, who was furious about the utter dishonesty of this essay, wrote a letter to the *New Republic* that appeared in August 1933, in which he simply noted that "This strange invention of Freeman's was refuted by the *Worker's Age* of June 15, 1933 by the simple procedure of publishing the original sketch and the final painting."[81] Rivera then went on to explain why he made the compositional changes that were utterly misrepresented by Freeman:

> The original sketch shows a woman sheltering a worker and a peasant. I considered the figure false because Mexico is not yet a nourishing mother to the workers and peasants. I removed it, as the *Worker's Age* photo shows, and replaced it not by "grapes and mangoes" but by the figure of a worker showing to the martyrs of the agrarian revolution the road to industrial communism. I put that correction on the wall in sketch form as early as 1929.[82]

RIVERA'S MURALS IN DETROIT

In April 1932, Rivera and his wife, Frida Kahlo, arrived in Detroit and took a room in a hotel directly across from the Detroit Institute of Arts, where Rivera would produce one of his greatest mural sequences (Figures #19, 20, 21, 22). For the first three months, Rivera simply wandered about sketching the machinery and workers in the Ford and Chrysler Plants, as well as in Parke-Davis Chemical, Michigan Alkali, Edison, and various other factories. His subject in the murals would be nothing less than "the human *spirit* that is embodied in the machine," rather than machinery as either inherently good (as with Léger and the "Machine Aesthetic") or as intrinsically evil (as is the case of Orozco's murals).[83]

Rivera's resolve and enthusiasm for the project were conveyed in a letter to biographer Bertram Wolfe on July 9, 1932: "The frescoes will be twenty-seven, making together a single thematic unity. I expect it to be the most complete of my works; for the industrial material of this place I feel the enthusiasm I felt ten years ago at the time of my return to Mexico with the peasant material."[84]

He began to paint on July 25, 1932 and finished on March 13, 1933, with the painting being officially dedicated on the 18th of March. These paintings did, in fact, demonstrate that the considerable latitude given the

artist by his patrons, Edsel Ford and Dr. William R. Valentiner, was hardly in vain. The original suggestion of Ford and Valentiner that Rivera paint "the history of Detroit, or some motif suggesting the development of industry in this town," was greatly expanded by Rivera to encompass both the geological processes that produced the raw materials for the Detroit auto industry *and* the future promises for all humanity lodged in the contemporary productive processes.[85]

As completed, Rivera's fresco cycle begins for the entering spectator on the east wall of the interior courtyard of the Detroit Institute of Arts, which is an early twentieth-century building by architect Paul Cret in the international beaux-arts style (Figure #19). The first view of the frescoes is of the origin of life and the advent of technology: an infant is contained fetus-like in the bulb of a plant, while steel plowshares appear embedded in geological strata of sandstone, limestone, and iron ore (which represent Michigan's specific geological strata). Flanking the infant and located one level above are two female nudes that hold in their arc-like embrace the fruit and grain that are again typical of Michigan. In relating to the fertility of the land, the plowshares also signify the first forms of technology invented by humanity to render nature more productive. Thus, these first wall panels initiate some of the major themes developed throughout the series; specifically, those of the dependence of industry on the resources of the land and the expansion of nature's potential through the intervention of technological development.

When the spectators turn around to examine the west wall through which they entered, they see a continuation of the themes already initiated (Figure #20). Once again, the idea of interdependency is compellingly used on a number of levels to interweave the most disparate of cultures, the most antithetical of forces. In the uppermost of the three areas, there are aviation panels that show the construction of both passenger planes (on the left) and war planes (on the right), with their counterparts in nature, a peaceful bird on the left and a predatory bird on the right, providing an analogue in nature for these competing tendencies within civilization.

Rivera depicts the potential of technology to be used either to advance humanity's peaceful self-realization or to increase human misery through militarism. Neither an uncritical proponent of technology in the tradition of Futurism nor an uncritical partisan of antitechnologism in the manner of Orozco, Rivera simultaneously presents the promises of the present and places the spectator in the symbolic position of choosing between quite

contrary historical trajectories.

The five panels that address this particular technological theme demonstrate a broad color range featuring both primary hues and an expansive tonal range manifested through Rivera's diffused lighting that creates no dramatic pockets of attention, but instead guides the viewer about through a richly integrated composition. The monochromatic panel in the center of the second level neo-classical frieze area, with its use of a lean line that gives an almost intaglio-like effect to the whole, provides a notable foil to the resonant color in the surrounding panels and also a thematic counterpart to the aviation panels.

On the left side of this compressed but lengthy passage are the city of Detroit and the industrial port of Rouge. On the right side, is a large body of water (in which one sees commercial ore freighters, leisure boats, and playful fish) that represent alternately both the Detroit River and the Amazon (a tropical land where one sees rubber trees being tapped). Here again the theme is interdependency on three different levels: 1) between nature (raw materials) and technology (finished goods); 2) between agricultural production (rubber trees) and industrial production (the automobile); 3) between the agrarian southern countries and the industrial north in the Americas.[86]

Up above all of this in the monochrome panel that has the same hue as the limestone architecture that frames it (thus accentuating the interplay formally of divergent components) is a singular cartouche-like configuration that includes the five-point star which, when painted red as at Chapingo, clearly signified the socialist movement. Here in monochrome, however, the star symbolizes more ambiguously the progressive aspirations of humanity for a better society. Flanking the heraldic star are a human visage on the left and a skull on the right, which again signify on various levels both the pre-Columbian emphasis on the dual aspects of nature and the historical predicament caused by modernization that confronts us with competing choices for the future: greater self-realization or mere self-destruction.

On the lower level are two large vertical panels in which are shown two powerful composites of technological apparatuses. These are a steam engine from Power House No. 1 at the Rouge Complex, on the left, behind a worker with the generalized features of Rivera himself. Directly across on the right, in front of a huge electrical generator, is an engineer with the generalized features of Henry Ford and Thomas Edison. Thus, here again we have the possibility of interpreting these scenes as being

either a future choice between the two — labor and management — or as an affirmation of the interdependency of the two from now on. The former would have been Rivera's reading of this set of images, but the latter would have been the most likely interpretation of this relationship by the majority of spectator's looking through the ascendant ideological values in the United States. In a sense, the artist's perspective on this situation would have been invisible to most viewers.

Nonetheless, this "minority" interpretation of the mural's theme — as one dealing with the future attainment of workplace democracy by labor when workers manage themselves — had struck a resonant cord with the more sophisticated labor leaders in Detroit. As Reuben Álvarez, a foundry worker and United Auto Worker's Union (U.A.W.) official recalled Rivera's murals, they had a formative impact on the later unionization of the work force in Detroit (there was no union when the murals were done in the 1930s): "When we organized the union at Ford, we used to bring delegations down to see the murals. Those who lacked words brought people down here to sign them on. They [Rivera's frescoes] were . . . inspirational."[87]

To progressive labor organizers, the most immediately inspirational of these Rivera murals were, no doubt, those on the north and south walls (Figures #21, 22). Each of them is huge at 5.40 x 13.72 meters and interpretatively depicts, on slightly larger than human scale, the inner workings of the Ford Factory. In keeping with the three-tiered structure of the interior, both of these north and south walls, which are the longest two of a rectangular shaped room, are devoted to three sets of images: 1) representations of the four "races" that have contributed to United States culture and have composed its workforce, plus the four basic raw materials essential for making an automobile *and a fresco mural;* 2) depictions of other industries in Detroit (such as those producing medicine, pharmaceuticals, and chemicals) that are replete with the competing consequences of their negative and positive uses; and 3) the automative industry itself. Together these themes provided the title for the whole series, *Detroit Industry.*[88]

The center panel on the north wall (2.69 x 13.72 meters) depicts two colossal female nudes representing American Indians and Native Americans who recline on the earth and, like all the protruding hands of miners around them, hold bits of iron ore and coal. The geological strata for iron ore and coal in the earth are depicted immediately below these two imposing personifications. (And, of course, iron ore when heated by

coal ultimately produces the steel from which automobiles are made *and* the type of scaffolding used for fresco painting by Rivera.) The precondition for industry is the beneficial use of natural resources, so that culture and nature are seen to be reciprocally linked and mutually determining. Flanking the two sizable center panels in the upper and main registers are four small panels that depict *Vaccination* (2.58 x 2.13 meters) on the right, and the *Manufacture of Poisonous Gas Bombs* (same size) on the left. In the smaller panels directly beneath them are, respectively, a healthy human embryo (.68 x 1.85 meters) and a microscopic look at human cells that have been damaged by nerve gas.[89]

Largely dominating this north wall, though, is the huge *tour de force* entitled *The Production and Manufacture of Engine and Transmission (Ford V-8)*. Using a Cubist composition that montages together nineteen different stages of production so as to orchestrate them into a single and quite "unrealistic" scene of epic sweep, Rivera gives a far more dynamic and humanly engaged representation of these operations than do the documentary photos of the period.[90] Furthermore, Rivera's representation of workers from the four "races" personified above are slightly larger than human scale and actually include portraits of his assistants (thus, subtly underscoring *yet again* the relationship of mural painting and factory work as analogous forms of labor). These portraits of his assistants include Stephen Dimitroff, Arthur Niendorf, Clifford Wright, Ernst Halberstadt, and Andrés Sánchez Flores. There are also portraits in this section of other workers that Rivera was befriended by while in Detroit: Chicano Alberto López (Rivera worked with the Chicano community on some economic projects while he was in Detroit) and museum guard John Bauer.[91]

The use in this panel of a predominantly lower value palette of luminous blues and somber greys is heightened by orange bursts of furnace flames and accented throughout by the silver-white sheen of metal used for some of the machines. Aside from constantly shifting levels, distances, and vantage points that propel the viewer all about the space, there are also sweeping, powerfully undulating industrial components that further enliven the interior space. Indeed, as Rivera noted later, his murals were meant to use a modern form of pictorial dynamism to counteract the architectural space in which his murals were being painted. In short, his paintings "had nothing to do with baroque refinement" in this space, whatever their link to an aesthetic of movement. Thus, Rivera intentionally set to work "to overpower the ornamentation of the room" through his rendition of a "mechanical orchestra."[92] To strengthen this

aesthetic conflict between architecture and murals, he also decided to paint "one of the dominant rhythms in the life process — the wave," which pervades the painting in a powerful way in the form of oscillating conveyor belts, industrial tubing, and soil substrata.[93]

Immediately across on the equally imposing south wall of the Institute of Arts are two colossal nude personifications of the European and the Asian ethnic groups that had also contributed substantially to the national culture and to the work force. These are identified with limestone and sandstone or sand, and the geological strata beneath them signify both the raw materials for glass windshields and the essential materials for producing the lime and sand plaster used for fresco paintings. The small corner panels represent pharmaceuticals on the left and commercial chemicals on the right. Beneath them, in the small panels, are depictions on a microscopic level of a surgical operation and the crystallization of sulfur and potash.[94]

Just as the north wall is devoted to representing the production of the motor of the automobile, so the south wall (Figure #22) features a composite depicting the production of the automobile body, along with its assembly. Also composed of a "collage" or montage of diverse operations, shifting vantage points, and different machines, this panel, nonetheless, has a lighter overall tonality than does the one across from it in the courtyard, owing to the pervasive sparkle of silvery machine parts throughout the entire composition. To a remarkable degree in this panel, as elsewhere in the cycle, Rivera's "alternative modernist" style has allowed him to synthesize "his study of Cubism, his knowledge of pre-Columbian art and the traditions and techniques of Italian Renaissance art, and his vision of the new aesthetic of the age of steel."[95]

A brilliant synthetic motif along these expansive lines is the impressive fender stamping press that has been deftly reworked to take on the features of Mayan art in the uppermost portion. Like his visual language in general, this depiction of technology as a product *of all human history*, rather than as some isolated and "pure" innovation of the contemporary West, bears eloquent testimony to Rivera's concept of uneven development in history. Hence, Rivera reminds us, once again, that past cultures still have advanced lessons for the modern age, which, in some cases, has left these earlier cultures behind and, in others, has yet to catch up with them.

About the historical vision that imbues the frescoes that make up *Detroit Industry*, Rivera stated:

My childhood passion for mechanical toys had been transmuted to a delight in machinery for its own sake and for its meaning to man — his self-fulfillment and liberation from drudgery and poverty. That is why now I placed the *collective hero, man-and-machine,* higher than the old traditional heroes of art and legend. I felt that in the society of the future . . . man-and-machine would be as important as air, water, and the light of the sun.[96]

Before concluding this section on the Detroit murals, I must summarize the signal points made about this artwork in an important new book by Australian scholar Terry Smith. In building on the important previous work of Stanton Catlin, Alicia Azuela, Linda Downs and Max Kozloff, among others, Terry Smith incisively demonstrated how in Rivera's alternative modernist paintings there is a sustained critique both of Taylorism and of the mainstream modernism allied to it.[97] Smith quite rightly notes that Rivera was a "political negotiator of the highest skill" who applied "the logic and the tactics of a political survivor and a political agitator to his work in Detroit."[98]

As Terry Smith's analysis shows, the mural program is "fundamentally Marxist," because of its "framework of values."[99] For example, if we link the upper registers with the main panels in terms of a vertical or top/down historical narrative, there emerges a composite portrait of the various modes of production basic to a Marxian analysis of history: "the primitive mode," "the slave/feudal mode," "the Asiatic mode," and "capitalist mode."[100] Concomitantly, by this emphasis on the centrality of class to the development of human industry, "Rivera may be implying that the very concept of race is itself inadequate. . . . [T]hey [the "races"] make up a commonality that transcends their differences."[101]

Contrary to the globalizing imagery of mainstream modernism that was tied uncritically to the logic of Western modernization in the work of artists like Charles Sheeler, who did a well-known painting of the exterior of the River Rouge Factory, Rivera produced an alternative modernism that entailed a critique of modernization. To quote Terry Smith:

His [Rivera's] response was, however, exceptional. He set out both to absorb the irresistible inventive energy of this emergent imagery of industrial modernity and to add to it two other contrary kinds of energy. These were first, an insistence on the organic ancientness

of industry itself, and, second, a related emphasis on the primacy and persistence of physical work as still central to industrial production. [102]

From there, Smith went on to observe there are three basic ways in which Rivera's depiction of machines differs from mainstream modernism's "machine aesthetic." First, Rivera was evidently interested in showing the spectator how each machine works, what its function is, and how it is constructed. Second, he was apparently concerned with demonstrating how the machine is operated by a worker. Third, Rivera was interested in an overall presentation of the factory that contradicted a Taylorist environment systematically organized "around the assembly line to which workers are robotic servants, in a series of buildings with separated but sequential functions."[103] Rather, Rivera insisted on the fundamental equality between workers and machines, as part of a process involving heroic human effort, in which there is a dynamic struggle within capitalism based on "a disequilibrium not a fictive balance."[104]

Similarly, no less notable is the absence of references in Rivera's paintings to the "new consumer society." With scenes being about labor and its potentially beneficial *public uses,* there is no signifier for the private consumption upon which commodity fetishism is based. As such, Rivera declares in pictorial terms that an adequate future for humanity is to be located most profoundly in productive work, rather than in the exchange of commodities, in use value more than in exchange value. The artistic vision of the Detroit project is one that, to quote Smith, combines the grand sweep and obsessive detail of an epic with the "worldview of a historical materialist" who discovers significant "human history in every act" of humanity.[105]

As for Rivera's treatment of modernity in relation to the future as a subject, Smith points out that this theme is not addressed in directly agitational terms, as would have been true of most social realism from the 1930s, but instead through the positing of a human-machine unity "beyond class struggle."[106] Management in the ploy of capital, rather than the work force per se, may have control over the means of production at present, but this need not always be the case in the future and Rivera intended to invite the spectator to re-imagine the current situation in other terms. Furthermore, Rivera's use of public painting, with its capacity to endure for long periods, reminds us of a famous remark attributed to Hippocrates, namely, *"Life is short, art is long."* [107]

RIVERA, TROTSKY, AND ANDRÉ BRETON
IN THE 1930s

The above interpretation of the Detroit murals was anticipated during the 1930s in the writings by Leon Trotsky. In his 1938 essay about Rivera versus Stalinism in the arts, for *Partisan Review*, Trotsky specifically contravened the orthodox Marxist view of the Communist Party, with its single-minded accent on agitational art. Instead, Trotsky contended that "art is an expression of the human need for a harmonious and complete life, that is, the need for those benefits of which humanity is deprived by a class-based society." Accordingly, he maintained that all great art contains an implicit protest against the present order of things, whether consciously or unconsciously, by projecting a sense of historical resolution into the future through the imaginative reworking of the present.

For Trotsky, as well as for Rivera, technically, formally, and thematically advanced art conveys a sense of the inadequacy of the given in contemporary society. After a stinging dissection of Soviet "socialist realism" in the arts, which repeats almost verbatim what the Mexican painter had written in 1932 about the ascendancy in Russia of "the old and bad academic painters" using "the worst techniques of bourgeois art" Trotsky declared as follows about the cult of the individual leader upon which this Soviet art was often centered:

The official art of the Soviet Union — and there is no other over there — resembles totalitarian justice.... The aim of such justice, as of art, is to exalt "the leader," to fabricate a heroic myth....

The style of presenting official Soviet painting is called "socialist realism." The name itself has evidently been invented by some functionary in the department of the arts. This "realism" consists in the imitation of provincial daguerreotypes of the third quarter of the last century; the "socialist" character apparently consists of representing, in the manner of pretentious photography, events which never took place.... The art of the Stalinist period will remain as the frankest expression of the profound decline of the proletarian revolution.[110]

From there, Trotsky went on to argue in the same essay that the most legitimate alternative to this travesty in the art from Russia was to be found in the murals of Diego Rivera:

In the field of painting, the October Revolution has found her greatest interpreter not in the USSR but in faraway Mexico, not among the official "friends," but in the person of a so-called enemy of the people whom the Fourth International is proud to number in its ranks. Nurtured in the artistic cultures of all peoples, all epochs, Diego Rivera has remained Mexican in the most profound fibres of his genius. . . . [Yet] without October, his power of penetration into the epic of work, oppression and insurrection would never have attained such breadth and profundity. Do you wish to see with your own eyes the hidden springs of the social revolution? Look at the frescoes of Rivera. Do you wish to know what revolutionary art is like? Look at the frescoes of Rivera.

Come a little closer and you will see clearly enough gashes and spots made by vandals. . . . You have before you, not simply a "painting," an object of passive contemplation, *but a living part of the class struggle* [my italics]. And it is at the same time a masterpiece![111]

Rivera's identification with Trotsky from 1929 until 1939 went beyond mere abstract displays of solidarity. On November 21, 1936, Rivera received a cable from Anita Brenner at a time when Trotsky was being driven out of Norway and given a visa to enter no other country (Trotsky had been exiled from the U.S.S.R. in 1929). Brenner requested that Rivera personally intercede with President Lázaro Cárdenas, a nonaligned leftist, to gain asylum for Trotsky in Mexico. Rivera, along with his colleague Octavio Fernández, attained an audience with Cárdenas who did indeed grant Trotsky a visa to enter Mexico, with the stipulation that he not engage in public political acts while in the country. On January 9, 1937, Trotsky and his wife, Natalia, arrived at Tampico and journeyed to the Rivera's home in Coyoacán, the *Casa Azul,* where they would live as guests of Rivera and Frida Kahlo until April 1939.[112]

Interestingly enough, the Trotskys even continued living in Rivera's home for over three months after there was a falling out with Diego (possibly because Frida Kahlo and Trotsky had an affair), at which time Trotsky declared, on January 11, 1939, that he no longer felt "moral solidarity" with Rivera's "anarchistic politics." Among other things, this accusation of "anarchism" probably referred to Rivera's abovenoted opposition to a "party line" along Leninist lines. It was only in April of that year that the Trotskys moved to their new and heavily buttressed residence in Coyoacán, a few blocks from *Casa Azul.*[113] It was there on

August 20, 1940 that Trotsky was assassinated by the Spanish Stalinist Ramón Mercader in the second attempt on his life by members of the Communist Party (the unsuccessful first attempt had been led by painter David Alfaro Siqueiros).[114] Because the assassination occurred only two months after Rivera's devastating criticism of Stalin was published in the United States in *Esquire Magazine* (May 1940), Rivera stationed an armed guard near his scaffold while he was in San Francisco executing a mural for San Franciso City College.[115]

One of the key collaborative ventures of this period involved not only Trotsky and Rivera, but also the Surrealist leader André Breton, who arrived in Coyoacán for a visit in April 1938 (See Frontispiece photograph). (In fact, Rivera's friend Meyer Schapiro had been an important intermediary between Trotsky and Breton prior to their having met each other in Mexico.) A manifesto resulted from a collaboration involving "the three foremost twentieth-century proponents of a revolutionary mission for modern art."[116] It grew out of the extensive discussions between Trotsky, Rivera, and Breton and was coauthored in the summer of 1938. Entitled *"Manifesto: For a Free Revolutionary Art,"* the manifesto was written by the three in French and translated into English by Dwight Macdonald. It was then published in the Fall 1938 issue of *Partisan Review*.[117]

The manifesto contains certain ideas that obviously originated with Breton's emphasis on the unconscious, others that surely came from Rivera's "anarchistic" commitment to civil liberties, and still others that clearly came from Trotsky's Leninist insistence on the vanguard role of the Fourth International. Because this manifesto not only represents one of the most significant documents of this decade, but also contains concepts crucial for understanding Rivera's position of "double marginalization" during this period, it deserves to be quoted at length. This chapter will conclude with these passages:

> We can say without exaggeration that never before has civilization been menaced so seriously as today. . . .
>
> In so far as it originates with an individual . . . any philosophical, sociological, scientific, or artistic discovery seems to be the fruit of a precious *chance,* that is to say, the manifestation, more or less spontaneously, of necessity . . . nor should we fail to pay all respect to those particular laws which govern intellectual creation.
>
> In the contemporary world we must recognize the ever more

widespread destruction of those conditions under which intellectual creation is possible. . . . The regime of Hitler, now that it has rid Germany of all those artists whose work expressed the slightest sympathy for liberty . . . it is the same in the Soviet Union, where Thermidorean reaction is now reaching a climax. . . .

True art, which is not content to play variations on ready-made models but rather insists on expressing the needs of humanity in its time — true art is unable *not* to be revolutionary. . . .

The process of *sublimation,* which here comes into play, and which psychoanalysis has analyzed, tries to restore the broken equilibrium between the integral "ego" and the outside element it rejects. This restoration works to the advantage of the "ideal of self". . . .

The conception of the writer's function which the young Marx worked out is worth recalling. . . . [H]e declared, . . . *"It [art] is an end in itself. . . ."*

If, for the better development of the forces of material production, the revolution must build a *socialist* regime with centralized control, it should from the first, in order to develop intellectual creation, establish an *anarchist* regime of individual liberty! No authority, no dictation, not the least trace of orders from above. . . .

We by no means insist on every idea put forth in this manifesto, which we ourselves consider only a first step in a new direction. . . .

Our aims:

The independence of art — for the revolution; The revolution — for the complete liberation of art![118]

CHAPTER FIVE

■

Rivera's Last Years:
The 1940s and 1950s

■

"Beyond the Mexican philosophical dispute . . . a cultural phenomenon of great importance may be glimpsed: namely, the birth of a modern myth based on the complex mediation and legitimization processes in a society in which the revolutionary forces that constituted it have declined. This is the myth of the stooping hero, hallowed by Diego Rivera as the man in his serape, squatting under an enormous sombrero, and made a comic figure in the wonderful caricatures *(Los agachados)* with which Rius has made mockery of the stereotype. It is obvious that this is an imaginary tributary into one of the oldest myths, the myth of the lost golden age; but what is odd about the modern Mexican re-creation of myth is that it features a multifaceted tragic hero, fulfilling different functions. He represents the wounded aboriginal virtues never to be seen again; at the same time he represents the expiatory sacrifice for Mexican guilt . . . [for] the landless peasants, the unemployed workers, the uninspired academics, the shameless politicians . . . In sum, he represents the tragedy of a fatherland in search of the lost nation."

> Roger Bartra,
> *Jaula de la melancolía*
> (1987) — (The Cage of
> Melancholy)[1]

Rivera's public artworks from the early 1940s onward were marked less by a visionary faith in the future, than by either a nostalgia for an idealized pre-Columbian past or by an overly easy assessment of the present. From the period of the Second World War until his death at seventy-one in 1957, Rivera found himself increasingly in the paradoxical position of

being a national icon (albeit a controversial one) for the more conservative post-Cárdenas Mexican state. Similarly, and hardly less paradoxically, Rivera was also an international Cold War symbol for the Communist Movement, which alternately held him at arm's length and then embraced him. In short, Rivera became more famous and less "ultra-leftist" or independent.

Without ever repudiating his "anarchistic" views on the necessity of unimpeded civil liberties, he came to serve a movement led by the Soviet Union that still had little place for these "undisciplined" concerns. In large part, this occurred because of how Rivera's lifelong commitment to the anticolonial struggle in the Third World (which was a major feature of the post-1945 collapse of Western colonialism) forced him to become realigned with a U.S.S.R. that, for better or worse, was the most imposing industrialized nation in favor of these national liberation movements in Latin America and elsewhere.[2] Rivera's "realistic" analysis of the geopolitical struggle *within* the Cold War framework caused him to become allied once again to the Communist Party from 1946 to 1957 (first as a fellow traveler and then, in 1954, as a member). This new alliance with his former adversaries on the left was the result neither of capricious behavior nor merely of opportunistic conduct, but of a political resolve, even resignation, that was predicated on aiding in *concrete and practical terms* the struggle for self-determination in the Third World.[3] The unfortunate price of this new alliance was, however, an embrace of Stalinism in some respects.

As a corollary, Rivera's artistic practice in 1946 after his sixtieth birthday (and in the few years leading up to it) became ever more uneven aesthetically, ever more unsettled ideologically, between "anarchistic" values Rivera could not relinquish and a "practical involvement" with a global struggle that he would not sit out. This was the case, however crudely reductive the viewpoint of each side on the East/West Divide in this North/South conflict. The visionary urgency of all his prewar public works thus receded before a guardedly affirmative muralism that often, but not always, careened back and forth between an uncritical sentimentalism and a shrill "socialist realist" agitationalism.

Conversely, his small-scale paintings, which had been enlivened with a new Surrealist dimension in the late 1930s, often commendably consolidated earlier innovations in a more private and personal vein. Rivera was drawn to and excelled at the genres of landscape painting and portraiture. One of this two finest murals of the last decade of his life,

Dream of a Sunday Afternoon in Alameda Central Park (1947–48), was a grand group portrait that involved a deeply lyrical look and a touchingly nostalgic reconsideration of the national life of Mexico from the Conquest to the present.

The other great mural painting of the eight or nine series of frescoes that Rivera executed in Mexico from 1942–57 is the compelling mural in the Hospital de la Raza.[4] This exceptional work contradicts much of what I have said about the general developments within Rivera's career, since this commanding painting returns in a nonsentimental way to a critical examination of the contribution of pre-Columbian culture to modern medicine. Thus, this fresco goes against the dominant tendency in Rivera's later years to depict pre-Conquest indigenous civilization with an unqualified idealism that resulted often in an illustrative sentimentality, especially in the eleven murals from 1942–51 for the patio area of the National Palace.[5] Just as Rivera's art, at its most profound, features a concept of uneven historical development (which disallows the attribution of harmony or perfection to any one historical moment), so his own individual progression as an artist is also characterized by a radical unevenness in the last decade and a half of his life. All of this, in turn, reminds us of just how complicated and not always consistent Rivera's contribution was to what has been called the diverse components of national identity in Mexico.[6]

THE LATER LANDSCAPES AND
PORTRAIT PAINTINGS

In January 1940, there was a large *"Exposición internacional del surrealismo"* at the Galeria de Arte Mexicano in Mexico City.[7] Curated by the Surrealist painter Wolfgang Paalen and the Peruvian poet César Moro, this large and generally well-received show featured two paintings by Diego Rivera. These were his *Lady in White* of 1939 (also known as *Mandragora* and probably depicting Mélida da la Selva), an oil on canvas of 120.6 x 91.4 cm. and his *Tree with Glove and Knife* of 1940, which is a slightly larger oil painting at 121.6 x 152.7 cm. This latter work was exhibited under the "surreal" title of *Minervegtanimortvida*, which was a word that Rivera invented for this occasion.[8]

The *Tree with Glove and Knife* accentuates tendencies that had already emerged in Rivera's small landscapes from around 1937 when, intrigued

by the tuberous ferns of Taxco with their almost animal-like attributes, Rivera executed six watercolors on linen canvases. The exquisite delicacy of these watercolors on canvas, particularly *Roots* of 1937 (45.7 x 61.5 cm.), derives from how the intensely concentrated focus, with no visual exit provided by a sky passage, is coupled with a deft painterly touch that is underscored through the way in which the pigment has been absorbed into the canvas, thus, in effect, dying the support rather than merely covering it.[9] In addition, this intensified delicacy in the execution is consolidated through the exceedingly subtle use of various high-value yellows and greens in tandem with high-value blues and white. By limiting the value range notably, Rivera has correspondingly expanded the overall subtlety of this image.

What seemed mildly suggestive of animal-like organicism in the landscape of roots and trees became emphatically so in the "Surrealist" renditions of landscapes, such as the *Tree with Glove and Knife* or *The Hands of Dr. Moore*, an oil on canvas of 45.7 x 55.9 cm. In both of these oil paintings, the tree takes on anthropomorphic traits, thus seeming to bleed, and recalling what John Ruskin once termed the "pathetic fallacy" of Romanticism: the ascription of human traits to plants.[10] Far from ending with his "Surreal" phase of the late 1930s, however, this trend continued on sporadically throughout the rest of his career. Perhaps the most well-known example of this tendency in Rivera's oeuvre is a 1947 oil on canvas entitled *The Temptation of Saint Anthony* (91 x 110 cm.). In this painting, Rivera uses anthropomorphized radishes to represent a traditional religious subject in a way that is indebted to popular culture peculiar to Oaxaca. In Oaxaca City there is an annual radish festival that, in the 1930s and 40s, featured a competition by vendors to "sculpt" radishes into the forms of popular icons, from bullfighters to movie stars. This influence of popular culture on Rivera in these landscapes reminds us that Surrealism has always been influenced by organic manifestations of non-European culture, particularly those which are based in indigenous artforms.[11]

As noted in Chapter 4, Rivera had a close collaborative relationship with André Breton in the late 1930s. At this time, Rivera made a pen and ink portrait of Breton that was published in *Letras de Mexico* (No. 27) in 1938 and he produced a Surrealist woodcut in two colors, *Homenaje á André Breton* (67 x 92.5 cm.), that was evidently influenced both by contemporary French artist André Masson and by the late sixteenth-century Mannerist Giuseppe Archimboldo.[12] Following

Archimboldo, Rivera has composed an image that combines two water glasses with a snake-like drinking straw and an anthropomorphized tree to create a fantastic portrait of a human visage that intentionally operates on several levels at once. The admiration that Rivera felt for Breton was certainly reciprocated by the French leader who, in 1938, wrote: "Diego Rivera . . . incarnates, of course, in the eyes of an entire continent, the battle that is being raged so brilliantly against all the forces of reaction and coercion, and so he symbolizes for me, too, everything that is most valid in this world.[13]

The influences of Surrealism and/or sixteenth-century Mannerism on Rivera's portraiture were intermittent ones that again lasted up through the 1950s. Aside from the early El Greco-inspired portraits of the teens, the paintings that most forcefully embody this visual language are some portraits from the late 1930s. The greatest of these and indeed one of the finest portraits of this century, is Rivera's *Portrait of Lupe Marín* (Figure #23), an oil on canvas (171.3 x 122.3 cm.) that elicits considerable attention where it hangs in the Museum of Modern Art in Mexico City. This work reminds us of how the centrality of portraiture to Rivera's oeuvre allowed him to exhibit, as Rita Eder has observed, "more respect for his own fantasies, his own exhuberances, and his emotions," than was true of his public murals.[14]

The use of space in this portrait of Lupe Marín is a *tour de force* in the orchestration of divergent directional lines and oblique points of entry along with complementary paths of exit. The spectator visually enters the composition at a sharp angle that appears to be almost above ground level and in a manner that recalls the work of Degas or Van Gogh (whose works were indebted to Japanese woodcuts in this regard). The splendid use of the mirror behind the model, throws the visual movement, via the reflection of Lupe Marín, back over our heads to the sky behind us. However high our angle of entry, then, the mirror features a reflection that is aimed far higher, despite the fact that the model is basically located in a corner. The Bauhaus-type fenestration reflected in the mirror breaks up the space in an acutely angled grid pattern. All of this goes along with the heavenward gaze of Lupe Marín, whose green eyes seem at once anguished and unfocused. A striking passage is the reflection from behind her of the stool on which she is seated, which recedes sharply away from us in the mirror while jutting sharply towards us in the painting.

It has been rightly noted that the painting's structure represents a

distillation of Rivera's knowledge through the course of his entire artistic development, ranging from the illusionistic affects of the Baroque and the enigmatic relationships of Mannerism, right up to the lessons of Cubism involving "the delicate balance that the artist has established between the figure and its possible metamorphoses."[15] This set of shifting relationships, nonetheless, features a strong current of formal continuity, owing to the superb use of understated color interaction by Rivera throughout the entire work. Although severely limited in terms of overall color — it is a painting that features white, green, and yellow, with deft hints of red and blue in select passages — this portrait is unsurpassingly nuanced in its use of a type of almost "prismatic" *facture,* or brushstroke, in the tradition of Cézanne.

Virtually every passage in this painting features a recourse to green combined with several other hues: green at normal hue plus yellow ochre in the shadow beneath the seat; high-value green plus high-value blue and green in the folds of the dress; low-value green plus low-value yellow and blue in the shadows on the white wall in the corner; tinges of green at normal value on the golden brown complexion of Lupe Marín from her hands up to her neck and forehead; and so forth. Simultaneously, this portrait features numerous, highly nuanced variations and yet it does so by the reduced means of a few hues, green and yellow foremost among them. As much as any other work by Rivera, this portrait attests to his brilliance as a colorist.

All of these formal attributes are further reinforced and extended by the psychological undercurrents in this painting that emanate both from the strong, and somewhat oversized, clasped hands of Lupe Marín and from the anguished heavenly look in her eyes. This depiction of her eyes partially recalls the calmer upward gaze of the figure of Justice in Rivera's mural for the auditorium of the National Preparatory School. This intertextual play of motifs and gestures, which is another manifestation of Rivera's ongoing modernist self-criticism as elements are repeatedly used and then reconsidered, is responsible for the recurrence of the clasped hand motif in Rivera's paintings that reiterates the same motif, albeit from a frontal rather than three-quarter view, that was earlier used to center the 1925 encaustic painting *Flower Day.*

In *Flower Day* (Figure #10), though, the tightly faceted grip of the symmetrically placed and centering hands was expressive of the particular type of imbricated space that Rivera was deriving from pre-Columbian art. Here, in the portrait of 1938 Lupe Marín, these powerful hands serve

as an axis around which these rotating relations find an organizing core. Similarly, in psychological terms, these hands were intended to signify her strength of character in tandem with her haunting beauty.[16] By being both underlined psychologically and underscored formally, the hands also call attention to the diagonal placement of the sitter's body so as to heighten the spatial tension.

This magisterial portrait of Lupe Marín, with its unsettling yet deeply engaging relationships, serves as an antecedent for one "surreal" genre portrait of 1954 and as something of an antithesis for a famous portrait of 1955. The work of 1954, *The Painter's Studio*, is an oil on canvas (178 x 150 cm.) in the Ministry of Housing and Public Credit and it is a Surrealist rendition of the interior of the artist's studio in the San Angel District of Mexico City. (This work also includes the type of fenestration that was used in the portrait of Lupe Marín.) Once again, popular culture, along with pre-Columbian art, not only figures in the painting but also sets the tone of it. The studio interior is filled with monstrous *papier maché* figures (*calaveras* or skeletons and humanoid goats) that, in conjunction with the troubled and averted expression of the woman who is reclining (the model was Lucila Retes), gives the painting a menacing if not threatening quality. The spectator, in turn, is meant to recall the earlier and even more frankly Surreal painting entitled *The Temptation of St. Anthony* (1947) that was also linked to popular culture. In this case, the *papier maché* "demons" are strung with fireworks that were exploded during *Santa Semana* (Easterweek).

Among the best of his late canvas portraits is the lyrical yet commanding portrayal of his patroness, Dolores Olemedo Patiño in 1953, which is a work that has little to do with the Surreal elements noted above. A large canvas at 200 x 152 cm., it is a painting that is characterized by an "intense luminosity" inspired by the light of Mexican landscape as well as popular cultural attire. In addition, and despite Rivera's age of sixty-nine at the time it was executed, it reasserts with great fluency Rivera's mastery of "renovated classicism."[17] There is a sureness of line, a deft linearity throughout, that reaffirmed Rivera's virtuosity since his teens with respect to crisply drawn yet fluid contours, a lean use of shading to evoke volume, and an utter command of the silhouette for maximum pictorial impact. Furthermore, the delicacy with which Rivera has used judicious overpainting involving both high-value blues and reds in conjunction with white, generate, again, a type of luminous color that shows a debt to Renoir and yet countermands such a link through a certain pensiveness

that counteracts the surface "prettiness" of this elegant painting.

Rivera's own self-portraits from the last decade of his life are no less resourcefully executed or multifarious in manner. In them, the alternating directness and dreaminess of earlier works is replaced by a questioning, even saddened, weariness that is perhaps most typically in evidence in one of the four compelling self-portraits that he painted in 1949. This is the *Self-Portrait: The Ravages of Time*, a watercolor on canvas (31 x 26.5 cm.). Aside from the sagging skin, droopy yet direct gaze, and the steely grey as well as thinning head of hair, there is another element that both comes as a surprise in light of his earlier paintings and yet tells us something profound about his less visionary, more resigned, and "realistic" view of life at this point in the Cold War years.

This rather unusual element, and it is an agitational one, is the apocalyptic background that seems to portend a world catastrophe which is depicted in the spectral background. This scene shows ghostly references to Paris (Eiffel Tower and Sacre Coeur), Moscow (St. Basil), and Manhattan (skyscrapers) that are all being destroyed by an exploding sphere in the right-hand corner of the painting. All in all, it is a painting of pessimism or perhaps exhaustion, if not of hopelessness, that has much more in common with the apocalyptic message of paintings by Orozco and Siqueiros. It is difficult not to agree with Xavier Moyssén who contended that Rivera's self-portraits are "perhaps the most psychologically profound of all of his portraits."[18] Nor should we end this discussion without recalling a fine description by Justino Fernández of this 1949 portrait: "His gray hair frames his forehead; the ironic look in his large eyes seems to insinuate a warning and the whole of Rivera's life pervades his face, from the wrinkles on his forehead to the sensual and aging mouth." [19]

THE LATER MURAL PAINTINGS

In his 1936 mural in four parts for the Hotel Reforma, Rivera had painted a controversial fresco that was supposed to be about a Mexican popular festival and ended up being a satire of much Mexican culture.[20] Although generally unimpressive because it is so heavy-handed in lampooning prominent people as well as popular practices, this series does include one outstanding and more "serious" panel entitled *Festival of Huejotzingo* (3.89 x 2.11 meters) that would be a defining element in his

work. The only one free of these crass caricatures, this fourth panel was done in contemporary solidarity with the popular mobilization that occurred during the later Cárdenas years.

The nature of this pictorial embrace was extremely sophisticated and involved a "dialogical" representation of popular culture quite at odds with official tourist-influenced affirmations of popular festivities. This painting depicted an historical event of the past — the guerrilla forces of Augustín Lorenzo combatting the French Army — that recalled the insurgent origins of this fiesta in the final years of colonialism and also triggered a retroactive reinterpretation of the popular festival as an ongoing demonstration of popular empowerment, not just an act of popular entertainment. This conception of "dialogical" popular carnival as an interplay between high culture and "low culture" *(and Rivera's mural itself concretely attested to this interplay)* has been analyzed by Russian author Mikhail Bakhtin.[21] For him, as for Rivera, the playfulness of carnival is also about the serious presentation of an alternative order to the existing system.

Such was exactly the point of Rivera's painting (although he would not have known of Bakhtin's work at the time since Stalin had banned it in the Soviet Union), as the Mexican artist stated in a passage about the iconography of his mural:

> [T]he masses utilize carnival as a means of evening up scores with the social classes that consider themselves above them. . . . [My] murals to the left of the entrance are of the carnival at Huejotzingo, Puebla, in which the epic battle against the French is represented in itself [as] a protest of the people.[22]

This treatment by Rivera attests to a genuine dialogical engagement with popular culture, rather than a mere recourse to the populist rhetoric of mainstream society, and it also demonstrates a telling emphasis on *popular national self-determination, as opposed to any embrace of official nationalism.* This emphasis on popular self-determination carries with it the corollary that all other people have the same right to it, thus being at odds with the hierarchical vision of nationalism in the ordinary sense.[23] It was precisely this point that was implicit in art critic Carlos Blas Galindo's treatment of the progressive tendencies *within* Mexican nationalism and/or self-determination that were articulated by the mural project of Rivera.[24]

While trying to protect himself from Soviet agents after their assassination of Trotsky in 1940, Rivera stationed armed guards at his scaffold in San Francisco where he was executing a five-panel mural for the City College of San Francisco (6.74 x 22.5 meters). Entitled *Pan-American Unity: The Marriage of the Artistic Expression of the North and South of this Continent* (Figure #25), this fresco contains in panel four a ghoulish group portrait of Stalin, Hitler, and Mussolini not long after the notorious *1939 Soviet/Nazis Non-aggression Pact*, that was so devastatingly demoralizing for many sections of the left both in the United States and abroad. It was also at this time that, as recently disclosed United States government records show, Rivera passed secret information about the Mexican Communist Party to the United States State Department.[25] Rivera's opposition to Stalin and his lifelong revulsion for anti-Semitism help account for his being an informant in this situation. At the time, the United States government was allied against *both* the Nazis and the Soviet Union (although this situation would obviously change with the subsequent invasion by the Nazis of the U.S.S.R.).

The most compelling panel in this five-part fresco in San Francisco is the center one (Figure #25), which features a remarkably hybrid motif that synthesizes a famous statue of Coatlicue, the Aztec Goddess, with a stamp press machine of the type that we noted earlier in Rivera's Detroit murals (Figure #22). Yet here the combination of modern and antique elements, of pre-Columbian culture and Western technology, is made far more explicit than it was in the previous work. The result is an image that, in making the synthesis more obvious, also becomes more illustrative and matter-of-fact.

Complementing this remarkably inventive image of hemispheric heterogeneity, of Pan-American multiculturalism and post-colonialism, is the quite commanding portrait of Frida Kahlo in the left foreground of this panel. Attired in the traditional clothing of Tehuántepec, she holds a palette in hand thus personifying modern painting in the Americas in this homage to her accomplishments as an artist. (For an English translation of Rivera's essay on Kahlo's gifts as an artist, see Appendix #3.) If the style and pictorial logic are less poetic, they are correspondingly more instructive. Clarity in iconographic terms is matched by an almost metallic crispness in a style that is as linear as that in any other painting by Rivera. In both cases, the urgent recourse to didacticism gives a strong historical accent to the populism in the "populist modernism." Concomitant with this tendentiousness is the strongly antifascist tenor of

this work — and it expressly identifies Stalin with the forces of fascism — on the eve of the Second World War.

Rivera's next public mural is one of the least accomplished of his entire career. It is executed in a visual language that is two parts neo-Baroque (Rembrandt's *Anatomy Lesson of Dr. Tulp* was possibly a stimulus in this regard), and one part montage with dull overtures to 1930s social realism and to pre-Columbian culture. It was executed in 1943–44 in fresco (each of the two panels is 6 x 4.05 meters) for the Instituto Nacional de Cardiología in Mexico City. The theme of this work was the "historical synthesis" of the scientific study of the human heart with the history of its clinical care, from the pre-Christian era in China, Egypt, Greece and Rome up through the mid-twentieth-century, all by means of a type of genealogical précis consisting of portraits of outstanding scientists (from Claudio Galen through William Harvey up through Agustín Castellanos).[26]

This 1943–44 mural in the National Institute of Cardiology is far more homogeneous in manner, far less original in compositional orchestration as well as cultural synthesis, than is another compelling mural on the same subject that Rivera executed in 1953, while in his late sixties. One of the two undeniable masterpieces among his murals from the last twenty years of his life, this large single-panel fresco was executed for the Hospital de la Raza (Figure #24), the foremost national hospital dedicated to the health care of Mexico's indigenous population. As its title indicates — *The History of Medicine in Mexico: The People Demand Better Health* — this pictorial tribute to the progressive institution of a system of national health care is thematically divided into two parts: there is a recounting in the right half of the ethnographic aspects of indigenous medical practices, including the curative practices as well as ancient medicines of pre-Columbian culture, and there is in the left half of the painting a presentation of modern medical science, with numerous scenes thoughout this work showing distinguished members of the Mexican medical profession.

Yet the dominant and axial motif of this large painting is an extraordinary depiction, entirely in the visual language of Aztec manuscript painting, of the Aztec deity Tlazolteotl (or Ixcuina), the goddess of eliminating "repulsive things" whose purview entailed the removal of filth and the guardianship of childbirth.[27] Revealingly, this remarkable and unrelievedly two-dimensional figure was taken from a facsimile of an early sixteenth-century pictorial manuscript, the *Codex*

Borbonicus (in the Bibliotheque de l'Assemblée National, Paris) and it shows her in archaeologically accurate terms: with cotton headdress and ear pendants, a covering of flayed human skin, and a blackened nose and mouth.[28] Below Tlazolteotl is a painted herbarium tablet on which eighty-four varieties of medicinal plants are named in Nahuatl, the Aztec's language. Beneath this tablet in the bottom register is a life/death mask flanked by two serpents.

Two towering tree-like forms are effectively employed as compositional devices to create a sense of cohesion among broadly disparate and competing vignettes that have been densely interwoven throughout this alternative centering and decentering composition. As Stanton Catlin has perceptively stated of these framing stems, one of which is bloodred and the other of which is fleshy yellow, they also function as giant arteries that create a massive vascular structure for this main wall. Thus, the formal elements and the thematic ones reinforce each other to give the painting added force in diverse directions.[29]

On the right of the work are "realistic" renditions of pre-Columbian medical practices for childbirth, surgery, and curatives. Surmounting this intricate montage is the imposing Aztec deity Izcuitl, who was the divine intercessor for her people's medical needs. On the left side of the mural, which is partitioned grid-like in the manner of the culminating 1935 panel in the National Palace, are various vignettes of modern medicine being put to socially beneficial uses. Accordingly, the transition from private to public medicine in Mexico is denoted by two facing groups of contemporary figures in the top part of this section, where the poor and the aged are informed by a government official that they no longer need to pay for their medical problems. Standing behind these humanitarian people are segments of the private sector that formerly profited from the personal misery of the poor. These profiteers of misfortune are consigned to the recent past and are shown to be displeased by this state of affairs.

The brilliance of this mural, not only artistically but also in terms of larger cultural discourses central to this era, can be summed up in a way that emphasizes Rivera's embrace of popular self-empowerment over simple populist rhetoric, along with a commitment to an alternative multiculturalism over official *indigenismo*. Such a summary of Rivera's innovations would list the following: 1) an unprecedented integration of European and non-European visual languages that is profoundly non-Eurocentric and post-colonial; 2) a nonidealistic focus on the

historical integrity and ultimate medical contributions of pre-Columbian culture that is quite at odds with the "Golden Age" pastoralism that tends to be characteristic of Rivera's other murals about the pre-Colonial era from the early 1940s through the 1950s; 3) a critical and empirically astute focus on the *incompleteness* of pre-Columbian medicine, however valuable its contribution, that allows no quixotic nostalgia for a "return" to a "better" period; and 4) a sustained artistic conceptualization of the unevenness of historical development. This last idea is found in certain texts of Marx that contradict the linear triumphalism of both orthodox Marxism and mainstream positivism. It is this latter attribute of Rivera's work that so often distinguishes his best paintings from the days of Anáhuac Cubism to the twilight of his career.

The concept of uneven development in history as found in the writings of Marx was explicated in 1937 by the philosopher Karl Korsch:

> The Marxist critique of the development concept of bourgeois social science starts from a recognition of the illusionary character of "so-called historical evolution," according to which "the last stage regards the preceding stages as being preliminary to itself, and therefore can only look at them one-sidedly. . . ."
>
> The false idealistic concept of evolution as applied by bourgeois social theorists, is *closed* on both sides, and in all past and future forms of society rediscovers itself. The new, critical and materialistic Marxist principle of development is, on the other hand, *open* on both sides. Marx does not deal with Asiatic, Antique, or Feudal society, still less with those primitive societies which precede all written history, *merely as "preliminary" stages of contemporary society* [my italics]. He regards them, in their totality, as so many historical formations which are to be understood in terms of their own categories.[30]

This conception of uneven historical development — which underscores the *in*conclusiveness to date of *every* moment in history from antiquity to the present — helps us to understand why Rivera's use of allegory, like his project of "epic modernism" that calls for spectator consummation, is about history as a field of fragments and as a composite of incomplete lessons, all of which await some greater degree of unity in a future phase of history. Just as Rivera spoke of Cubism as an art of historical fragments, so his greatest murals are both ambiguous and didactic, focused yet indeterminate. They are allegories but singularly

modern allegories. Revealingly, these allegories are of an epic yet fragmentary nature that recalls what Walter Benjamin wrote in the mid-1920s:

> It is nevertheless legitimate to describe the new concept of the allegorical as speculative, because it was in fact adapted so as to provide the dark background against which the bright world of the symbol might stand out . . . *Allegories are, in the realm of thought, what ruins are in the realm of things* [my italics].[31]

There was little that was fragmentary in the two portable murals that Rivera executed in 1952 and in 1954 on behalf of the Communist Party. It is precisely the presumption to finality, along with the Manichean presentation of the respective sides in the Cold War plus the concern with "social protest," that keep these paintings from being among Rivera's greatest public murals. In short, these murals, which were aimed at gaining Rivera readmission into the Communist Party, were little more than visual slogans with the usual cast of evil characters unreflectively and uninspiringly interpreted.

However much one might agree with the political stand taken in these artworks, the fact remains that the crudity with which this position is articulated, especially in the 1952 mural, undermines any claims for their being works of aesthetic merit or of probing criticism. Like slogans become shibboleths, they are baldly declarative, utterly unself-critical, and entirely without nuance. As such, the spectator has no role but to ratify or repudiate what is already the "correct" position in history.

The first of these paintings is 33 x 15 meters and covers forty square meters. It was entitled *The Nightmare of War and the Dream of Peace*. In an unreservedly illustrative manner closer to that of Juan O'Gorman than his own style, Rivera depicts a sentimental and sanctimonious scene of Stalin simply desiring peace and the West merely pushing for war. A towering and serene Joseph Stalin, flanked by an apple-cheeked and dreamy-eyed Mao Tse-tung, pleasantly offers a pen to a much smaller and sour-looking trio composed of Uncle Sam, John Bull, and Marianne holding the French Tri-color, with the hope that these three will sign the Stockholm Peace Accord.

Far below Stalin the lofty giant are "ordinary people," peasants from Asia and Latin America, while to the right are various scenes of United States troops executing Korean people, a wheelchair-ridden Frida Kahlo

collecting signatures for peace, and scenes of torture along with those of honest laborers being exploited. The sweet clarity with which the whole panorama of good and evil unfolds makes it seem that here Rivera had decided to become the Soviet version of Norman Rockwell. Bertram Wolfe has rightly noted that, "As painting it was pretty bad; Rivera had rarely done worse. But as an illustration or propaganda poster it had its points."[32]

Ironically, though, the response both by the Mexican government and some Western leaders gave the mural a certain amount of credibility in addition to the celebrity from controversy that this artistically indifferent, cliché-ridden work otherwise would not have merited. The painting was originally commissioned in the aftermath of the hugely successful 1949 retrospective of five hundred of Rivera's artworks in the Palace of Fine Arts, entitled *Diego Rivera, 50 Años de su Labor Artística* (Fifty years of His Artistic Labor). This resounding success, during which the Mexican President Miguel Alémán even spoke of Rivera's work as a "national treasure" (despite Rivera's utter lack of support for Alémán himself), was followed up in 1951 by a comprehensive symposium monograph published by the Ministry of Culture.

Subsequently, Fernando Gamboa and Carlos Chávez, the Director of the Fine Arts Institute, were instrumental in the commissioning of a new movable fresco by Rivera for 40,000 pesos (about $5,000 at the time) to accompany his retrospective when it went to Paris along with a selection of paintings by Orozco, Siqueiros, and Tamayo. Stipulating only that it be a movable panel fresco board but leaving entirely open the size and theme of the work, the Mexican government gave Rivera enough latitude to cause an international controversy, if not to create an important painting.

Rivera quickly decided that his candidacy for reentry into the Communist Party, which had been denied since 1946 owing to his well-known history of anti-Stalinism, would be advanced in spectacular fashion by a new work siding with the Soviet Union over the current debate around the Stockholm Peace Congress. After having told Chávez that he was "painting a mural which will be dedicated to peace," Rivera publicly unveiled the portable fresco shortly before his show was to travel to Paris. The controversy sought by Rivera was definitely triggered. Not surprisingly given the conservative politics of the government, Chávez refused to send the work to Paris for the 1952 show or to exhibit it in the Palace of Fine Arts in Mexico. To do so, Chávez reasoned, would

offend the governments of several powerful Western nations with which Mexico was then allied. Rivera responded by denouncing what he called the "fascist censorship" of the Alemán administration.

It was at this point, in 1952, that the Communist Party finally decided to forgive Rivera for his long history of anti-Stalinism and to help arrange for a public showing of this work. Throughout the world, the Communist Party rallied to Rivera's side. In the May 13, 1952 *Daily Worker* of New York, there was an open letter from nine United States artists (including Philip Evergood, Jack Levine, and Jacob Lawrence) expressing solidarity with Rivera as "spokesman of the Mexican people."[33] Furthermore, the day that the exhibition opened in Paris without Rivera's painting the official newspaper of the Communist Party, *L'Humanité*, reproduced his *Peace Mural* for distribution to remind viewers who attended this show that Rivera's mural had been banned.[34] Conversely, in Detroit, this incident almost resulted in the destruction of his murals in the Institute of Arts during the heyday of McCarthyism.[35]

The *Glorious Victory*, a portable mural of 2 x 5 meters, was done in response to the United States-backed military coup in Guatemala that overthrew the democratically-elected government of Jacobo Arbenz.[36] Arbenz was eliminated because of his social programs on behalf of the poor that led to the expropriation of land owned by United Fruit, a United States-based corporation. This tragic act of United States intervention through the C.I.A. in the domestic affairs of this small Central American country led to a reign of horrific repression that has still not come to an end. The Eisenhower administration claimed at the time that it was not involved in this violent overthrow of democracy, although United States government records now demonstrate the contrary.[37] In fact, the last public appearance of Frida Kahlo with Rivera, shortly before her death in 1954, was in the large demonstration against United States imperialism that was held in Mexico City shortly after the coup.[38]

While Rivera's indignation about this suppression of self-determination in a Latin American country was certainly justified, the painting he produced to convey this anger was not a successful one. Although probably heartfelt and well-intentioned, this painting sheds more heat than light on the issue. It is far too crudely caricatural and conceptually unsophisticated to provide a serious analysis of the event or to reward the viewer for sustained looking. In a centered composition replete with caricatures rather than expressive portraits, for example, a bomb with the features of Eisenhower, Rivera uses all the standard devices for "social

protest" painting, including massacred children and tortured but defiant campesinos.

This is non-nuanced history painting in starkly black and white terms, where the task of the spectator is simply one of passively recognizing the self-evident and the transparently clear. It is history without complexity and art as a shrill reflection of other more urgent concerns. Among the most populist paintings that Rivera ever did, this artwork is unabashedly dogmatic in intent. As such, Rivera never transformed his understandable political outrage into something more insightful or critically engaging. The resulting painting is more a spontaneous scream, than an impassioned but illuminating treatment, of this horrific moment in Guatemalan history. In a word, it is a missed opportunity.

A DREAM OF ALAMEDA CENTRAL PARK

Qualitatively speaking, a real coda, or perhaps culminating achievement, of Rivera's career was not one of these angry visual slogans of the 1950s. Rather it was a huge portable fresco (15 x 4.8 meters) that he painted for the Hotel del Prado, which was located near Alameda Central, the oldest park in Mexico City. (As noted, the building was entirely destroyed in 1985 by an earthquake yet the mural by Rivera survived with almost no damage to it.) Entitled *Dream of a Sunday Afternoon in the Alameda Central Park*, this work from 1947–48 is of commanding scope, featuring color interaction at the most sophisticated level that is matched, in turn, by a densely montaged profusion of aptly accented compositional shifts. The work as a whole is a luminous valedictory look by Rivera at the high and low points of Mexican history from the Conquest to the present.

Simultaneously pervaded by a nostalgic celebration of the national life and imbued with a graphic sense of the convulsive process of popular advances within it, this mural neither shies away from punctual editorial detailing nor avoids a loving recapitulation of the society to which Rivera will always be so deeply wedded in the popular imagination. It is a work of skillful condensation and telling displacements that contains both a manifest context and a latent content. As Stanton Catlin has noted in his indispensable discussion of this most autobiographical of Rivera murals, the work is, in a certain sense, "an uninterrupted stream of reflective consciousness."[39]

Particularly important for setting the tone for this painting is how Rivera in both title and style has looked back to one of the first European avant-garde movements as a stimulus for his own subsequent odyssey as an "alternative modernist." This was Neo-Impressionism, which was centered around the paintings of Georges Seurat and deeply committed to anarchism. This movement would be influential on Mexican artists in the early twentieth century owing to the efforts of Dr. Atl, Rivera's older friend. Nor is it without importance that Neo-Impressionism would burst on the art scene in Paris in 1886 — the year of Diego Rivera's birth — with a brilliant painting by Seurat called *Sunday Afternoon on the Grand Jatte*.[40] Aside from the subject of class-based forms of leisure in one's "free time," Rivera's painting is indebted to Seurat's high-keyed use of color that shows somber hues at high-value and luminous hues at normal value in an overall palette that evokes something approaching "belle epoch" gaiety and lightheartedness (especially with the superb use of multicolored toy balloons in relation to the hot air balloon). Counterbalancing this Neo-Impressionist color range in the central area that exists on one plane are two double-tiered side passages that are rendered by means of a deeply resonant chiaroscuro that recalls understated elegance in the manner of Titian and the Venetian School.

The autobiographical nature of this fresco sees Diego Rivera situated in the center, but as a youth with knee britches, in close relation to a congenial José Martí, a motherly Frida Kahlo, a dignified José Guadalupe Posada (who escorts a woman dressed as a *calavera*), and the two greatest anarchist leaders of Rivera's adolescent years, the Flores Magón brothers. Nonetheless this autobiographical dimension does not dominate the other parts of this animated mural. As Stanton Catlin has observed of the composition:

> The focusing of interest at this central point is subtly reinforced by the downward sloping arc created by the overhead branches, toy balloons, building profiles, and flames of revolution at the right. Although the figures face the observers as a theatrical *mis-en-scene,* the sense of assemblage promenading, or being seen on promenade, is ever present. Any avalanching effect of a massed procession is, however, absent. This dispersal, together with the equal implausibility of presenting such a historical progression seemingly at one moment in time, contributes to the work's aura of illusion or fantasy, especially when in its present setting it is lit while the

rest of the room remains dark.[41]

Rivera's last years were ones of pain (he suffered from cancer and went to the Soviet Union for cobalt treatments), of public controversy and, above all, of international fame. His seventieth birthday in 1956 was one on which he was paid national homage. After he died of heart failure on November 24, 1957, he was given official honors at the Palace of Fine Arts, where his body lay in state. Subsequently, he was buried in the Rotunda de los Hombres Ilustres (Rotunda of Illustrious Men) at the Pantheon de Dolores in Mexico City.[42]

A few words of tribute by Rivera's longtime partner Frida Kahlo would seem to be the best way to conclude this study. She wrote the following about him in 1949:

> To Diego painting is everything. He prefers his work to anything else in the world. It is his vocation and his vacation in one. For as long as I have known him, he has spent most of this waking hours at painting: between twelve and eighteen a day. . . .
>
> He has only one great social concern: to raise the standard of living of the Mexican Indians, whom he loves so deeply. This love he has conveyed in painting after painting.[43]

APPENDIX

■

"Diego Rivera, Painter of America"

by David Alfaro Siqueiros
El Universal Ilustrado (Mexico City)
July 7, 1921

Within the superbly cosmopolitan character of his emotive modern painting, the energy generated by the magnificent work of Diego M. Rivera is essentially Mexican; in everything he does, his labor reveals with more power and precision than that of any other painter of the Americas the vigor of our Hispano-Indian tradition. (It is a fatal error of ours frequently to consider a painter to be truly Mexican when he merely absorbs our typical aspects, while nevertheless using them in the manner of Audrey Beardsley or Ignacio Zuloaga.)

1906–10 — He lost four years in the Academy of Fine Arts in Mexico.

1910–12 — He arrived in Paris where he was a "metec" until the moment in which he triumphed over French "chauvinism." In the *House on the Bridge, Notre Dame in Paris*, and in some other landscapes from this epoch (of unsettled technique), his paintings stood out owing to their excellence.

1912–13 and part of 1914 — He lived in Spain, painted the landscape of Toledo (examples of which are in the Gallery of Fine Arts) and worked under the powerful spiritual influence of El Greco: as for example in *Portrait of the Painter Adolfo Best [Maugard]*, and so forth.

1914–15 — He was moved by a profound necessity to inquire into the emergent spiritual/intellectual tendencies toward universality (that is, the spirit peculiar to his epoch). He frequently became an adherent of "Deductive Cubism" in the advent of which he became an originating personality along with Braque, Picasso, Gris, Léger, Severini, and others;

passing through the magnificent epoch of debunking that brought forth Cubism, by means of which he audaciously asserted his individuality along the firm tracks of a systematic process; exalting as is normal in this new tendency that was unique to the plastic or visual arts and that left behind literary approaches as well as all anemic sentimentalism, as part of the intrinsic necessity of "making material" and concomitantly creating, manifesting and classifying Organic Plasticity with more vigor than any of his comrades in theory. During this advanced time, when Cubism was uniquely constructed in its first epoch, he transformed this art along evolutionary lines into an art more his, that is, more tropical and impassioned, in which the real forms were set with more clarity, in his geometric compositions of magnificent harmony; so that there was a profound comprehension and admirable definition of multiple qualities, of superimposed planes, his generative volumes, with intermeshed solids located in real space: in the form of landscapes, portraits, still lifes, nudes.

1915–17 — His Cubism was equally admirable in presenting a complete aspect of Transition; the entities and objects grouped together are shown with complete precision by means of an intelligent architectonic development, in which there is an expansive and lucid understanding of form: in portraits, landscapes, still lifes, and so forth. (A large portion of the artwork from this fascinating epoch is under the control of a "marchand" Jew who malevolently conceals it and from whose tyrannical guardianship Rivera had to liberate himself.)

1917–20 — His work approximates that of Cézanne and Renoir, from whom he expertly learned. He returned anew (in good time and gradually) to a type of painting that we may term "realist," with an enormous equipment-bag of innovative constructive skills and a great mastery in the workplace, but he did not paint forms uniquely validated by a chiaroscuro produced from an artificial or natural light, along with its shadow, as did the artists of antiquity; he determined, in feeling the dimension, the natural deformation and weight of the volume and schema, how to conform to its given sensation. He specialized in portraits and painted a number of works that will endure for all time. Elie Faure, the great French critic, in his *Histoire de l'art*, in which he referred to the influence of sixteenth-century France on contemporary painting, said: "concerning the 'portraits' of certain foreign artists, those of Rivera seem to me the most interesting both for their architectonic framework and for their fluctuating

volumes, in which there persists a doubly spirited action derived from Cézanne and Renoir that is unexpected, and through the specter of which is revealed a Spanish ascendancy that is manifested under the auspices of Goya and Zurbarán. (As in the Portraits of the Sculptor Cornet, of Elie Faure, of Mr. Pani, of the Engineer Alberto Pani, and of a Sage, etc.)

1920–21 — He made a trip to Italy in which he worked with zeal; he admired the Etruscan primitives, which strengthened his work; he repositioned himself by means of a very important collection of drawings in which he intimated a new tendency: Humanization. He understood with a clarified vision that construction, ambience, and the classification of qualities are inescapable means for arriving at a superior pictorial finality; that is, blurring drawing into reality, twisting form in order to humanize it, driving the responsive construction of his emotivity into accord with a prior rationality; his drawing is able to create the primitive or the child-like, that is, the naive, which is a form of intellectual rebirth, in portraits.

Diego Rivera is unquestionably the most powerful painter from the Americas; along with Matisse, Picasso, and Gauguin, he will represent a force of the first order in the history of contemporary painting.

Within the next few days when Rivera sets out on his much anticipated trip to Mexico, his return will assume the importance of a Fundamental Affirmation of our opaque artistic means.

Translated by David Craven
Paris
June 9, 1921

"Edward Weston and Tina Modotti"

by Diego Rivera
Mexican Folkways, No. 6
April–May, 1926

For many years now it has been a fact accepted by everyone that photography liberated painting, demarcating the area between the *image* (the copy of an aspect of the physical world) and *artistic creation,* within which falls the art of painting for which, given painting's particular reality *parallel to nature,* the employment or non-employment of the image of the interior world is different, yet indispensable for the *establishment of its proper order* to exist.

More than eighteen years ago, the great photographer Alfred Stieglitz was one of the first people in New York to fight on behalf of Picasso, the great painter and my comrade.

Today our sensibility is no longer fooled by the novelty of the camera and, as modern men, we clearly feel the personality of each author in different photographs made under equal conditions of time and space. We feel the photographer's personality as clearly as that of the painter, sketcher, or etcher.

The camera and its manipulations are actually a technique, like oil, pencil, or watercolor, and, above it all, persists the expression of two human personalities that serves itself through this technique.

One day while we were looking at their work, I said to Edward Weston and Tina Modotti: "I'm sure that if Velásquez were born again he would be a photographer." Tina and Weston replied that they had already thought the same. Naturally, some will mistakenly think this a modernist absurdity directed at the king of "pure" Spanish painting; but anyone who is not an imbecile will agree with me, because, in revealing Velásquez's talent in accordance with an image of the physical world, his genius would have led him to choose the most adequate technique for the task, i.e., photography. Keep in mind that for Velásquez, his greatest subtlety and

strength, as well as his greatest originality, lies in his values. And I believe that people like Weston and Tina, his students, are, on a parallel plane, equal to painters or other artists of the highest caliber.

There are few modern artistic expressions that bring me a more pure and intense pleasure than the masterpieces frequently found among the works of Edward Weston, and I confess that I prefer the productions of this artist to most significant contemporary paintings.

But the point is that Weston's talent has its place among the first-rate artists of today, although his work may be much less celebrated than theirs, and even if in his own country, the United States, they have not generally discovered him. In Mexico, where we are lucky enough to have him living and producing, they ignore him . . . since "the foreign boss's voice does not command admiration." One of these days, when the artist wills it, the "boss" of the poor intellectual bourgeoisie of Mexico will admire the work that Weston shows him — if modesty and indifference to notoriety can be broken by chance or some economic reason — and it will be reluctantly perceived that in Europe there is not, nor could there be, a photographer of Weston's stature. Then, in Mexico, they will finally realize that he exists.

Edward Weston now embodies best *the artist of America*, namely, he whose sensibility contains the extreme modernity of *Northern art and the vital tradition born out of the Southland.*

Weston's student, Tina Modotti, has achieved marvels of sensibility on perhaps an even more abstract or intellectual plane, as is natural for an Italian temperament whose work flourishes perfectly in Mexico and agrees so precisely with our passions.

"Frida Kahlo and Mexican Art"

by Diego Rivera
Buletín del Seminario de Cultura Mexicana, Vol. 1 No. 2
October, 1943

Mexico has been the place of encounter for two potent artistic traditions: Indoamerican and the Spanish. Not only the relative position of conqueror and conquered with its immediate economic, ideological, and aesthetic consequences, but also the very nature of the elements involved in these traditions, have been and continue to be uncombinable opposites. When they are found in the typical works of mestizo art, they are separated and give the work a contradictory character, which in turn precisely determines certain aspects of the work's originality.

Sensual and mystical idealism translates into an objective-subjectivized realism on the part of Spain: from the Archpriest to Cervantes, through Saint Teresa and Valle Inclán; from Castillian, Aragonese, and Catalán *retablos* to Velásquez, Goya and Zurburán through El Greco to Picasso; Spanish art is always characterized by individual inflections.

For Mexico, occultist and poetic materialism translates into a magical geometry, that uses signs more than symbols to create an abstracted and monumental realism. Such realism leaps over a superficial, anatomical and descriptive one and is elevated to a pure expression of superior proportions, to an inherent movement toward action, and to continual transformation. From Netzahualcoyotl and the Popol Vuh to Cuicuilco and Tulum-Lamna, moving through Teotihuacán and Monte Alban, to arrive at contemporary art, especially painting, indigenous art is always characterized by a collective inflection.

Elements of those traditions have always been rebellious to the amalgam. Each time that one has tried to unite them, sooner or later they have broken away from their emulsifying agent and separated like oil from water.

Throughout Spanish domination, the emulsifying agent was

constituted by the imposed force of the conqueror along with all the tools he made use of: the armed civil police, oral and written propaganda made by priests and doctors, the Laws of the Indies and Decrees of the Guilds of New Spain, and above all, the powerful economic law of supply and demand. Those who established that demand were naturally the richest consumers: the colonial administrators, the *comendadores,* religious and secular landowners, mine owners, bosses of industry and artisans, vice royalties, judges, merchants, officers, clerics, and priests. All worked for their own interest in seeking products to satisfy their own taste and in rejecting those that did not accommodate it. They proscribed any clandestine or non-cooperative producers through punishments specified by the Decree of the Guilds of New Spain, which left the exercise of the most lucrative crafts and posts to the Spaniards and Creoles, leaving only what remained to the Indians. Control of the production of art was verified by the overseers or functionaries charged with destroying heterodox works and seeing to it that the Indians did not paint, sculpt or carve any sacred images that they were prohibited from creating, thus allowing them only to paint landscapes and still lifes, ornamental graphics and sculpture. Whenever sculpted or painted objects went beyond the ornate, Indians were forced to copy stamps or images authorized by the Spanish bosses be they *encomenderos,* the overseers themselves, or Catholic priests. This and nothing else is the origin of the persistent fact that even today the fabrication of religious images is reserved for Spaniards and trusted Creoles. Such were the precautions taken by the dominant class against artistic genius in Mexico. But, if they managed to suppress and condition its manifestations throughout three centuries, they could not manage to destroy its existence completely.

It must be said that this situation came about by experience. Still, in the sixteenth century at the dawn of the new state of things, evangelical priests (definitively efficient assistants to the military and civilian conquistadors), found themselves at a loss for visual material to serve their propaganda. That propaganda was of immense importance, since there was not only the difficulty of idiomatic difference, but also an abyss between two modes of writing: the Mexican mode of ideographic images, and the Spanish phonetic mode of signs. Thus it was that paintings, drawings, stamps, and sculptures which spoke a language understood by all were greatly needed. Priests sent catechized Indians to Italy to learn Catholic painting. When they returned it was apparent that they were not influenced by the pompous rhetoric of overblown art that Baroque

underlings of Michaelangelo and Raphael were using at that time. The Indian painters were influenced, instead by pre-Giottists and Giottoists of the Late Italian Middle Ages, when people struggled against Feudal lords and exploitative popes, by using as parabolic examples scenes from the life of Christ throwing the merchants out of the temple, or sentencing the rich who would later enter Paradise with greater difficulty than a camel passing through the eye of a needle.

As was true of the best of the rebellious and rejuvenated painting at the end of the Italian Middle Ages, the work of those Mestizo Indian artists was beautiful. Proof of that is what remains of those works in the murals of Actopan, Epazoyucan, Huejotzingo, Tepeaca, and other places, where early colonial architecture is also the best that was done under Spanish domination. But the prevalent and evident parentage in the work of those evangelized Indians, along with the marvellous frescoes and codices of their ancient culture, must have greatly alerted priests, doctors, and auditors to a new subversiveness that was implicit in its clear connection to that of the masters with whom they joined in painting the lives of people fighting for their freedom.

But something else had happened: While constructing churches, the Indians (surreptitiously, or under the furtiveness of the priest who needed a good clientele and copious tithes that necessarily had to come from the Indians themselves) had buried beneath those churches and even under altars, their ancient idols, the poetic-materialist personifications of the forces of nature and indestructible human impulses.

But much more happened too: Indian artists painted crucifixes flanked by the Sun and Moon, with bouquets of flowers upon altars that at a glance seem clearly integrated with elements of Catholic painting. One sees the image of Tlaloc, our god of water, with the cross made of cornstalks whose horizontal branch signifies earth and whose vertical trajectory is drops of water that fall to fertilize it. One sees the *nahui-olin* cross, the four movements of the sun, the four equinoxes, the four corners of the firmament, North, South, East and West; the four elements of earth, air, fire and water; the first four human beings of red, yellow, black and white, created by three plumed serpents with the green plumes of the quetzal, the only one to exist before everything, when water was on the verge of water in its gaseous state. Now integrated are the three persons of our creator trinity: the Master Light of Lightening, the Master of Thunder, the Master of Lightening's Trace, who with the Master Thunderbolt make four and are the first force of matter and the authors

of all its forms. Out of these marvellous occultist Tlaloc-Christs come some examples that escaped the envy of the overseers and have survived for us to this day.

The adoration that the Mexican Indian performs in Catholic temples with dances and prayers was and continues to be directed toward those occult images. That is why it was necessary to place the Sun and Moon in a prominent place in all Churches since, without them, Indians would not have been good clients and would have skimped on charity and tithes.

Compounded by the need to construct a solid base for colonial domination, laws, decrees, and overseers were established to uproot the ancient culture as much as possible, and all things Spanish were used against the genius of Mexican art. That is why only in the eighteenth century was the official appearance of the first Indian painter recognized by an exploitative colonial society which consumed his production with great approval. That painter was Miguel Cabrera who, from his Indian heritage, conserved only his face and in his painting preserved a feline refinement, quite different from the austerity and somberness of the Hispanic style. The Indian painter's genre of elegance was now full of Catholic light blues and pleasant pinks and fit in marvelously with the purposes of the highly intelligent Jesuits who were also first-rate politicians. From early on when the first storm clouds were barely visible on the horizon, the Society of Jesus clearly understood all the dangers that would follow the storm of the bourgeois revolution, with its militant francomasonry, its Goddess of Reason, and terrible battalions of *sans-culottes*. In its smooth mystical sensualism, adorned with aromatic spices of incense, and the always pardonable sin offset by gallant and devout penitence accompanied by personal economic contributions for the pleasure of its ministers and the Church's capital gain, the Society of Jesus found a magnificent oil to spill around the Church nave to keep the big wave (of revolution) from capsizing it. Among the elements of that calming and holy oil, Baroque art and literature were crucial; today in Mexico we still endure its aromas, conserved in all types of urns.

Later on, after political independence failed owing to the lack of a necessary base for national economic independence, the post-feudalist sub-bourgeoisie of the former colony (who in eleven years of struggle and sacrifice were able to achieve only the status of a semicolony) supplanted the Spanish boss by oppressing the indigenous and mestizo masses in the same way as before, or worse. But in that enterprise, as in all others, they failed.

The social classes succeeding Spanish domination failed due to inherent historical ineptitude and biological incapacity.

First, the social regime's feudal and paternalistic forms that prevailed in the Spanish colonies were impermeable to the Reformation that arose in European countries, a movement that with its ideas of free examination and liberalism already held within it the makings of a bourgeois revolution and tremendous progressive potential. Secondly, in their social makeup they had inherited a considerable part of the boundless treasures of pathological wealth, collected by illustrious ancestral conquerors together with war booty from their "discoveries." They inherited syphilis, with its mentally incapacitating states, and long processes of general paralysis. They suffered from a multiform neurosis caused by repression and traumas as a consequence of an ancient education system where sexual repression was connected to social, moral, and religious prejudices. Any kind of elemental human drive was disciplined in order to form and serve the dominant caste system — All of this was a result of the most ancient collective mental suffering whose roots lie in the entire slave-based culture of Greco-Latin Europe.

In social terms, the failure of the post-colonial social classes stemmed from their incapacity to exercise power. Everyone from the postfeudal lord to the peasants evinced that incapacity. Without a social class, the only force able to do so took power: the armed police state or the military police. That army, commanded by militant political associations with or without uniforms but always armed, has been without exception the only force capable of maintaining a national cohesion in Mexico and in all the rest of the Amerindian-Iberian semicolonial countries like ours. In all our countries, the power of the military always exists as the only true government authority behind the more or less civilian appearance and simulated democracy. That military, with all the major defects that it could and does have, is the only thing that has made possible a national existence of Amerindian peoples on our continent, after our separation from the metropolis.

Although these countries have lacked a national economy, there have clearly been more or less liberal and progressive governments in the different nations that compose what is called Latin America, including Mexico and the rest of the countries south of the Rio Bravo. At times there have even been heroic ones, as in the case of Paraguay, a shining light of Amerindianism in the darkness of Latin America, which always seem to be searching for foreign bosses. The progressive character of these

governments has been determined by social exigencies with natural repercussions for the physiognomy of the culture, mediated by the needs of modern industrialization for the gain of invested capital, and has meant the unavoidable elevation of the standard of living for the masses with the object of creating consumers for industries established by capital. In other words, the propulsive force of that progressivism has advanced the capacity to organize and, consequently, has improved the mentality of the producing workers and industrialized peasants who have necessarily emerged as this social phenomenon has been realized.

Precisely that phenomenon, with its continually growing and fluid dialectical contradictions, has made the old trunk of ancient Indoamerican culture reemerge. An archaic and backward colonialism established to try and keep alive a dying European feudalism and, later, an inept sub-bourgeois semicolonialism in a pseudoindependent country could not destroy it. The survival of that culture is one of the most valuable and positive things produced by the dialectical contradictions in the debit and credit of the history of Mexico. It benefits the progressive aspects of the Mexican people and all inhabitants of the American continent today who want to march toward a better social order that could come, if only they know how to achieve it through the struggles of our time, in order to construct a unified and truly democratic America.

Mexico's development over time and space has naturally not followed a cut and dried linear course. It has been more like an electric spark, quick yet sinuous and full of ramifications in its trajectory through the atmosphere. This sociological and historical atmosphere in Mexico is highly complicated because of the diversity of the multiple elements that constitute it.

In current and past examples of Mexican art, one clearly reads the modalities of the country's uneven social development. The art produced in Mexico without exterior coercion that is the most spontaneous and free, i.e., the art of the people for the people, delineates with great clarity its two great originating elements that are reconciled without degenerating. That kind of accommodation happens in the votive paintings, or what we call *retablos*. These paintings conserve the Amerindian sensibility with its enormous coloristic power and monumental realism that remain in effect even within the smallest of physical dimensions. On the other hand, the mystical element suspended in the ambiance of the painting is accepted as a heavenly element and nothing more, while occultist and poetic materialism rules over the

personalities on earth who believe themselves to benefit from the miracle of Christ, the Virgin, and the Spanish saints. From the entire nineteenth century and the beginning of the twentieth, the *retablos* are the best product of the *mestizo* hybridity of semicolonial Mexico. Hence, Mexican José-María Velasco was a hero who was clean of all "Spanishism" in his paintings.

Around 1921 symptoms began to present themselves in Mexican art that translated the impulse of the people as they moved out of their semicolonial status and reclaimed their economic and political independence and began to emerge into the world with their own free character. All Mexican painting of value produced during the period between 1921 and 1943 reflects that state of affairs. As a dialectical counterpart to these positive acquisitions in modern Mexican painting, there coexists an artistic manifestation that continues to portray a subaltern and semicolonial character. The latter are lamentable and provincial imitations of European art. They are the same as the miserable by-products of North and South American artists who suffer from the same disease of dependency, in contrast to those who, in the United States and South America, are now beginning to brilliantly affirm an independent existence for the art and culture of America. The pseudoartists, who still suffer from a semicolonialism that converts them into European lackies, can be divided into two large groups:

a) Those who copy the most inferior products of bourgeois and petty bourgeois European art, the authors of originals for chromium destined to be sold in churches or to adorn tear-off calendars and commercial magazines; painters of portraits of people in bad taste; makers of "paintings" that only can be seen in the homes of generals and the nouveau riche with little culture or, what is even more lamentable, portrait painters of state officials.

b) The most astute and aware group — old style and modern young artists, the providers of art galleries — have substituted for the academism they used to copy from San Carlos based upon Murillo, Raphael, and Ingres . . . or Clave and Fabrés, a new academicism that tries to copy from, here, there, and everywhere Picasso, Chirico, Miró . . . or Dalí and Sert. There is no digestion without waste products.

In the midst of this panorama of Mexican painting of quality produced during the last twenty years, and like a diamond in the very center of a great jewel box, clear and hard, precious and cutting, shines the painting of Frida Kahlo Calderón. From the *retablo* now disappear Christ, the

Virgin, and the Saints. In place of some lasting miracle, what now constitutes the theme of the painting, i.e., its ever-flowing and vital content, is always different and always the same in its venous and sideral circulation. One life contains the elements of all life, and if one penetrates deep inside, one finds the profound abyss, the vertiginous height and the weavings of infinite ramifications prolonged in centuries of Life's light and shadow.

That is why Frida's *retablos* always portray her own life.

The German analyst, constructor-destructor and enlightened skeptic — all inherited from her father's genes, prevailed. These traits were cleansed of everything Spanish and allied with the Indian genes of the mother. Behind heaven's door, opening by and by, there was only an implacable and marvellous space, from where the Sun and Moon are above the pyramids at the same time, portentous and great in their microscopic size in relation to the astro and planet, and immense in their systems of proportions, which are those of the entire universe. The child seated in the center of the world possessed the toy plane that, moving faster than light, equaled in velocity an imagination/reason that knows stars and cities before arriving at them via telescopes and locomotives. That velocity resides in Frida, alone in mechanized space, suspended upon a cot, from where she cries and sees that the life-fetus is a flower-machine, a slow shell, a mannequin and a bony armor in appearance, but in reality is essential over and above the imagination/reason that moves faster than light.

It is a recurring self-portrait that never looks like any other, yet each time looks more like Frida, changing and permanent like the universal dialectic.

Monumental realism shines; an occultist materialism is present in the heart cut in half, the flow of blood on the table, in the bath, in plants, flowers, and the arteries that close the hemostatic clips of the author.

Monumental realism is expressed in its smallest dimension; the smallest heads are finely sculpted as if they were monumental in size, and appear that way when the magic of a projector amplifies them to the size of an entire wall. When the photomicroscope amplifies the ocular depth of Frida, the reason why is apparent; the weaving of veins and the networks of cells are different, they lack the elements to increase with a new perception the total capital of the art of painting.

Frida's retablos do not resemble the retablos of anyone else or anything. The art of Frida is collective-individual. It contains a realism so

monumental that in all its space, it possesses Nth dimensions. As a consequence, she paints the exterior, the interior, and the depth of herself and of the world at the same time. In the sky of oxygen plus hydrogen, carbon, and contained electricity, the spatial beings of Hurakan, Kukulcan, and Gukamatz are alone with mother and father, grandmother and grandfather, and she is in the earth and in the material, the thunder, the lightening, and the lightening bolt, which, in their conversation, finally construct man. But, for Frida, the mother is the tangible element, the center of everything, the womb: sea, storm, nebulous woman.

And Frida is the only example in the history of art of someone who tore out her breast and heart to tell the biological truth of what she feels in them. Possessed of reason/imagination that is faster than light, she painted her mother and wetnurse, knowing that she really does not know their faces. The nourishing "nana's" face is only the Indian mask of hard rock, and her glands are clusters that drip milk like the rain fertilizes the earth, or like the tear that fertilizes pleasure. The mother is the grieving *mater* with seven daggers of pain that makes possible the torn opening through which emerges the Child Frida, the only human force that, from the portentous Aztec master who sculpted it in black basalt, has created birth by means of its own action in reality.

NOTES
■
Notes to Introduction

1. Jorge Luis Borges, *Ficciones* (1956). Trans. Anthony Bonner (New York: Alfred Knopf, 1993), 37.

2. Luís Cardoza y Aragón, "Diego Rivera's Murals in Mexico and the United States," *Diego Rivera: A Retrospective* (Detroit: Detroit Institute of the Arts, February 10, 1986–April 27, 1986), 185. See also Luís Cardoza y Aragón, *Diego Rivera: los frescoes en la Secretaria de Educación Publica* (Mexico City: Secretaria de Educación Publica, 1980).

3. Cited by Gerardo Mosquera, "The Conflict of Being Updated," *New Art From Cuba* (Old Westbury: State University of New York, Wallace Gallery, 1985), 45.

4. On Rivera and modernity see Olivier Debroise, *Diego de Montparnasse* (Mexico City: Fondo de Cultura Económica, 1979). Rita Eder, "El Muralismo Mexicano: Modernismo y Modernidad," *Modernidad y Modernización en el Arte Mexicano, 1920–1960*, Ed. Olivier Debroise (Mexico City: Instituto Nacional de Bellas Artes, Museo Nacional de Arte, 1991), 67–81. Jorge Alberto Manrique, "La vanguardia de Diego Rivera," *Diego Rivera Hoy* (Mexico City: Palacio de Bellas Artes, 1986), 25–32.

5. Lázaro Cárdenas, "Diego Rivera," *Testimonios sobre Diego Rivera*, intro. Andres Henestrosa (Mexico City: National Autonomous University of Mexico Press, 1960), 11: "En sus murales es cómo un campesino que reclama su tierra." For a quite different Hispanophile perspective of José Vasconcelos, see José Vasconcelos, "Sobre Diego Rivera," *Antología Tributaria: Diego Rivera y los Escritores Mexicanos*. Ed. Elisa García Barragán (Mexico City: National Autonomous University of Mexico, 1986), 227–28.

6. Alberto Híjar, "Diego Rivera: contribución política," *Diego Rivera Hoy*, 37–72. For a fine look at the essentialism of official *indigenismo*, see

David Brading, "Manuel Garmo and Official Indigenismo in Mexico," *Bulletin of Latin American Research*, VII, I (1988), 75–89.

7. Leon Trotsky, "Art and Politics in Our Epoch" (1938), reprinted in *Leon Trotsky on Art and Literature*. Ed. Paul Siegel (New York: Pathfinder Press, 1970), 110. O. K. Werckmeister, "The Summit Meeting of Revolutionary Art: Trotsky, Breton, and Rivera at Coyoacán," February 1938, Paper at the *XXVIIe Congrès International d'Histoire de l'Art.* Colmar, France, September 7, 1989.

8. David Alfaro Siqueiros, "Rivera's Counter-Revolutionary Road," *The New Masses* (May 1934): 16–17, 38. This attack also appeared in Spanish in Mexico City as "El camino contra revolucionario del pintor Rivera," *El Universal Ilustrado*, 13 (September 1934).

9. Mikhail Bakhtin, *Rabelais and His World* (1965). Trans. Helene Iswolsky (Bloomington: Indiana University Press, 1984). This book was written in the 1930s but remained unpublished in the Soviet Union until 1965.

10. Carlos Mérida, *Frescoes in Salubriadad and Hotel Reforma* (Mexico City: Francis Toor Studios, 1937), n. p. This text, a statement by Rivera, was originally published in English without credit to a translator.

11. See, for example, Gerardo Mosquera, "Raíces en Acción," *Revolución y Cultura* (Havana), 2 (February 1988): 37–39, Roger Bartra, *The Cage of Melancholy* (1992). Trans. Christy Hall (New Brunswick: Rutgers University Press, 1992), Stuart Hall, "The Local and the Global: Globalization and Ethnicity," *Culture, Globalization and the World System*, Ed. Anthony King (Binghamton: State University of New York, 1991), 19–40, and Paul Gilroy, *The Black Atlantic* (Cambridge, Mass.: Harvard University Press, 1993).

12. Raquel Tibol, "Diego Rivera: su visión de la mujer" and Elena Urrutia, "Comentario a la ponencia de Raquel Tibol," *Diego Rivera Hoy*, 125–34, 135–38.

13. Diego Rivera, "Los primeros murales" (1925), *Arte y Política.* Sel., ed., and intro. Raquel Tibol (Mexico City: Grijalbo, 1979), 51.

14. Alicia Azuela, "Rivera and the Concept of Proletarian Art," *Diego Rivera* (Detroit, MI: 1986), 125–30.

15. Meyer Schapiro, "The Patrons of Revolutionary Art," *Marxist Quarterly*, 1, 3 (October/December 1937): 463: "With all its limitations, Rivera's art is the nearest to a modern epic painting."

16. Raquel Tibol, *Arte y Politica*, 27.

17. Adolfo Sánchez Vázquez, "Claves de la ideología estética de Diego Rivera," *Diego Rivera Hoy*, 205–28.

NOTES TO CHAPTER ONE

1. Justino Fernández, *Arte Moderno y Contemporaneo de México, Vol. II: El Arte del Siglo XX.* 1952. Mexico City: Universidad Nacional Autónoma de Mexico, 1994, 44. Hereafter this volume will be referred to as *El Arte del Siglo XX.*

2. Bertram D. Wolfe, *The Fabulous Life of Diego Rivera.* 1963. Chelsea, MI: Scarborough House, 1990, 6–7.

3. Ibid., 17. See also Florence Arquín, *Diego Rivera: The Shaping of an Artist: 1889–1921* (Norman: University of Oklahoma Press, 1971), Ernestine Evans, *The Frescos of Diego Rivera* (New York: Harcourt Brace, 1929), Gladys March, *Diego Rivera: My Art, My Life* (1960). New York: Dover Publications, 1991, Luís Suárez, *Confesiones de Diego Rivera* (Mexico City: Ediciones E.R.A., 1962), and Loló de la Torriente, *Memoria y razón de Diego Rivera*, 2 vols. (Mexico City: Ed. Renacimiento, 1959). Among the recent scholars to more sharply distinguish legend from actuality is Linda Downs, "Introduction," *Diego Rivera* (Detroit, MI: Detroit Institute of Arts, 1986), 19. At present a team of scholars in Mexico led by Armando Torres Michúa is carefully reviewing the primary documents in these cases. Conversation with the author in Mexico City on June 21, 1995.

4. *Baptismal Certificate for José Diego María Rivera and José Carlos María Rivera* (December 13, 1886), Archivo de la Parroquia de Nuestra

Señora de Guanajuato, Guanajuato, Mexico. The first scholar to verify these facts was Ramón Favela. See *Diego Rivera: The Cubist Years* (Phoenix Art Museum, March 10–April 29, 1984), 154. See also Ramón Favela, *"Rivera Cubista": A Critical Study of the Early Career of Diego Rivera, 1898–1921*. Diss. University of Texas at Austin, 1984 and Linda Downs, "Introduction," *Diego Rivera* (1986), 17.

5. See *Diego Rivera: Catálogo General de Obra de Caballete* (Mexico City: Instituto Nacional de Bellas Artes, 1989), 1–10: 9–10. This impressive two volume catalogue raisonné is the compilation to which I shall refer all subsequent attributions of Rivera's works.

6. Peter Bakewell, "Mining," *Colonial Spanish America*, Ed. Leslie Bethell (Cambridge: Cambridge University Press, 1987), 245. This essay was previously published in *The Cambridge History of Latin America* (Cambridge University Press, 1984).

7. Gladys March, *Diego Rivera: My Life, My Art*, 10.

8. Eduardo Galeano, *Las venas abiertas de América Latina (Open Veins of Latin America)* (1971), Trans. Cedric Belfrage (New York: Monthly Review Press, 1973), 48–49.

9. Alexander von Humboldt, *Political Essay on the Kingdom of New Spain* (London, 1811), Book IV, Chapter XI. Cited by Galeano, *Las venas abiertas*, 48. See also "Introduction" by Fernando Carmona, Diego López Rosado, *Historia y pensamiento económica de Mexico* (Mexico City: Siglo ventiuno, 1968), and Peter J. Bakewell, *Silver Mining and Society in Colonial Mexico: Zácatecas, 1546–1700* (Cambridge: Cambridge University Press, 1971).

10. Alexander von Humboldt, *Political Essay*, cited by Eduardo Galeano, *Las venas abietas*, 48.

11. *Diego Rivera: Catálogo General de Obra de Caballete*, 9, 12: 10. The material about Rivera's childhood and early adolescence is taken from several sources, such as Gladys March, *Diego Rivera* and Ramón Favela, *Diego Rivera: The Cubist Years*.

12. Gladys March, *Diego Rivera*, 15.

13. Justino Fernández, *El Arte del Siglo XX*, 35: a "síntesis de Apolo y Huitzilopochtli." On the Academy of San Carlos, see Dawn Ades, "Academies and History Painting," *Art in Latin America* (New Haven: Yale University Press, 1989), 27–40.

14. *Diego Rivera: Catálogo General de Obra de Caballete*, 14, 15, 13: 10. For a discussion of these French Academic forms, see Albert Boime, *The Academy and French Painting in the Nineteenth Century* (London: Phaidon, 1971). For an overview of Rivera's accomplishments, see Ellen Sharp, "Rivera as a Draftsman," *Diego Rivera* (1986), 203-14.

15. Ibid. 17: 11: *Cabeza* (Head), drawing in pen and ink (27.6 x 18.8 cm.), Collection of the National School of Visual Arts, National Autonomous University of Mexico.

16. Jean Charlot, "Diego Rivera at the Academy of San Carlos," *An Artist in Art: Collected Essays of Jean Charlot* (Honolulu: University Press of Hawaii, 1972), 201–3.

17. Bertrand Russell, *Wisdom of the West* (New York: Crescent Books, 1959), 275. For other critiques of positivism in Mexico see, for example, the three essays by Leopoldo Zea, Karl M. Schmitt, and Walter N. Breymann in *Positivism in Latin America, 1850–1900*, Ed. Ralph Lee Woodward, Jr. (Lexington, Mass: D.C. Heath and Co., 1971), 65–94. It is common among scholars who write about Diego Rivera to make the mistake of referring to Rivera's so-called "positivism." Such a view implicitly confuses positivism with science and explicitly misattributes an embrace of positivism to Rivera himself. An otherwise fine recent study in which this error occurs several times is Lawrence Hurburt, *The Mexican Muralists in the United States* (Albuquerque: University of New Mexico Press, 1989), 93 ff. Some major Rivera scholars who have underscored Rivera's critical attitude towards positivism both in his art and thought are Justino Fernández, Adolfo Sánchez Vázquez, and Alberto Híjar. See, for example, Justino Fernández, *El Arte del Siglo XX*, 3–4, Adolfo Sánchez Vázquez, "Claves de la ideología estética de Diego Rivera," *Diego Rivera Hoy*, 205–28, and Alberto Híjar, "Diego Rivera: contribución política," *Diego Rivera Hoy*, 37–72.

18. *Diego Rivera: Catálogo General de Obra de Caballete*, 26: 12. *Paisaje*

(Landscape), oil on canvas (34 x 22 cm.) and with the dedication: "Á mi querido maestro el notable artista don Félix Parra."

19. Gladys March, *Diego Rivera*, 17.

20. Ibid., 18.

21. Justino Fernández, *El Arte del Siglo XX*, 3–4.

22. Jean Charlot, "Diego Rivera at the Academy of San Carlos," 203–10.

23. Gladys March, *Diego Rivera*, 18.

24. Among the Rivera scholars who have disputed what Rivera claimed about his relationship to Posada are Lawrence Hurlburt and Ramón Favela. See Ramón Favela, *Deigo Rivera: The Cubist Years*, 20.

25. Justino Fernández, *El Arte del Siglo XX*, 15.

26. Ibid.

27. José Martí, "Una visita a la Exposición de Bellas Artes, II," (December 28, 1875), reprinted in *Ensayos Sobre Arte y Literatura*. Ed. and intro. by Roberta Fernández Retamar (Havana: Editorial Letras Cubanas, 1979), 2. For a brief discussion of José Martí as an art critic of Mexican art, see Justino Fernández, *El Arte del Siglo XX*, vol. II, *Arte Moderno y Contemporaneo de Mexico*, 132. For an excellent discussion of the work of José María Velasco, see Dawn Ades, "José María Velasco," *Art in Latin America*, 101–10.

28. Alfonso Reyes, *Pasado Inmediato y otros ensayos* (Mexico City: El Colegio de Mexico, 1941), 2–3. As for a reproduction of Rivera's cover, it can be found in *Diego Rivera, Catálogo General de Obra de Caballete*, 46: 14. Cover for *Savia Moderna Revista mensual de arte*, no. 3, 4, and 5. Collection of the National Library at the National Autonomous University of Mexico.

29. Alfonso Reyes, *Pasado Inmediato*, 2–3.

30. Pedro Henríquez Ureña, quoted in Ibid.

31. These works can be found in *Diego Rivera, Catálogo General de Obra de Caballete*, 29: 12, 40: 13, 44: 14.

32. Bertram D. Wolfe, *The Fabulous Life of Diego Rivera*, 40. Gladys March, *Diego Rivera*, 21.

33. Bertram D. Wolfe, *The Fabulous Life of Diego Rivera*, 41. Gladys March, *Diego Rivera*, 22.

34. James Cockcroft, *Mexico: Class Formation, Capital Accumulation and the State* (New York: Monthly Review Press, 1983), 93. See also Pablo González Casanova, Ed., *La clase obrera en la historia de México*, 22 vol. (Mexico City: Siglo XXI, 1980–83), and Jorge Basurto, *El proletariado industrial en México, 1850–1930* (Mexico City: National Autonomous University of Mexico, 1975).

35. Gladys March, *Diego Rivera*, 24.

36. James Cockroft, *Mexico*, 94–95.

37. Ibid.

38. Ibid.

39. Ibid.

40. Ibid.

41. Ibid.

42. Ibid., 96–98.

43. Gladys March, *Diego Rivera*, 25.

44. Ibid., 30 and Bertram D. Wolfe, *The Fabulous Life of Diego Rivera*, 84, 265. See *Diego Rivera, Catálogo General de Obra de Caballete*, 51: 15.

45. *Diego Rivera, Catálogo General de Obra de Caballete*, 53: 15, 59: 16.

46. Eduardo Chicarro y Agüera, *Informe* (June 1907), Personal Papers of Diego Rivera, Mexico City. Cited Bertram D. Wolfe, *The Fabulous Life of Diego Rivera*, 47.

47. Gladys March *Diego Rivera*, 28–30.

48. *Diego Rivera, Catálogo General de Obra de Caballete*, 64: 16. The dedication goes as follows: "A Sr. Don Teodoro Dehesa, Gobernador de Veracruz con mi grande reconocimiento. Madrid, 1908."

49. Gladys March, *Diego Rivera*, 30.

50. Ibid., 25–27.

51. *Diego Rivera, Catálogo General de Obra de Caballete*, 62: 16.

52. Gladys March, *Diego Rivera*, 27–28.

53. Ibid., 30.

54. Ibid.

55. *Diego Rivera, Catálogo General de Obra de Caballete*, 77: 18. The observation about Bruges in the background was made by Lawrence Hurlburt, *Diego Rivera: A Retrospective* (Detroit, MI: Detroit Institute of Arts, February 10, 1986–April 27, 1986), 33.

56. Gladys March, *Diego Rivera*, 34.

57. *Diego Rivera, Catálogo General de Obra de Caballete*, 75: 18.

58. On the technique of Claude Monet, see Robert Herbert, "Method and Meaning in Monet," *Art in America*, 67, 5 (September 1979): 90–108.

59. Gladys March, *Diego Rivera*, 48–50.

60. Ibid., 47.

61. Ramón Favela, *Diego Rivera: The Cubist Years*, 29.

62. Bertram D. Wolfe, *The Fabulous Life of Diego Rivera*, 62.

NOTES TO CHAPTER TWO

1. Antonio Castro Leal, "Diego Rivera y Rubén Darío," *Antología Tributaria: Diego Rivera y los Escritores Mexicanos*, Eds. Elisa García Barragán and Luís Mario Schneider (Mexico City: National Autonomous University of Mexico, 1986), 45.

2. Perry Anderson, "Modernity and Revolution," *New Left Review*, 144 (March/April 1984): 104.

3. Bertram D. Wolfe, *The Fabulous Life of Diego Rivera*, 64.

4. Olivier Debroise, *Diego de Montparnasse* (Mexico City: Fondo de Cultura Economica, 1979), 65. Debroise attributes the origin of his phrase to Justino Fernández.

5. Rita Eder, "El Muralism Mexicano: Modernismo y Modernidad," *Modernidad y Modernizacion en el Arte Mexicano, 1920–1960* (Mexico City: National Museum of Art, 1991), 67–81.

6. Ibid.

7. Gladys March, *Diego Rivera*, 68.

8. Ibid., 58.

9. This statement by André Malraux is cited in Renato Poggioli, *The Theory of the Avant-Garde*. Trans. Gerald Fitzgerald (Cambridge, Mass.: Harvard University Press, 1968), 55.

10. For a fine recent look at the link between Neo-Impressionism and anarchism, see Stephen Eisenman, "Mass Culture and Utopia: Seurat and

Neo-Impressionism," *Nineteenth Century Art: A Critical History* (London: Thames and Hudson, 1994), 274–87.

11. Kenneth Frampton, *A Critical History of Modern Architecture* (London: Thames and Hudson, 1980), 64–73.

12. On the insurrectionary forces led by anarchists in Barcelona in 1908–09, see James Joll, *The Anarchists* (Cambridge, Mass.: Harvard University Press, 1980), 215–20.

13. *Diego Rivera: A Retrospective* (1986), 34.

14. Olivier Debroise, *Diego de Montparnasse*, 20.

15. Ramón Gómez de la Serna, "Riverismo," *Ismos* (Madrid: Biblioteca Nueva, 1931), 1171. See also Ramón Gómez de la Serna, "Riverismo," *Sur* (Buenas Aires), 1, 2 (October 1931): 59–85.

16. Roger Shattuck, *The Banquet Years: The Origins of the Avant-Garde in France* (New York: Vintage Press, 1968).

17. Guillaume Apollinaire, "Montparnasse" (June 23, 1914) *Apollinaire on Art: Essays and Reviews, 1902–18*. Trans. Susan Suleiman, ed. Leroy C. Breunig (New York: Viking Press, 1972), 409.

18. See, for example, Ramón Favela, *Diego Rivera: The Cubist Years*, 32–38.

19. Ramón Favela, "The Problem of Rivera, El Greco, and Cézanne," *Diego Rivera: The Cubist Years*, 38–41.

20. *Diego Rivera, Catálogo General de Obra de Caballete*, 89: 20. The first major article devoted to Rivera's work was about this painting and it was written by the Peruvian critic Francisco García Calderón. See Francisco García Calderón, "La obra del pintor mexicano Diego M. Rivera," *El Mundo Ilustrado* (Mexico City), May 17, 1914, n. p. See also Ramón Favela, *Diego Rivera: The Cubist Years*, 32–33.

21. *Diego Rivera: A Retrospective*, 36.

22. For the most comprehensive show to date on this period, see *Diego Rivera, the Cubist Years* (Phoenix Art Museum, March 10–April 29, 1984). For reproductions of almost all the works extant from the cubist period, see *Diego Rivera, Catálogo General de Obra de Caballete* 91–226: 20–37.

23. *Diego Rivera, Catálogo General de Obra de Caballete*, 105: 22.

24. Robert Hughes, "Diego Rivera," *Nothing If Not Critical* (New York: Penguin Books, 1992), 204.

25. Gladys March, *Diego Rivera*, 59.

26. Bertram D. Wolfe, *The Fabulous Life of Diego Rivera*, 65–66.

27. Olivier Debroise, *Diego de Montparnasse*, 37.

28. Gladys March, *Diego Rivera*, 61.

29. Guillaume Apollinaire, "A Curious Preface" (May 7, 1914), *Apollinaire on Art*, 376–77. In the same anthology, see also Apollinaire's praise of Rivera's drawings, in *Les Soireés de Paris* (March 15, 1914): 367.

30. Interview with Leonce Rosenberg (1936) in Bertram D. Wolfe, *The Fabulous Life of Diego Rivera*, 86. See also Malcolm Gee, "The Avant-garde, Order, and the Art Market," *Art History*, 2, 1 (March 1979): 95–106, and Malcolm Gee, *Dealers, Critics and Collectors of Modern Art* (London: Garland, 1981).

31. Ibid., 89.

32. Ibid.

33. Ramón Favela, *Diego Rivera: The Cubist Years*, 132.

34. Pierre Reverdy, "Une nuit dans la plaine," *Nord-Sud*, 3 (May 15, 1917): 27–33. For various interpretations of the episode, see Olivier Debroise, *Diego de Montparnasse*, 75–95 and Ramón Favela, *Diego Rivera: The Cubist Years*, 121–52.

35. André Salmon, "L'Affaire Rivera," *L'art vivant* (Paris: Les editions de Grès et Cie, 1920), 157–59.

36. Gladys March, *Diego Rivera*, 65.

37. Patricia Leighton, "The White Peril and *L'Art negrè:* Picasso, Primitivism, and Anticolonialism," *The Art Bulletin*, LXXII, 4 (December 1990): 604–30.

38. André Malraux, *Picasso's Mask* (1974). Trans. J. Guicharnaud (New York: Random House, 1976), 10–11.

39. Patricia Leighten, "The White Peril and *L'Art negrè,*" 63.

40. Gladys March, *Diego Rivera*, 64.

41. Ibid., 65.

42. Ibid., 64–65

43. Ibid., 70–71.

44. Ibid.

45. Patricia Leighton, *Reordering the Universe: Picasso and Anarchism* (Princeton: Princeton University Press, 1989), 13 ff.

46. Olivier Debroise, *Diego de Montparnasse*, 75.

47. Martín Luís Guzmán, "Diego Rivera y la filosofía del cubismo" (1915), reprinted in *Obras completas de Martín Luís Guzmán*, vol. I (Mexico City: Compañía General de Ediciones, 1961), 85 ff. Favela has rightly noted that this piece was written in 1915, not 1916. See Ramón Favela, *Diego Rivera: The Cubist Years*, 156.

48. Gladys March, *Diego Rivera*, 31.

49. Alberto Híjar, "Los Zapatas de Diego Rivera," *Los Zapatas de Diego Rivera* (Mexico City and Cuernavaca: Consejo Nacional del Instituto

Nacional de Bellas Artes, 1984), 22: *"La única relación que Zapata tuvo con los pintores fue una entrevista con el Dr. Atl en 1915."* For the relationship of the Rivera painting with the Casasola photograph, see: Ramón Favela, *Diego Rivera: The Cubist Years,* 106–7.

50. Gladys March, *Diego Rivera,* 65. For a fine discussion of this painting by Rivera, see Dawn Ades, "Modernism and the Search for Roots," *Art in Latin America,* 129. As for the links to Mexican literature, see Ramón Favela, *Diego Rivera: The Cubist Years,* 104: "The distant land of the Mexican central plateau ('meseta central') had only recently been characterized in poetic synthesis by Rivera's friend, Alfonso Reyes, as existing in the most transparent region of the air ("La región más transparente del aire") (*Vision de Anáhuac,* Madrid, 1915). It was a characterization that could not be more accurately descriptive of Rivera's own vision of his *tierra natal* in the *Zapatista Landscape.*"

51. Arthur Danto, "Diego Rivera: A Retrospective," *The Nation* (July 19–26, 1986): 56.

52. John Berger, "The Moment of Cubism" (1968), *The Sense of Sight* (New York: Random House, 1985), 159–88.

53. Adolfo Gilly, *La revolución interrumpida* (1971). Trans. Patrick Camiller (London: Verso Press, 1971), 72. For a discussion of yet another leader during this period, see Michael C. Meyer, *Mexican Rebel: Pascual Orozco and the Mexican Revolution, 1910–15* (Lincoln: University of Nebraska Press, 1967).

54. Ibid.

55. James Cockcroft, *Mexico,* 100.

56. Ibid., 110–11.

57. Ibid., 113.

58. Adolfo Gilly, *La revolución interrumpida,* 294: "The Morelos Commune, the first attempt at workers' and peasants' power in Latin America, is the finest and most deeply rooted tradition which can serve

for the continuation of Mexico's interrupted revolution." *The* classic study of Zapata remains, of course, that of John Womack, Jr., *Zapata and the Mexican Revolution* (New York: Alfred A. Knopf, Inc., 1969). See also Robert P. Million, *Zapata: Ideology of a Peasant Revolutionary* (New York: Random House, 1972) and Samuel Brunk, *Emiliano Zapata: Revolution and Betrayal in Mexico* (Albuquerque: University of New Mexico Press, 1996).

59. Paul Gilroy, *The Black Atlantic* (Cambridge, Mass.: Harvard University Press, 1993) 42.

60. See Andreas Huyssen, "Mapping the Post-Modern," *After the Great Divide* (Bloomington, Indiana University Press, 1986), 179–221, and Nestor García Canclini, "Modernity after Post-Modernity," *Beyond the Fantastic*, Ed. Gerardo Mosquera (Cambridge, Mass.: MIT Press, 1996), 20–52.

61. For more on this, see David Craven, "Clement Greenberg and the 'Triumph' of Western Art," *Third Text*, 25 (Winter 1993/94): 3–9, and David Craven, "The Latin American Origins of 'Alternative Modernism,' " *Third Text*, 36 (Autumn 1996): 29–44.

62. For the etymology of the term *"modernismo,"* see Max Henrique Ureña, *Breve Historia del Modernismo* (Mexico City: Siglo XXI, 1954), 158 ff. See also Juan Ramón Jiménez, *El Modernismo* (1953) (Madrid: Aguilar, 1962), and Angel Rama, *Rubén Darío y el modernismo* (Caracas: Ediciones de la Biblioteca, 1920).

63. For a fine analysis of Darío's poetry and politics, see Jean Franco, *Modern Culture of Latin America: Society and the Artist* (Harmondsworth: Pelican, 1970), and Jean Franco, *Introduction to Spanish-American Literature* (New York: Prager, 1967), 142–47. See also David E. Whisnant, "Rubén Darío as a Focal Cultural Figure in Nicaragua," *Latin American Research Review*, XXVII, 3, (1992): 7–49; Edelberto Torres, *La dramática vida de Rubén Darío* (Mexico City: Ediciones Grijalbo, 1966), and Charles D. Watland, *Poet-Errant: A Biography of Rubén Darío* (New York: Philosophical Library, 1965).

64. Rubén Darío, "Cabezas: Angel Zárraga," *Mundial Magazine*, II,

19 (November 1912): 640–41. This included the reproduction of Diego Rivera's *Portrait of (Retrato de) Angel Zárraga (Diego Rivera Catálogo General*, 85: 19, oil on canvas, 46 x 38.3 cm.). Another Latin American art critic briefly discussed Rivera's work in the same issue of Darío's publication: Ulrico Brendel, "El Salón de Otoño," *Mundial Magazine*, II, 19 (November 1912): 623–24.

65. Rubén Darío, "Palabras Luminares," *Prosas Profanas y Otros Poemas* (1896–1901), reprinted in *Rubén Darío Poesia*. Eds. Julio Valle Castillo and Ernesto Mejía Sánchez (Managua: Editorial Nueva Nicaragua, 1994), 180: "Si hay poesía en nuestra América, ella está en las cosas viejas: en Palenke y Utatlán, en el indio legendario y el inca sensual y fino, y en el gran Moctezuma de la silla de oro. Lo demás es tuyo, demócrata Walt Whitman."

66. José Martí, "Nuestra America" (1891), *Our America*. Trans. Elinor Randall, Ed. Philip Foner (New York: Monthly Review Press, 1977), 84–95.

67. See José Martí, *Ensayos sobre Arte y Literatura*. Ed. Roberto Fernández Retamar (Havana: Editorial Letras Cubanas, 1979).

68. Philip Foner, "Introduction," *Our America*, 58.

69. José Martí, "Nuestra America," 88.

70. Ibid., 94, 93.

71. See David E. Whisnant, "Rubén Darío as a Focal Cultural Figure in Nicaragua," *Latin American Research Review*, XXVII, 3 (1992): 7–49.

72. Rubén Darío, "Á Roosevelt," *Rubén Darío Poesia*, 255–56.

73. Ibid.

74. José Enrique Rodó, *Ariel* (1900). Trans. Margaret Sayers Peden (Austin: University of Texas Press, 1988). See also Roberto González Echevarría, "The Case of the Speaking Statue: *Ariel* and the Magisterial Rhetoric of the Latin American Essay," *The Voice of the Masters* (Austin:

University of Texas Press, 1985), 8–32. I would like to thank Florencia Bazzano Nelson for this latter citation.

75. Rubén Darío, "El Rey Burgués (Cuento alegre)," reprinted in *Rubén Darío: Cuentos Completos*. Eds. Ernesto Meijía Sánchez and Julio Valle-Castillo (Managua: Editorial Nueva Nicaragua, 1994), 127–31.

76. Rubén Darío, "La cancíon del oro," reprinted in *Cuentos Completos*, 141–44.

77. Dore Ashton, "Speculations on Modernism," Museum of Fine Arts, Santa Fe, New Mexico, April 15, 1994.

78. Charles Baudelaire, "Le Peintre de la Vie Moderne" (1863), reprinted in *The Painter of Modern Life and Other Essays*. Trans. Jonathan Mayne (London: Phaidon, 1965), 12–15.

79. Rubén Darío certainly was influenced by Baudelaire, as Jean Franco and others have pointed out. See Jean Franco, *Introduction to Spanish-American Literature*, 357–63.

80. Charles Baudelaire, "Le Peintre de la Vie Moderne," 12–15.

81. Ibid.

82. See, for example, Roland Barthes, *Le Degré Zéro de L'Ecriture* (1953). Trans. Annette Lavers and Colin Smith (New York: Hill and Wang, 1983), 75–76.

83. Perry Anderson, "Modernity and Revolution," 97–98. See also Marshall Berman, *All That is Solid Melts into Air* (New York: Simon and Schuster, 1982), 15–16.

84. B. W. Ife and J. W. Butt, "The Literary Heritage," *The Spanish World: Civilization and Empire*. Ed. J. H. Elliott (New York: Harry N. Abrams, 1991), 212–13.

85. In fact, Picasso even designed the Menu for *el Quatre Gats* Cafe and Rubén Darío left a memorable account of the interior decor. For the

latter, see Enric Jardí Casary, *Historia de els Quatre Gats* (Barcelona: Editorial Aedos, 1972), 66. For a fine look at Picasso's relation to the cafe, see the catalog essay by Marilyn McCully in *Els Quatre Gats: Art in Barcelona Around 1900* (Princeton: Princeton University Press, 1978). For a broader look at the relation of anarchism to avant-garde art and popular culture in Barcelona see Temma Kaplan, *Red City, Blue Period: Social Movements in Picasso's Barcelona* (Berkeley: University of California Press, 1992).

86. B. W. Ife and J. W. Butt, "The Literary Heritage," 212.

87. Kenneth Frampton, *A Critical History of Modern Architecture* (London: Thames and Hudson, 1980), 64–73.

88. Ibid.

89. Antoni Gaudí, *Manuscritos, Artículos, Conversaciones y Dibujos*. Ed. Marcia Codinachs (Murcia: Consejeria de Cultura del Consejo Reyional, 1982), 93: "Originalidad es volver al origen."

90. Kenneth Frampton, *A Critical History of Modern Architecture*, 64–73.

91. Ibid.

92. George R. Collins, *Antonio Gaudí* (New York: George Braziller, Inc., 1960), 7, 13.

93. Walter Benjamin, "Thesis VII on the Philosophy of History" (1940), *Illuminations*. Trans. Harrry Zohn (New York: Schockin Books, 1969), 256.

94. Walter Benjamin, "Thesis IX," *Illuminations*, 257–58.

95. Pablo Picasso, "The Picture as a Sum of Destructions" (1935), *Picasso on Art*. Ed. Dore Ashton (New York: Viking Press, 1972), 38.

96. See Temma Kaplan, *Red City, Blue Period*, 24–28, and James Joll, *The Anarchists*, 207–57.

97. Gladys March, *Diego Rivera*, 58.

98. Thomas Crow, "Modernism and Mass Culture in the Visual Arts," *Pollock and After*. Ed. Francis Fascina (New York: Harper & Rom, 1985), 250.

99. This is, of course, the argument made in Clement Greenberg, "Modernist Painting" (1965), *The New Art*. Ed. Gregory Battcock (New York: 1973), 66–77.

100. Rosalind Krauss, "In the Name of Picasso," *The Originality of the Avant-Garde and Other Modernist Myths* (Cambridge, Mass.: MIT Press, 1986), 23–41.

101. See, for example, Meyer Schapiro,"The Nature of Abstract Art" (1957) and "Recent Abstract Painting" (1957) *Modern Art: 19th and 20th Centuries* (New York: George Braziller, 1978), 185–227.

102. See *Diego Rivera: The Cubist Years* (Phoenix Art Museum, March 10–April 29, 1984), 104–9. Moreover, Favela observed that, "It was in Cubism, as Martín Luís Guzmán so astutely perceived in 1915, that Rivera had discovered the road back to his birthplace, Anáhuac." (152).

103. Arnold Toynbee, *A Study of History* (London: Macmillan, 1947). See also Charles Jencks, *What Is Post-Modernism?* (London: Art and Design, 1986), 2.

NOTES TO CHAPTER THREE

1. Oriana Braddeley and Valerie Fraser, *Drawing the Line: Art and Cultural Identity in Contemporary Latin America* (London: Verso, 1989), 80–81.

2. David Alfaro Siqueiros, "Diego Rivera Pintor de America," *El Universal Ilustrado* (Mexico City), July 7, 1921, 20–21. For an insightful look at this article as part of the Mexican discourse around Rivera in the early 1920s, see Esther Acevedo, "Las decoraciones que pasarón a ser revolucionarias," *El Nacionalismo y el Arte Méxicano*, IX Coloquio de

Historia del Arte (Mexico City: Universidad Nacional Autónoma de Mexico, 1986), 180–81. See also Xavier Moyssén, "El periodo formativo de David Alfaro Siqueiros, Roberto Montegro, Diego Rivera y José Clemente Orozco," *Historia del Arte Méxicano*, 91/92 (September–November 1983): 21–25.

3. For a discussion of the ideological origin of this program, see Esther Acevedo, "Las decoraciones que pasarón a ser revolucionarias." See also the collection *Boletin de la Secretaria de Educación Pública*, from 1921–24, in the Hemerotea Nacional, Mexico City.

4. *Diego Rivera Catálogo General de Obra de Caballete*, 247: 39 *El matemático* (oil on canvas, 117 x 85 cm.), and 282: 44, *Mujer con gansos* (oil on canvas, 62.5 x 81.5 cm.).

5. David Alfaro Siqueiros, "Three Appeals for Modern Direction to the New Generation of American Painters and Sculptors," *Vida Americana* (Barcelona, Spain), 1 (May 1921). Trans. Polyglossia, reprinted in Dawn Ades, *Art in Latin America*, 322–23.

6. Ibid.

7. Ibid.

8. Ibid.

9. Renato Poggioli, *The Theory of the Avant-Garde* (1962). Trans. Gerald Fitzgerald (Cambridge: Harvard University Press, 1968), and Peter Bürger. *Theory of the Avant-Garde* (1974), Trans. Michael Shaw (Minneapolis: University of Minnesota, 1984). See also Nicos Hadjinicolaou, "On the Ideology of Avant-Gardism," *Praxis*, 6 (1982): 39–70.

10. Poggioli, *Theory of the Avant-Garde*, 18–20.

11. Ibid.

12. Gabriel-Désiré Laverdant, *De la mission de l'art et du role des artistes* (Paris: Aux Gureaux de la Phalange, 1845), 4. Cited by Poggioli, *Theory of the Avant-Garde*, 9.

13. Poggioli, *Theory of the Avant-garde*, 16–41.

14. Peter Bürger, *Theory of the Avant-Garde*, p. 49.

15. Ibid., 12–13, 27.

16. Edward Lucie-Smith, *Latin American Art* (London: Thames and Hudson, 1993), 54–55: "For much of his career he [Rivera] was trying to make art which would achieve objectives closely related to those of Soviet Socialist Realism. . . . [H]is aims remained fundamentally opposed to basic Modernist concepts." The mistaken view that Rivera's work qualified as "Social realism" was convincingly rebutted by Linda Downs, "Introduction," *Diego Rivera* (1986), 18.

17. Interview of Meyer Schapiro and Lillian Milgram by the author, Rawsonville, Vermont, July 15, 1992.

18. Meyer Schapiro, "The Patrons of Revolutionary Art," *Marxist Quarterly*, 1, 2 (October–December 1937): 463. Meyer Schapiro also hand wrote a four-page essay entitled "Rivera on Russian Art," which remains unpublished. It is in Folder #6 of the forty folders that make up *The Personal Papers of Meyer Schapiro*, New York City. Written in the 1930s, this essay took issue with Rivera's claim that Soviet theater (rather than Soviet cinema) was the most revolutionary art form in the Soviet Union. On May 21, 1993, at their home in New York City, the Schapiros allowed me to read "Rivera on Russian Art." Meyer Schapiro then elaborated in a conversation with me and Lillian Milgram on his view that cinema, not theater, was the most advanced art form of the 1920s and 1930s.

19. Ibid., 464.

20. Octavio Paz, "Social Realism in Mexico: The Murals of Rivera, Orozco, and Siqueiros," *Artscanada* (December/January 1979/80): 59.

21. See, for example, José Vasconcelos, "Sobre Diego Rivera," *Antología Tributaria*, 227–28, and José Vasconcelos, *Estética* (Mexico City: Andres Bota, c. 1928/29). This latter source is discussed in Bertram D. Wolfe, *The Fabulous Life of Diego Rivera*, 211.

22. For a discussion of these popular forces, see James Cockcroft, *Mexico*, 129–33.

23. Ibid.

24. For a fine treatment of this issue and the considerable power brought to bear, see Linda Hall, *Oil, Banks, and Politics: The United States and Post-Revolutionary Mexico, 1917–1924* (Austin: University of Texas Press, 1995). In her response to Esther Acevedo, *"Las decoraciones que pasarón a ser revolucionarias,"* Mari Carmen Ramírez rightly emphasized the conflict between the Obregón government and the United States in the early 1920s as an important force shaping decision making. See Mari Carmen Ramírez, "Comentario," *El Nacionalism y el Arte Mexicano* (Mexico City: Universidad Nacional Autonoma de Mexico, 1986), 206. See also Mari Carmen Ramírez, *The Ideology and Politics of the Mexican Mural Movement: 1920–1925* (Diss., The University of Chicago, 1989).

25. James Cockcroft, *Mexico*, 117–18. See also Esther Cimet, *El Movimiento muralista mexicano: Una nueva forma de organización de la producción artística* (Tesis U.I.A., 1979), Roger Bartra, *Estructura agraria y clases sociales en México* (Mexico City: Era, 1978), Barry Carr, *El movimiento obrero y la política en México: 1910–1929* (Mexico City: Ediciones Era, 1981), and M. Márquez Fuentes and O. Rodríguez Araujo, *El Partido Communista Mexicano* (Mexico City: Ediciones El Caballito, 1973). For some important discussions of the state in Mexico, see Pablo González Casanova, *El estado y los partidos políticos en México* (Mexico City: Era, 1981), and Nora Hamilton, *Mexico: The Limits of State Autonomy* (Princeton: Princeton University Press, 1982).

26. James Cockcroft, *Mexico*, 128–29.

27. Alvaro Obregón, *Discursos* (Mexico City: Biblioteca de la Dirección General de Educacion Militar, 1932), vol. II, 274. See also Linda Hall, *Alvaro Obregón: Power and Revolution in Mexico, 1911–20* (College Station: Texas A & M University Press, 1981).

28. James Cockcroft, *Mexico*, 124–31. On the Cárdenas years, see also Edwin Williamson, *The Penguin History of Latin America* (London: Penguin Books, 1992), 397–400.

29. Carlos Fuentes, "History Out of Chaos," *The New York Times Book Review* (March 13, 1988): 12–13.

30. Ibid.

31. Ibid.

32. Ibid.

33. Ibid.

34. John Mason Hart, *Revolutionary Mexico* (Berkeley: University of California Press, 1987), 16.

35. *"Manifesto of the Union of Mexican Workers, Technicians, Painters and Sculptors,"* El Machete (June 1924). Trans. Polyglossia, reprinted in Dawn Ades, *Latin American Art*, 323–24. For a fine article about the union's journal, see Alicia Azuela, *"El Machete and Frente a Frente,"* Art Journal, 52, 1 (Spring 1993), 82–87. The first issure of *El Machete*, in March 1924, carried a front page article by Diego Rivera entitled "Asesinos," (Assassins), in which the artist denounced the murder of Felipe Carrillo Puerto by counter-revolutionaries.

36. Gladys March, *Diego Rivera*, 72.

37. Ibid., 71–72. For the works that are extant, see *Diego Rivera Catálogo General de Obra de Caballete*, 53–62.

38. James Cockcroft, *Mexico*, 124–25.

39. Bernard Myers, *Mexican Painting in Our Time* (Oxford: Oxford University Press, 1956), 22.

40. Ibid.

41. Dawn Ades, "The Mexican Mural Movement," in *Latin American Art*, 154.

42. Gladys March, *Diego Rivera*, 72–73.

43. The 1921 study of the Zapatistas to which he was referring is evidently the one entitled *Zapatistas* (Puebla, July 3, 1921): 113, which was reproduced in the catalog for his huge 1949 retrospective. For the works of this period that are still extant, see *Diego Rivera Catálogo General de Obra de Caballete*, 63–65.

44. Stanton Catlin, "Mural Census," *Diego Rivera: A Retrospective*, 239.

45. José Vasconcelos, *Pitágoras* (Havana: Editorial Letras, 1916).

46. Esther Acevedo, Alicia Azuela, et al., *Guía de murales del centro histórico de la Ciudad de Mexico* (Mexico City: Consejo Nacional de Fomento Educativo, 1984), 14–16, and Stanton Catlin, "Mural Census," 237–39.

47. Ibid.

48. Gladys March, *Diego Rivera*, 76. See Plato, *The Symposium*, *Philosophic Classics*. Ed. Walter Kaufmann, vol. II (Englewood Cliffs, New Jersey: Prentice Hall, 1968), 125–57.

49. Esther Acevedo, Alicia Azuela, et al., *Guía de Murales*, 15.

50. Diego Rivera, "Los primeros murales" (1925), *Arte y Política*, 49–50.

51. Esther Acevedo, Alicia Azuela, et al., *Guía de Murales*, 15.

52. Stanton Catlin, "Mural Census," 237.

53. Diego Rivera, "Los primeras murales," 50.

54. Bertram D. Wolfe, *The Fabulous Life of Diego Rivera*, 150.

55. Ibid., 140.

56. Stanton Catlin, "Mural Census," 248. See also Antonio Rodríguez, *Guía de los Murales de Diego Rivera en la Secretaria de Educación Pública*

(Mexico City: Secretaria de Educación, 1984).

57. Stanton Catlin, "Mural Census," 246.

58. Diego Rivera, "Los primeros murales" (1925), 51.

59. Bertram D. Wolfe, *The Fabulous Life of Diego Rivera*, 204.

60. Alberto Híjar, "Diego Rivera: contribución política," 51.

61. Rubén Darío, *Prosas Profanes*, 180.

62. Bertram D. Wolfe, *The Fabulous Life of Diego Rivera*, 174.

63. Ibid.

64. Ibid., 175.

65. Ibid.

66. Ibid.

67. Stanton Catlin, "Mural Census," 253.

68. On the relation of one-point-perspective to colonialism, see Meyer Schapiro, "The Nature of Abstract Art," 199.

69. Antonio Rodríguez, *Guía de los murales*, 39.

70. James Cockcroft, *Mexico*, 88–91.

71. Ibid., 88.

72. Esther Acevedo, "Las Decoraciones," 175–80.

73. James Cockcroft, *Mexico*, 132.

74. Raquel Tibol, "Diego Rivera: su visión de la mujer," *Diego Rivera Hoy*, 128.

75. "Gabriela Mistral en la escuela que lleva su nombre," *El Maestro*, III, 7 (April 1922): 129.

76. Diego Rivera (on art as labor)

77. *Diego Rivera: A Retrospective*, 59.

78. Diego Rivera, "Los primeros murales," *Arte y Politica*, 52: "no era posible el empleo del color, que hubiera debilitado la idea de resistencia y viabilidad del edificio."

79. Stanton Catlin, "Mural Census," 245.

80. For a brief discussion of this recollection, see Jorge Hernández Campos, "The Influence of the Classical Tradition, Cézanne, and Cubism on Rivera: Artistic Development," *Diego Rivera: A Retrospective*, 119.

81. José Martí, in fact, wrote an essay about this work. See José Martí, "Marat's Death by Santiago Rebull" (1876), *José Martí on Art and Literature*, 54–62.

82. José Carlos Mariátegui, *Seven Interpretive Essays on Peruvian Reality* (1928). Trans. Marjory Urquidi (Austin: The University of Texas Press, 1988).

83. Francis J. O'Connor, "An Iconographic Interpretation of Diego Rivera's *Detroit Murals* in Terms of Their Orientation to the Cardinal Points of the Compass," *Diego Rivera: A Retrospective*, 215–34.

84. Betty Ann Brown, "The Past Idealized: Diego Rivera's Use of Pre-Colombian Imagery," *Diego Rivera: A Retrospective*, 141. See also, Barbara Braun, *Pre-Columbian Art and the Post-Columbian World* (New York: Harry N. Abrams, 1993), 185–250. Braun deftly links contemporary archaeological investigations with the particular usage that Rivera made of pre-Columbian ideas, symbols, and images.

85. Ibid., 140–41.

86. Antonio Rodríguez, *Guía de los murales*, 49.

87. See *"The Plan de Ayala,"* in John Womack, Jr., *Zapata and the Mexican Revolution* (New York: Random House, 1968), 393–404, and James Cockcroft, *Mexico*, 110–11.

88. Bertram D. Wolfe, *The Fabulous Life of Diego Rivera*, 255.

89. James Early, *The Colonial Architecture of Mexico* (Albuquerque: University of New Mexico, 1994), 26–29, and Justino Fernández, *El Arte del Siglo XX*, 22.

90. Antonio Rodríguez, *Guía de los murales*, 95–126, and Stanton Catlin, "Mural Census," 245–46.

91. The entire "Corrido de la revolución" is reproduced in Antonio Rodríguez, *Guía de los murales*, 95–96. See Bertram D. Wolfe, *The Fabulous Life of Diego Rivera*, 208–10 for a discussion of how this *"corrido"* was actually made-up of several different *corridos*. Wolfe also includes an English translation of part of it on pages 204–10.

92. Translation by Bertram Wolfe, *The Fabulous Life of Diego Rivera*, 204–10.

93. Translation by David Craven.

94. Stanton Catlin, "Mural Census," 246.

95. Gladys March, *Diego Rivera*, 80.

96. Lawrence Hurlburt, "Diego Rivera: A Chronology," *Diego Rivera: A Retrospective*, 53. See also Jean Charlot, *The Mexican Mural Renaissance* (New Haven: Yale University Press, 1962). The literature detailing Rivera's use of fresco is an extensive one. Among the major *primary* sources by firsthand observers are: Juan O'Gorman, *La técnica de Diego Rivera en la pintura mural* (Mexico City: Frente Nacional de artes plásticas, 1954), Stephen Pope Dimitroff, *Apprentice to Diego Rivera in Detroit, 1932/3* (published privately by Stephen Pope Dimitroff, 1986), Beaumont Newhall, "How Diego Rivera Paints," unpublished manuscript, Archives of the Museum of Modern Art in New York City, and Bertram D. Wolfe, *The Fabulous Life of Diego Rivera*, 177–81. Perhaps the best *secondary*

source is to be found in Lawrence P. Hurlburt, *The Mexican Muralists*, 253–56.

97. On this history, see Jonathan Stephenson, *The Materials and Techniques of Painting* (London: Thames and Hudson, 1989), 11–16.

98. Lawrence P. Hurlburt, *The Mexican Muralists*, 253, and Bertram D. Wolfe, *The Fabulous Life of Diego Rivera*, 178.

99. Ibid., 254–55.

100. Bertram D. Wolfe, *The Fabulous Life of Diego Rivera*, 177.

101. Ibid., 178.

102. Ibid.

103. Lawrence P. Hurlburt, *The Mexican Muralists*, 254.

104. Gladys March, *Diego Rivera*, 78.

105. Bertram D. Wolfe, *The Fabulous Life of Diego Rivera*, 180.

106. Ibid., 180–81.

107. For a discussion of the work of Canales and the Nicaraguan Mural Movement, see David Craven, *The New Concept of Art and Popular Culture Since the Revolution in 1979* (Lewiston, New York: Edwin Mellen Press, 1989), 183–223. More recently, see David Kunzle, *The Murals of Revolutionary Nicaragua* (Berkeley: University of California Press, 1995).

108. Arthur Danto, "Diego Rivera: A Retrospective," *The Nation* (July 19/26, 1986): 59.

109. Ibid.

110. Reproduced in Bertram D. Wolfe, *The Fabulous Life of Diego Rivera*, 204–05.

111. Ibid., 207.

112. José Vasconcelos, *Estética* (Mexico City: Andres Botas, n.d., c. 1928), 20.

113. Katherine Ann Porter, "Diego Rivera: From a Mexican Painter's Notebook," *The Arts* (January 1925): 21–23.

114. John Dos Passos, "Paint the Revolution," *New Masses* (March 1927): 1.

115. Reproduced in Bertram D. Wolfe, *The Fabulous Life of Diego Rivera*, 212.

116. "Diego Rivera Marries: Noted Mexican Painter and Labor Leader Weds Frida Kahlo," *The New York Times* (August 23, 1929).

117. Bertram D. Wolfe, *The Fabulous Life of Diego Rivera*, 202, 229.

118. Ibid., 229. Lawrence P. Hurlburt, "Diego Rivera: A Chronology," 70.

119. Ibid.

120. Ibid.

121. Ibid.

122. Lawrence P. Hurlburt, "Diego Rivera: A Chronology," 70.

123. Diego Rivera, "Position of the Artist in Russia Today," *Arts Weekly*, 1, 1 (March 11, 1932): 6–7.

124. Gladys March, *Diego Rivera*, 84–5. Since it dates from around the time that Diego Rivera was trying to gain readmittance to the Communist Party, this interview makes clear just how deeply upset Rivera had been *before* (!) it was necessary to moderate his language to gain favor with the Soviet Union.

125. Bertram D. Wolfe, *The Fabulous Life of Diego Rivera*, 235. For a

broad overview of the consequences of the Soviet policies, see Wolfgang Abendroth, *A Short History of European Working Class* (1965) (New York: Monthly Review, 1972), 69–100.

126. James Cockcroft, *Mexico*, 122.

127. Gladys March, *Diego Rivera*, 99.

128. Ibid., 100.

129. Ibid.

130. E. J. Hobsbawm, *The Age of Extremes, 1914–1991* (New York: Pantheon, 1994), 4.

131. Alberto Híjar, "Diego Rivera: contribución política," 41.

NOTES TO CHAPTER FOUR

1. Translation by David Craven of Bertolt, Brecht, "Fragen eines lesenden Arbeiters" (1939), *Gedichte: 1934–1941* (Frankfurt am Main: Suhrkamp Verlag, 1961), 45–46.

2. Diego Rivera in 1957, quoted by Raquel Tibol, *Arte y Política*, 27.

3. Bertolt Brecht, "The Modern Theater is the Epic Theater" (1930), *Brecht on Theater*. Ed. and trans. John Willet (New York: Hill and Wang, 1964), 33–42.

4. Rita Eder, "The Portraits of Diego Rivera," *Diego Rivera: A Retrospective* (1986), 198. See also Guy Brett, *Through Our Own Eyes* (Philadelphia: New Society Publishers, 1986), 18–29, and Guy Brett, "The Mural Style of Diego Rivera," *Block*, 4 (1981): 18–29. For yet another argument that interprets the National Palace murals as conservative, if not reactionary, see Leonard Folgarait, "Revolution as Ritual: Diego Rivera's National Palace Mural," *Oxford Art Journal*, XIV, 1 (1990): 18–33.

5. Stanton Catlin, "Mural Census," 261.

6. Edwin Williamson, *The Penguin History of Latin America*, 397–400.

7. Paul Sweezy, "A Great American: Lázaro Cárdenas" (1962), *Monthly Review*, 40, 11 (April 1989): 37–44. For a fine assessment of the important role of Paul Sweezy, Paul Baran, and the Monthly Review School of Political Economy in the conception of dependency theory for Latin America, see Roger Burbach and Orlando Núñez, *Fire in the Americas* (London: Verso Press, 1987), 35–37.

8. Gladys March, *Diego Rivera*, 82.

9. Stanton Catlin, "Mural Census," 253.

10. James Cockcroft, *Mexico*, 39. For a scholarly look at these utopian communities, see Alicia Barrabas, *Utopías Indias* (Mexico City: Editorial Grijalbo, 1987).

11. Stanton Catlin, "Mural Census," 253.

12. Diego Rivera, "Scaffoldings," *Hesperian*. Trans. Emily Joséph (Spring 1931).

13. Stanton Catlin, "Mural Census," 254.

14. Bertram Wolfe, *The Fabulous Life of Diego Rivera*, 132.

15. Ibid. See also Edwin Williamson, *The Penguin History of Latin America*, 392–94.

16. Cited by Bertram Wolfe, *The Fabulous Life of Diego Rivera*, 212.

17. André Malraux, "Los fresquitas revolucionarios de Mexico," *Todo* (July 7, 1938): 38–39.

18. André Malraux, *L'Espoir* (Man's Fate), 1938. Trans. Stuart Gilbert and Alistair Macdonald (New York: Random House, 1938), 37–38.

19. Diego Rivera, "Los retablos," *Arte y Politica*, 55–58.

20. Beaumont Newhall, *The History of Photography* (New York: The

Museum of Modern Art, 1982), 184–85.

21. Jean Charlot, *Mexican Art and the Academy of San Carlos, 1785–1915* (Austin: University of Texas Press, 1962), 278–79.

22. Diego Rivera, "Edward Weston y Tina Modotti" (1926), *Arte y Politica*, 64: *"la modernidad extrema de la plástica del norte y la viviente tradición nacida de la tierra del sur."*

23. Bertram Wolfe, *The Fabulous Life of Diego Rivera*, 307.

24. Raymond Williams, *Marxism and Literature* (Oxford: Oxford University Press, 1977), 19.

25. Karl Marx, *The Economic and Philosophical Manuscripts of 1844*. Trans. Martín Milligan (New York: International Publishers, 1964), 140–41.

26. Gladys March, *Diego Rivera*, 95.

27. Dawn Ades, *Art in Latin America*, 2.

28. Stanton Catlin, "Mural Census," 263.

29. Mark Ashton, "Allegory, Fact and Meaning in Giambattista Tiepolo's Four Continents in Würzburg," *The Art Bulletin*, LX, 1 (March 1978): 109–25.

30. Dawn Ades, *Art in Latin America*, 172.

31. Betty Ann Brown, "The Past Idealized: Diego Rivera's Use of Pre-Columbian Imagery," *Diego Rivera: A Retrospective*, 144. See also Jacinto Quirate, "The Coatlicue in Modern Mexican Painting," *Research Center for the Arts Review*, 5, 2 (April 1982): 5 ff, and Barbara Braun, *Pre-Columbian Art and the Pre-Columbian World*, 185–250.

32. Ibid. For a somewhat different interpretation of these murals than I am giving, see Leonard Folgarait, "Rovolution as Ritual," 18–33.

33. Ibid.

34. Stanton Catlin, "Mural Census," 263.

35. Ibid., 262.

36. James Cockcroft, *Mexico*, 124–25.

37. Ibid., 126–27.

38. Ibid., 130.

39. Ibid.

40. Ibid.

41. Ibid., 131–32.

42. Dawn Ades, *Art in Latin America*, 4.

43. M. H. Abrams, *A Glossary of Literary Terms* (New York: Holt, Reinhart and Winston, 1957), 49.

44. Ibid., 49–51. For an excellent look at the epic nature of Milton's work in relation to that of Herman Melville, see Paul Craven, " 'A Universal Blanc': Adam, Ahab, and Ambiguity," *James H. Sims Award for Literary Excellence*, the University of Southern Mississippi (May 1996), 1–17.

45. Ibid.

46. Ibid.

47. Karl Marx, *The Communist Manifesto* (1848). Trans. Samuel Moore (London: Penguin, 1967), 79.

48. Bertram Wolfe, *The Fabulous Life of Diego Rivera*, 267. For reproductions of both the original sketch preferred by the Communist Party and the one he ultimately chose to use, see *Diego Rivera Catálogo General de Obra Mural y Fotografía Personal*, 118, 2A and 2B. For an incisive dissection of the party line put forth by David Alfaro Siqueiros,

see Alberto Híjar, "Diego Rivera: contribución política," 59 ff, 65 ff.

49. Stanton Catlin, "Mural Census," 262–63, and Betty Ann Brown, "The Past Idealized," 143.

50. Bertolt Brecht, "The Modern Theater is the Epic Theater," 37–41.

51. Ibid., 39.

52. One of the most comprehensive accounts of the censorship of the Rockefeller mural is to be found in Irene Herner de Larrea, *Diego Rivera's Mural at the Rockefeller Center* (Mexico City: Edicupes, 1990). This anthology contains a substantial number of the primary sources from the debate around the censorship and subsequent destruction of the mural in late 1933 and early 1934.

53. Lawrence Hurlburt, "Diego Rivera: A Chronology," 89–92. On LEAR, see Dawn Ades, *Art in Latin America*, 181–93.

54. Justino Fernández, *El Arte del Siglo XX*, 33. See also, Rafael Angel Herrerias, "Diego Rivera's Mural in the Palace of Fine Arts (Mexico City)," *Diego Rivera's Mural at the Rockfeller Center*, 215–19.

55. Lawrence Hurlburt, "Diego Rivera: A Chronology," 79.

56. Bertram Wolfe, *The Fabulous Life of Diego Rivera*, 307.

57. Bertolt Brecht, "The Epic Theater and Its Difficulties" (1927), 23: "The essential point of the epic theater is perhaps that it appeals less to the feelings than to the spectator's reason."

58. On the place of these works in the oeuvre of each of these artists, see Justino Fernández, *El Arte del Siglo XX*, 33, 53, 74.

59. Bertram Wolfe, *The Fabulous Life of Diego Rivera*, 160.

60. Pablo Neruda, *Hácia la Ciudad Espléndida*, Noble Prize Acceptance Speech in 1972 (New York: Random House, 1974), 19.

61. Lázaro Cárdenas, "Diego Rivera," *Testimonios sobre Diego Rivera*, 11.

62. For two fine discussions of the Cuernavaca murals, see Stanton Catlin, "Some Sources and Uses of Pre-Columbian Art in the Cuernavaca Frescoes," *Proceedings of the 35th International Congress of Americanists* (Mexico City, 1962), 439–49, and Stanton Catlin, "Political Iconography in the Rivera Frescoes at Cuernavaca, Mexico," *Art and Architecture in the Service of Politics*. Eds. Henry Millon and Linda Nochlin (Cambridge, Mass.: MIT Press, 1978), 195–215.

63. Bertram Wolfe, *The Fabulous Life of Diego Rivera*, 277.

64. Albert M. Bender, Letter to Diego Rivera on July 15, The Bertram Wolfe Collection (The Hoover Institute: Stanford University). Cited in Bertram Wolfe, *The Fabulous Life of Diego Rivera*, 282.

65. Albert M. Bender, Letter to Diego Rivera on August 13, 1929, The Bertram Wolfe Collection (The Hoover Institute: Stanford University). Cited in Bertram Wolfe, *The Fabulous Life of Diego Rivera*, 282.

66. On the patrons of Rivera in San Francisco, see Bertram Wolfe, *The Fabulous Life of Diego Rivera*, 283.

67. Interview with Maynard Dixon, United Press International (September 23, 1930). Cited in *The Fabulous Life of Diego Rivera*, 285.

68. Sarah Lowe, *Frida Kahlo* (New York: Universe, 1991), 285.

69. Editorial, *San Francisco News* (May 9, 1931). Cited in Bertram Wolfe, *The Fabulous Life of Diego Rivera*, 287.

70. Diego Rivera, "Scaffoldings," *Hesperian* (Spring 1931).

71. Karl Marx, *The Communist Manifesto*, 83–85.

72. Alicia Azuela, "Rivera and the Concept of Proletarian Art," *Diego Rivera: A Retrospective*, 126. For a related and quite insightful discussion,

see Adolfo Sánchez Vázquez, "Claves de la ideología estética de Rivera," *Diego Rivera Hoy*, 205–29, and Ida Rodríguez Prampolini, "Comentario a la ponencia de Adolfo Sánchez Vázquez, 229–34. In addition, see Adolfo Sánchez Vázquez, "Diego Rivera: Pintura y Militancia," *El Universal* (December 12, 1977): 6.

73. Stanton Catlin, "Mural Census," 283–85.

74. Ibid.

75. Ibid., 331.

76. Lawrence Hurlburt, "Diego Rivera: A Chronology," 79.

77. Alicia Azuela, "Rivera and the Concept of Proletarian Art," 125–29. For a concise discussion of these Marxian economic concepts cited above, see Ernest Mandel, *Late Capitalism* (1972). Trans. Joris De Bres (London: Verso, 1975), 39–40, 79–84, 113 ff.

78. Stanton Catlin, "Mural Census," 331–32.

79. William Stockton, "Rivera Mural in Mexico Awaits its New Shelter," *The New York Times* (January 4, 1987): 6.

80. For a solid discussion of this controversy, see Bertram Wolfe, *The Fabulous Life of Diego Rivera*, 266–70. See also Robert Evans (Joséph Freeman), "Diego Rivera," *New Masses* (February 1932). For a rather different set of reactions, see "Einstein on Rivera," *Worker's Age* (March 15, 1934), Anthony Blunt, "The Art of Diego Rivera," *The Listener* (April 17, 1935), Frank Jewett Mather, "Rivera's American Murals," *The Saturday Review of Literature* (May 19, 1934), and Edmund Wilson, "Detroit Paradoxes," *New Republic* (July 12, 1933).

81. Bertram Wolfe, *The Fabulous Life of Diego Rivera*, 266–70.

82. Ibid.

83. Stanton Catlin, "Mural Census," 287–91.

84. Diego Rivera, Letter to Bertram Wolfe on July 9, 1932, The

Bertram Wolfe Collection, (The Hoover Institute: Stanford University). See also Diego Rivera, "Dynamic Detroit," *Creative Art*, 12, 4 (1933): 289–95.

85. The literature on the Detroit murals is substantial. Among the most important studies are Alicia Azuela, *Diego Rivera en Detroit* (Mexico City: Universidad Nacional Autonóma de Mexico, 1985), Linda Downs and Mary Jane Jacob, *The Rouge: The Image of Industry in the Art of Charles Sheeler and Diego Rivera* (Detroit: Detroit Institute of Arts, 1978), Linda Downs, "Los frescoes de la Industria de Detroit," *Diego Rivera Hoy*, 235–43, Max Kozloff, "The Rivera Frescoes of Modern Industry at the Detroit Institute of Arts: Proletarian Art under Capitalist Patronage," *Art and Architecture in the Service of Politics*. Eds. Henry Millon and Linda Nochlin (Cambridge, Mass.: MIT Press, 1978), 216–29, and Terry Smith, "The Resistant Other: Diego Rivera in Detroit," *Making the Modern* (Chicago: University of Chicago Press, 1993), 199–246.

86. Stanton Catlin, "Mural Census," 289.

87. Reuben Alvarez, The Voice-Over to the film *The Age of Steel* (Ford Fund, 1978). Cited in Terry Smith, *Making the Modern*, 235.

88. Stanton Catlin, "Mural Census," 287–93.

89. Ibid.

90. Terry Smith, *Making the Modern*, 216–25.

91. Stanton Catlin, "Mural Census," 287–93.

92. Gladys March, *Diego Rivera*, 116.

93. Ibid.

94. Stanton Catlin, "Mural Census," 287–93.

95. Ibid.

96. Gladys March, *Diego Rivera*, 111–12.

97. Terry Smith, *Making the Modern*, 216–25.

98. Ibid., 205.

99. Ibid., 210.

100. Ibid., 212.

101. Ibid.

102. Ibid., 216.

103. Ibid., 218.

104. Ibid., 221.

105. Ibid., 228.

106. Ibid., 231.

107. Ibid., 235.

108. Leon Trotsky, "Art and Politics in Our Epoch," *Partisan Review* (August 1938), reprinted in *Leon Trotsky on Literature and Art*. Ed. Paul Siegel (New York: Pathfinder Press, 1970), 104.

109. Ibid.

110. Ibid., 109.

111. Ibid., 110.

112. See O. K. Werckmeister, "The Summit Meeting of Revolutionary Art: Trotsky, Breton, and Rivera at Coyoacán, February 1938," Paper at the *XXVlle Congrès International d'Histoire de l'Art*. Colmar, France, September 7, 1989.

113. Lawrence Hurlburt, "Diego Rivera: A Chronology," 96–99.

114. See Meyer Schapiro, "On David [Alfaro] Siqueiros — A Dilemma

for Artists," *Dissent*, 10, 2 (Spring 1963) 106–07.

115. Lawrence Hurlburt, "Diego Rivera: A Chronology," 99.

116. O. K. Werckmeister, "The Summit Meeting of Revolutionary Art: Trotsky, Breton, and Rivera at Coyoacán, February 1938."

117. André Breton, Diego Rivera, and Leon Trotsky, "Manifesto: Towards a Free Revolutionary Art" (1938. Trans. Dwight Macdonald, reprinted in *Theories of Modern Art*. Ed. Hershel Chipp, (Berkeley: University of California Press, 1968), 483–86.

118. Ibid.

NOTES TO CHAPTER FIVE

1. Roger Bartra, *Jaula de la melancolía* (1987). Trans. Christopher Hall (New Brunswick: Rutgers University Press, 1992), 80–81.

2. Here, I am in complete agreement both with Alberto Híjar's claim that "En principio parece indubable que ninguno de los cambios del Rivera multiple y variado contradicen su proyecto de liberación nacional" and with Adolfo Sánchez Vázquez's view that throughout his entire career, "Rivera hace suya una idea clave marxista: la hostilidad capitalista al arte que tiene su raíz en la transformación de la obra artístic en mercancía." See Alberto Híjar, "Diego Rivera: contribución politica," 39, and Adolfo Sánchez Vázquez, "Claves de la ideología estética de Diego Rivera," 208.

3. The charge of "opportunism" has most often been made by members of the Communist Party, such as Carlos Cortes, David Alfaro Siqueiros, Hernan Laborde, and Valentin Campa. See Raquel Tibol, "Datos biográficos," *Diego Rivera, Arte y Política*, 349–443.

4. Jesus Kumate, "Diego Rivera: la medicina y el arte," *Diego Rivera Hoy*, 77–84, and Stanton Catlin, "Mural Census," 320–23.

5. See Shifra Goldman, "Mexican Muralism: Its Social-Educative Roles in Latin America and the United States," *Aztlán*, 13, 1–2 (1982): 111 ff,

and Shifra Goldman, *Contemporary Mexican Painting in a Time of Change* (Austin: University of Texas, 1977), Chapter One.

6. Roger Bartra, *Jaula de la melancía*, 80–81.

7. Ida Rodríguez Prampolini, *El Surrealismo y el Arte Fantastico de Mexico* (Mexico City: Universidad Nacional Autonoma de Mexico, 1969), Chapter Five.

8. *Diego Rivera: A Retrospective* (1986), 100.

9. *Diego Rivera Catálogo General de Obra de Caballete*, 1421–1426: 186–87.

10. John Ruskin, *Modern Painters*, vol .III, Chapter XII, *The Collected Works of John Ruskin*, vol. V. Eds. E. T. Cook and Alexander Wedderburn (London, 1904), 201–20.

11. See, for example Elizabeth Cowling, "The Eskimos, the American Indians, and the Surrealists," *Art History*, 1, 4 (December 1978): 488–89, and James Clifford, "On Ethnographic Surrealism," *The Predicament of Culture* (Cambridge, Mass.: Harvard University Press, 1988), 117–51.

12. *Diego Rivera Catálogo General de Obra de Cabllete*, 1464, 1465: 192. As the reader will immediately notice, No. 1465 and 1466 have been *erroneously* switched in the catalogue.

13. André Breton, "Frida Kahlo y Rivera" (1938), reprinted in *Surrealism and Painting*. Trans. Simon Watson Taylor (New York: Harper and Row, 1972), 143.

14. Rita Eder, "Portraits of Diego Rivera," *Diego Rivera: A Retrospective* (1986), 197.

15. Ibid.

16. Ibid., 199.

17. Xavier Moyssén, "The Self-Portraits of Diego Rivera," *Diego*

Rivera: A Retrospective, 189–96.

18. Ibid., 195.

19. Justino Fernández, "Diego Rivera: antes y después," *Anales del Instituto de Investigacionces Estéticas*, 18 (1950): 81.

20. Stanton Catlin, "Mural Census," 305–07.

21. Mikhail Bakhtin, *Rabelais and His World* (1965).

22. Statement by Rivera as quoted in Carlos Mérida, *Frescoes in Salubriadad and the Hotel Reforma* (Mexico City: Frances Toor Studios, 1937), n. p.

23. This distinction is fundamental to the now classic study by Benedict Anderson, *Imagined Communities* (London: Verso, 1983).

24. Carlos Blas Galindo, "Nationalism, Ethnocentrism, and the Avant-Garde," *Latin American Art*, 2, 4 (Fall 1990): 38–43.

25. F. Orgambides, "Diego Rivera: la historia de un confidente de lujo," *El Pais* (Madrid), Edición Internacional (November 29, 1993): 28. The discovery of these documents from 1940 in the Archives of the United States State Department was made by two scholars from the University of Pittsburgh, William Chase and Dana Reed.

26. Stanton Catlin, "Mural Census," 312–15.

27. Ibid., 321.

28. Ibid.

29. Karl Korsch, "Leading Principles of Marxism: A Restatement," *Marxist Quarterly*, 1, 3 (October/December 1937): 356, 375–76. Rivera's friend, art historian Meyer Schapiro, was one of the founders of this journal and an admirer of the work of Karl Korsch, who is sometimes called the teacher of Bertolt Brecht.

30. Water Benjamin, *Ursprung des deutschen Trauerspiels* (1928).

Trans. John Osborne (London: Verso Press, 1985), 178.

31. Bertram Wolfe, *The Fabulous Life of Diego Rivera*, 389.

32. Ibid., 389.

33. Ibid.

34. Ibid.

35. Ibid., 390.

36. *Diego Rivera Catálogo General de Obra Mural y Fotografía Personal,* 251.

37. Stephen Schlesinger and Stephen Kinzer, *Bitter Fruit: The Untold Story of the American Coup in Guatemala* (New York: Doubleday, 1982), Richard Barnett, *Intervention and Revolution: The U.S. and the Third World* (New York: Random House, 1964), and Walter LaFeber, *Inevitable Revolutions: The United States in Central America* (New York: W. W. Norton and Co., 1983), 9.

38. Hayden Herrera, *Una biografía de Frida Kahlo* (Mexico City: Editorial Diana, 1984), photograph #82.

39. Stanton Catlin, "Mural Census," 317.

40. Meyer Schapiro, "Seurat and *La Grande Jatte*," *Columbia Review,* 17, 1 (November 1935): 9–17.

41. Stanton Catlin, "Mural Census," 317.

42. Lawrence Hurlburt, "Diego Rivera: A Chronology," 115.

43. Frida Kahlo, "Retrato de Diego," *Hoy,* 22 (January 1949): 18–21.

A Bibliographic Note on
Primary and Secondary Sources
■

Three of the major collections of primary sources for doing research on Diego Rivera are the following: 1) the *Fideicomiso Técnico Diego Rivera* in Mexico City, access to which is regulated by Sra. Dolores Olmedo Patiño; 2) *The Bertram Wolfe Collection* at the Hoover Institute, Stanford University, and 3) the *Diego Rivera Catálogo* compiled by the team of scholars at the *Centro Nacional de Investigación, Documentación e Información de Artes Plásticas (CENIDIAP)* of the Instituto de Bellas Artes. Currently in the new Fine Arts Library of the *Centro Nacional de las Artes,* this huge collection contains forty-one volumes of material, both published and unpublished, about the career of Diego Rivera. CENIDIAP was also responsible for compiling the two-volume catalogue raisonné of Rivera's work that is *indispensible* for doing research on this artist: *Catálogo General de Obra de Caballete*, Vol. 1, and *Catálogo General de Obra Mural y Fotografía Personal*, Vol. 2.

In addition, there are several more institutions that are highly important repositories for primary sources on Diego Rivera: the *Museo Anahuacalli* in Mexico City, which contains sketchbooks, the cartoons for several murals, and Rivera's personal collection of 60,000 pre-Columbian artworks; the *Museo Estudio San Angel* in Mexico City, which contains paintings and drawings, in addition to his collection of Mexican folk art, plus some unpublished correspondence; the *Museo Casa Diego Rivera* in Guanajuato, Mexico, which contains 110 drawings, paintings, and prints, in addition to three major sketchbooks he completed in the 1920s; the *Biblioteca del Museo Franz Meyer,* which contains a few paintings by Rivera plus a collection of books from Europe about the artist; the *Biblioteca "Justino Fernández"* at the Instituto de Investigaciones Estéticas of the Universidad Nacional Autónoma de Mexico, Mexico City, which contains both primary sources, such as copies of *Savia Moderna*, and an excellent collection of rare secondary sources on Diego Rivera; the *Museo Frida Kahlo, Casa Azul,* in Coyoacán, which contains important early work by Rivera, as well as his collection of Mexican retablos; the *Escuela Nacional de Artes Plásticas* (Academy of San Carlos), which contains work from his

student years and records of his studies there; and, finally, the *Detroit Institute of Arts,* which contains most of the documents relating to Rivera's mural project there, including some unpublished writings by Rivera himself.

There are two important but not comprehensive anthologies of Diego Rivera's wrtings, neither of which has yet been translated into English. These are: Raquel Tibol, *Diego Rivera: Arte y Política* (Mexico City: Editorial Grijalbo, 1978) and Xavier Moyssén, *Diego Rivera: Textos de Arte* (Mexico City: Universidad Nacional Autonóma de Mexico, 1986).

Among the best and most comprehensive bibliographies of writings on Diego Rivera are those that are found in three major exhibition catalogues: *Diego Rivera, 50 años de su labor artística* (Museo Nacional de Artes Plasticas, 1949), *Exposición nacional de homenaje a Diego Rivera con motivo del XX aniversario de su fallecimiento* (Palacio de Bellas Artes, 1977/78), and *Diego Rivera: A Retrospective* (Detroit Institute of Arts, 1986). In addition, there is the significant bibliography that was compiled by Olivier Debroise, "Diego Rivera, bibliografía (1950-diciembre 1977)," in *Artes Visuales*, No. 16 (Winter 1977).

INDEX

■

Z

ABOUT THE AUTHOR

■

Dr. David Craven has degrees in Art History from Vanderbilt University and the University of North Carolina, Chapel Hill, where he recieved his Ph.D. Now a Professor of Art History at the University of New Mexico, he has also been on the faculty at Duke University and the State University of New York, College at Cortland. He has been a Visiting Professor at the University of Bremen (Germany), the University of Leeds (England), and the Institute of Aesthetic Investigation at the National Autonomous University of Mexico, as well as a Guest Lecturer at Trinity College, Dublin and a Visiting Fellow at Princeton University. Moreover, he has given guest lectures in over thirty different universities and museums both here and abroad, from the University of Hamburg and Cambridge University to the University of Central America Managua and the National Gallery in Washington, D.C.

He is the author of almost a hundred articles and reviews that have appeared in leading journals of over ten different countries throughout Europe and Latin America, as well as in the United States and Canada. In addition, he has written a catalog essay for the Tate Gallery, Liverpool (1992), guest edited a special issue of the *Oxford Art Journal* (1994), and authored six books. Aside from this study of Diego Rivera for G.K. Hall (1997), the other books are *The New Concept of Art and Popular Culture in Nicaragua Since the Revolution in 1979* (Edwin Mellen, 1989), *Poetics and Politics in the Art of Rudolf Baranik* (Humanities Press, 1996), *Modern Art and Revolution in Latin America* (Thames and Hunson, 1989), *Abstract Expressionism as Cultural Critique in the Age of McCarthyism* (Cambridge University Press, 1998), and *Critical Dialogue: The Paintings of May Stevens* (forthcoming).